This book is dedicated in loving memory to Gary L. Lowrie whose life and courageous struggle against ALS inspired all who knew him.

© *Sandy Rippel*

Acknowledgments

Special thanks to Peter Burian, photographer and friend who kindly contributed images for this book. Also special thanks to Heath Hamblin and other models who generously donated their time to model for images in this book.

Contents

Part I: Using Canon EOS 30D 9

Chapter 1: Exploring the EOS 30D 11

Chapter 2: Canon EOS 30D Setup 53

Part II: Exposure, Composition, Lighting, and Lenses 75

Chapter 3: Reviewing the Elements of Exposure 77

Chapter 4: Working with Light 89

Chapter 5: Brush Up on Composition 101

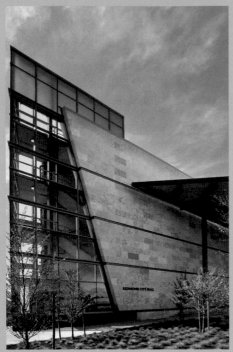

Chapter 6: Selecting and Using Lenses 111

Part III: Techniques for Great Photos 123

Chapter 7: A World of Subjects 125

Introduction

Welcome to the *Canon EOS 30D Digital Field Guide.* You may already know that you have one of the finest and most versatile digital cameras on the market. This book is designed to help you master using the camera and to help you get the best images possible from it. Ultimately, of course, the camera is simply a tool for expressing your creative vision—the means by which you capture the fleeting moment, whether it's the smile of a friend, a news event, or the joy of a bride and groom on their wedding day. It is your vision and understanding of life that are always the defining characteristics that set your images apart from the thousands of everyday images.

Much of this book deals with photographic subjects. As most art directors and photo representatives can tell you, there is an advantage in developing and mastering a photographic specialty. But remember that all of life is a photographic subject. In his book *The Mind's Eye: Writings on Photography and Photographers,* Cartier-Bresson said, "There is subject in all that takes place in the world, as well as in our personal universe. We cannot negate subject. It is everywhere. So we must be lucid toward what is going on in the world, and honest about what we feel . . . In photography, the smallest thing can be a great subject. The little human detail can become a leitmotiv. We see and show the world around us, but it is an event itself which provokes the organic rhythm of forms."

I hope that this book is a rewarding journey for you, not only into learning to use the EOS 30D, but also into exploring a universe of subjects and distilling the essence of each image with freshness and creative vision.

As you use this book and try the various photographic subjects, keep in mind that it is the photographer who makes the picture—although having a camera like the EOS 30D is definitely a plus in getting great images.

Getting the Most from This Book

If you're anxious to begin shooting with the EOS 30D, go first to the Quick Tour that takes you quickly through the basic setup and shooting controls you need to begin taking pictures. Setup is relatively easy on the camera, and you'll get good results from the first picture onward. After you have the first frames from the camera, be sure to go through Chapters 1 and 2 — they offer a detailed guide to the camera features, functions, and setup procedures. You may be familiar with some of the information already, but browsing through these chapters with an eye toward anything that may be new, including things such as extended ISO setup, is still worthwhile. These chapters also help you to get to know

the camera thoroughly and to be able to use it quickly and confidently in all types of shooting situations.

Subsequent chapters review the basics of exposure and the characteristics of light and provide an overview of lenses and their performance on the EOS 30D. If you are relatively new to photography, and especially digital photography, these chapters provide a foundation on which you can build your skills. If you've been away from photography for a time, these chapters offer quick refreshers on the basics.

Most important, these chapters help you understand how the controls and functions on the EOS 30D work together with your photography knowledge to get great images. With this background and the chapters on camera setup and functions, you'll have the confidence to use the camera in almost any shooting situation.

The rest of the book explores specific photography specialty areas. Chapter 7 may seem daunting at first glance, but it provides lots of information aimed at helping you get the most from the camera in specific scenarios. The chapter is divided into popular photography specialties and subjects ranging from various types of portraiture to sports and photojournalism. Each section includes tips and techniques for making the best possible images. This is also a good chapter to help you explore photography subject areas that you may not have tried before.

Within each photography subject area, you'll find the following:

+ Sample photos
+ Discussions about each type of subject
+ Ideas to inspire you for making pictures of each subject
+ An in-the-field photo with notes on setup, lighting, lens, exposure mode, exposure settings, and optional accessories used to make the image
+ Composition tips and notes

Also scattered throughout the chapter are suggestions and techniques for handling difficult scenes and subjects.

Chapter 8 and Appendixes A and B provide a guide to help you complete the workflow, from downloading images to the computer to establishing a solid workflow. For those who shoot in RAW capture mode, you'll find an introduction to conversion programs and workflow notes and tips to help make the process efficient.

Now is the best time to get started reading and shooting. The editor, the staff at Wiley, and I all hope that you enjoy using this book as much as we enjoyed creating it for you.

Quick Tour

QT

Welcome to the world of digital photography with the Canon EOS 30D SLR camera. The EOS 30D is a gateway into a creative world of visual fun, excitement, and professional-quality images. This section of the book is designed to give you a quick overview of camera setup and functions so that you can begin shooting right away.

Because the EOS 30D is designed to serve both the advanced amateur and the professional, the camera's versatility and ease of use make it a great choice for both traditional and creative genres of photography. Not only do you have the advantage of instant results, but also you have a powerful tool that serves you well in a variety of venues. The control you have during and after capture is gratifying, giving you more time to shoot while spending less time processing and tweaking images.

By now, you've probably already attached the lens, charged the battery, and inserted the media card, so you need a quick tour of setup controls and camera functions. This Quick Tour helps you double-check any setup that you've already done, points out areas that you may not know about, and guides you through getting images onto the computer.

Taking the First Pictures

After you've charged and inserted the battery, inserted the CompactFlash (CF) card, attached the lens, and turned on the camera, take a quick round of images to get a sense of the camera and the image quality from it. Depending on your skill level, you can use one of the programmed modes such as Portrait, Landscape, or Full Auto, or one of the semi-automatic modes to take the test shots. Even point-and-shoot images taken on Full Auto give you a sense of the dynamic range that you can expect from the image sensor.

The large, bright 2.5-inch, 230,000 pixel LCD monitor can display the image histogram and shooting information for you to

make initial exposure evaluations. You can set the LCD to show the image histogram by pressing the Info button on the back of the camera twice right after the image is displayed. Or if the image display has already disappeared, press the Playback button, and then press the Info button twice to display the histogram. If you're shooting in Full Auto mode or semi-automatic mode such as Landscape or Portrait, the image preview and histogram are for the JPEG image. If you're shooting RAW, the display and histogram are also for a JEPG version of the image. Either way, you'll likely find that the camera tends toward rich color but somewhat dark images. After you've done further image evaluation, you can set positive exposure compensation if you find that you need to open up shadow areas to show more detail.

If you are new to digital SLR cameras, taking the first picture is simple. With the camera turned on, press the Shutter button halfway down to focus on the subject, and then press the Shutter button completely to take the picture. In Full Auto and semi-automatic modes, the camera chooses the autofocus points automatically. It chooses the appropriate autofocus points (displayed in the viewfinder with one or more red dots), and then focuses on the subject closest to the camera. If you want to set the autofocus points yourself, you must switch to one of the Creative Zone modes described later in the Quick Tour.

The EOS 30D displays the image you took for 2 seconds on the LCD monitor. If you have multiple images on the CF card, you can press the Playback button and then turn the Main dial to browse through the images.

 Caution *Never open the media card door while the access light is lit. The access light remains lit as the camera records the pictures that* you took to the CompactFlash card. If you open the media card door, the most recent images you took will be lost.

Setup Basics for the EOS 30D

Canon's menus are simple and easy to navigate, which makes setup fast and painless. Minimizing the menu structure makes changing settings on the fly an easy task as well.

Setup on the camera is dependant on the shooting mode that you choose. The Mode dial on the EOS 30D has two broad categories, Basic Zone and Creative Zone modes. The diagram in figure QT.1 shows which modes fall into each category. In Basic Zone modes, the camera sets the ISO, f-stop, and shutter speed (file type). In Creative Zone modes, you can set the exposure elements as well as the autofocus points. During camera setup, be sure to set up for both zones as applicable. An overview of both zones is provided later in the Quick Tour.

Formatting the CompactFlash card

Now is also a good time to format the CompactFlash card. Formatting the card the first time and periodically as you use the card is a good idea because it structures the card for the camera data.

1. **Press the Menu button, and then rotate the Quick Control dial to the Set-up (yellow) menu.**

2. **Rotate the Quick Control dial to select Format, and press the Set button.** A confirmation screen appears.

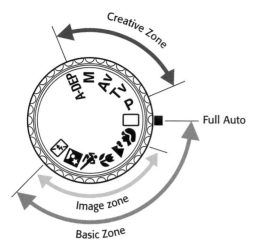

QT.1 The shooting mode categories on the EOS 30D

3. Rotate the Quick Control dial to select OK, and press the Set button. The EOS 30D formats the CF card.

 A more in-depth discussion of the CF card and how to work with it can be found in Chapter 2.

Setting the image recording quality

The file format and quality level that you select is one of the most important decisions you make when using your 30D. The settings determine the size at which you can print the images you take. It also affects the number of images that you can store on the CF card. Capturing images at a high-resolution setting is important in order to maximize printing capability over the long term. The higher the image quality you choose, the larger the print that you can make.

 For an overview of image quality settings, see Chapter 2.

To set the image recording quality, follow these steps:

1. Press the Menu button on the back of the camera. The Shooting (red) menu is displayed. If another menu is displayed, press the Jump button until the Shooting menu is displayed.

2. Press the Set button. The Quality submenu is displayed. If the camera is set to a Basic Zone mode, you can choose JPEG quality ranging from Large/Fine to (8.2 megapixel-images at 3504 × 2336 pixels) to Small/Normal (2 megapixels at 1728 × 1152 pixels). If the camera is set to a Creative Zone mode, the Quality menu includes the previous settings in addition to RAW options: RAW, or RAW + Large through to RAW + Small. These RAW + settings capture a RAW image in addition to a JPEG at a Large, Medium, or Small size image.

3. Rotate the Quick Control dial to select the image-recording quality setting that you want, and then press the Set button.

4. If you shoot in both Basic Zone and Creative Zone modes, you can repeat this procedure for the other mode category. For example, you can set the quality for Creative Zone modes, then set the camera to a Basic Zone mode, and repeat Steps 1 through 3 to set image-recording quality for those modes.

5. Lightly press the shutter button to dismiss the Menu display.

Setting file numbering

File numbering options are Continuous, Auto Reset, and Manual Reset. For most photographers, the Continuous option is

best because it avoids the possibility of having duplicate filenames on the computer, and it records the shutter actuations on the camera, and that information can be helpful should you need to send the camera for repair or sell it.

To set a file numbering option, follow these steps:

1. **Press the Menu button on the back of the camera.** The Shooting (red) menu is displayed. If another menu is displayed, press the Jump button until the Shooting (red) menu is displayed.

2. **Rotate the Main dial until File numbering is selected.**

3. **Press the Set button.** The camera displays the File numbering options.

4. **Rotate the Main dial to select the option you want and then press the Set button.**

5. **Lightly press the Shutter button to dismiss the Menu display.**

Basic Zone Shooting

The fully automated Basic Zone modes function as point-and-shoot options for catching quick grab shots and snapshots. The modes in this zone do not allow you to set the ISO, shutter speed, or aperture. The modes are grouped together on the Mode dial with symbols that depict the type of scene that they are best suited for. For example, Portrait mode is denoted by the image of a person's head.

In Basic Zone modes, you choose the mode that fits the scene, and the camera automatically sets the exposure settings for you.

Focus on the subject by pressing the Shutter button halfway down, and then depress the Shutter button completely to take the picture.

 For an overview of camera controls, see Chapter 1.

The EOS 30D offers these Basic Zone modes:

+ Full Auto
+ Portrait
+ Landscape
+ Close-up
+ Sports
+ Night Portrait
+ Flash off

Creative Zone Shooting

Creative Zone modes offer automatic, semi-automatic, and manual control over all or some of the exposure settings and focusing. Most of these modes operate in a fashion that is similar to their film camera counterparts. Using different Creative Zone modes, you can control depth of field, control how motion is shown in the image, switch between equivalent exposures, and have the camera maximize depth of field in specific scenes.

 For an overview of Creative Zone modes, see Chapter 1.

In the Creative Zone modes, you can set the ISO and the autofocus point, except for A-DEP mode where the camera sets the autofocus points automatically. You can choose the Picture Style that you want in any of the Creative Zone modes.

✦ **Program AE.** Program AE is displayed as P on the Mode dial and is a fully automatic, but shiftable mode. *Shiftable* means that you can change the programmed exposure by changing, or shifting, the aperture or the shutter speed while the camera automatically adjusts the other setting to maintain an equivalent exposure. In many ways, this mode is convenient because it allows you to adjust either shutter speed or aperture, whereas the Aperture-priority AE and Shutter-priority AE modes allow you to adjust either aperture or shutter speed without the ability to switch between the two on the fly. To use this mode, turn the Mode dial to P. To shift the shutter speed or aperture, watch in the viewfinder as you rotate the Main dial to the desired setting, and then focus and take the picture.

✦ **Shutter-priority AE.** This mode is displayed on the Mode dial as Tv (Time Value). In this mode, you set the shutter speed, and the camera automatically sets the aperture. To use this mode, rotate the Mode dial to Tv. Watch in the viewfinder as you rotate the Main dial to the desired shutter speed, and then focus and take the picture. If the aperture value shown in the viewfinder blinks, it means that the exposure cannot be made at the current combination of shutter speed and aperture. Rotate the Main dial to adjust the shutter speed until the blinking stops.

✦ **Aperture-priority AE.** This mode is displayed on the Mode dial as Av (Aperture Value). In this mode, you set the aperture (f-stop), and the camera automatically chooses the correct shutter speed. To use this

mode, rotate the Mode dial to Av, and watch in the viewfinder as you rotate the Main dial to the desired aperture. Focus on the subject, and take the picture.

✦ **Manual.** This exposure mode is displayed on the Mode dial as M. In this mode, you can set all exposure settings independently: ISO, shutter speed, and aperture. Before using this mode, be sure that the Power/Quick Control dial is in the uppermost position. To get an accurate exposure, watch in the viewfinder as you adjust shutter speed using the Main dial and the aperture using the Quick Control dial until the marker on the Exposure Level Indicator is in the middle of the scale or is at the level of overexposure or underexposure that you want.

✦ **Automatic depth of field.** This mode is displayed on the Mode dial as A-DEP. When you use this mode, the camera automatically calculates the optimum depth of field between near and far subjects in a scene. To use this mode, rotate the Mode dial to A-DEP, focus on the subject, and take the picture.

Setting the ISO

The ISO setting determines how sensitive the image sensor is to light in the scene. The EOS 30D can be set to ISO 100 to 1600 in 1/3–stop increments. In addition, ISO can be pushed to 3200 using ISO expansion offered in Custom Function 08 (C.Fn-08). The EOS 30D's default ISO setting is 100.

 Cross-Reference *See Chapter 2 for more information on ISO expansion.*

If you want to change the ISO setting, follow these steps:

1. **Turn the Mode dial, and select a Creative Zone mode.**

2. **Press the Drive-ISO button on the top of the camera.** The camera displays the current ISO setting on the LCD panel. When the camera is set to a Basic Zone mode, the LCD panel displays Auto.

3. **Rotate the Quick Control dial until the ISO setting that you want is displayed in the LCD panel.**

4. **Lightly press the Shutter button to begin shooting.**

Setting the White Balance

The white balance setting tells the camera the type of light that is in the scene so that the camera can render white and other colors accurately. The EOS 30D is initially set to Auto White Balance, abbreviated and displayed as AWB in the LCD panel. And in Basic Zone modes, the 30D automatically sets the white balance to Auto — a setting that you can't change in these modes.

 For more details on white balance options and white balance bracketing, see Chapter 2.

To change the white balance setting, follow these steps:

1. **Turn the Mode dial, and pick a Creative Zone mode.**

2. **Press the AF-WB button on the top of the camera.** The camera displays the current white balance

setting on the LCD panel. When the camera is set to a Basic Zone mode, the LCD panel displays AWB.

3. **Rotate the Quick Control dial until the white balance setting that you want is displayed in the LCD panel.**

4. **Lightly press the Shutter button to begin shooting.**

Setting the Autofocus Point

The EOS 30D features a nine-point autofocus (AF) system that allows you to focus on the subject whether it is in the center of the frame or off center. By selecting the autofocus point, you set the point of sharpest focus in the image. Autofocus points can be manually selected only in Program AE, Shutter-priority AE, Aperture-priority AE, and Manual modes in the Creative Zone. In the Basic Zone, the camera automatically selects the AF points.

 For more on the EOS 30D autofocus system and autofocus modes, see Chapter 1.

To select the autofocus point, follow these steps:

1. **Rotate the Mode dial to P, Tv, Av, or M mode.**

2. **Press the AF point selection button on the top-right side of the back of the camera.**

3. **Rotate the Main dial or use the Quick Control dial to cycle through the AF points until the point you want is highlighted in red in the viewfinder.** As long as

you do not press the Shutter button, you can continue to choose different AF points. If you press the Shutter button, repeat Steps 2 and 3 to set a different AF point.

Setting the Color Space

Setting the color space determines the color *gamut*, or range of colors, that can be reproduced in your images. The EOS 30D offers sRGB, which encompasses a smaller gamut of colors, and Adobe RGB, a larger color gamut. In general, you should choose the color space the matches your color management system and your workflow.

To set the color space, follow these steps:

1. **Set the Mode dial to a Creative Zone mode, and then press the Menu button.** If the Shooting (red) menu is not displayed, press the Jump button until it is displayed.

2. **Rotate the Quick Control dial to highlight Color space, and click the Set button.** The camera displays two options.

3. **Rotate the Main dial to choose sRGB or Adobe RGB, and press the Set button to confirm your choice.**

4. **Lightly press the Shutter button to return to shooting.**

Setting the Drive Mode

Choosing a drive mode determines whether the camera shoots one image at a time or multiple images in rapid sequence. The EOS 30D offers single, high-speed continuous at a maximum of 5 frames per second (fps), low-speed continuous at a maximum of 3 fps, and a 10-second self-timer mode. The EOS 30D is initially set to single shot mode.

 Cross-Reference *For more on drive modes, see Chapter 1.*

To set the drive mode, follow these steps:

1. **Rotate the Mode dial to P, Tv, Av, M, or A-DEP mode.**

2. **Press the Drive-ISO button, and rotate the Main dial until the drive mode that you want is displayed in the LCD panel.** Note that the High-speed continuous mode is indicated with an H, and Low-speed continuous has no alphabetic notation. Self-timer mode is indicated with a clock-like icon.

3. **If you set the camera to a continuous mode, focus on the subject and hold down the Shutter button to take a continuous sequence of images.**

Setting the Metering Mode

With the EOS 30D, you can choose Evaluative, Partial, Spot, and Center-weighted average metering when you are shooting with Creative Zone modes. The new Spot metering mode covers approximately 3.5 percent of the viewfinder area at the center, and it is a good choice when a specific area of the subject is critical for exposure, or when you want to properly expose a subject in difficult lighting such as backlighting. The EOS 30D is initially set to Evaluative metering.

In Basic Zone modes, the camera automatically sets the metering mode. You can change the metering mode in Creative Zone modes.

Note *If you're new to photography, a metering mode determines how the camera's built-in light meter measures light in the scene so that it can determine the correct exposure. Based on the ISO, the camera calculates the aperture and shutter speed combinations required to make a good exposure.*

To set an exposure mode, follow these steps:

1. **Rotate the Mode dial to P, Tv, Av, M, or A-DEP mode.**

2. **Press the Metering mode selection/Flash exposure compensation button above the LCD monitor, and then rotate the Main dial to select the metering mode that you want.** If you rotate the dial to the right, the camera cycles through metering modes in this order: Evaluative, Partial, Spot, and Center-weighted average metering modes.

Setting the Picture Style

Canon's Picture Styles allow you to choose specific combinations of sharpness, contrast, color saturation and tone, filter effects, and color toning for a specific image effect. In Basic Zone modes, the camera automatically chooses the Picture Style. You can select the style in Creative Zone modes.

In addition, you also can modify the preset styles and set your own styles.

Cross-Reference *For more on Picture Styles, see Chapter 2.*

The EOS 30D offers these predefined Picture Styles:

✦ **Standard.** Provides a vivid, sharp, and crisp look.

✦ **Portrait.** Maximizes the appearance of skin tones with a sharp and crisp rendering. You can also change the color tone to adjust the skin tones.

✦ **Landscape.** Provides vivid blues and greens with good sharpness.

✦ **Neutral.** Produces natural colors and more subdued images with no sharpness applied to images.

✦ **Faithful.** Used for images shot under 5200 K temperatures. The color is colorimetrically adjusted to match the subject color with no sharpening.

Cross-Reference *For more information on white balance and Kelvin temperatures, see Chapter 2.*

To choose a Picture Style, follow these steps:

1. **Rotate the Mode dial to P, Tv, Av, M, or A-DEP mode.**

2. **Press the Menu button.** If the Shooting (red) menu is not displayed, press the Jump button until it is displayed.

3. **Rotate the Main dial to highlight Picture Style, and press the Set button.** The camera displays Picture Style options.

4. **Rotate the Quick Control dial to select the style you want.**

5. **Press the Set button to confirm your selection.** Your selection remains in effect until you change it by repeating these steps.

Using the Canon EOS 30D

Exploring the Canon EOS 30D

Whether you're a wedding photographer, a photojournalist, or an advanced photography aficionado, the Canon EOS 30D is a versatile tool with excellent image resolution and quality, a range of usable and expandable ISO settings so that you can rely on getting great images in low light at higher ISO settings. And at 5 frames per second (fps), you can capture everything from a bride and groom's quick exit to a limousine to the action of a breaking news story.

Weighing in at 24.7 ounces sans lens, the EOS 30D is easy to pack and easy to use. With instant on and instant wake-up from the battery-saving sleep mode via the shutter button and other camera buttons, there is no delay between seeing the image and capturing it.

In this chapter, you get an overview of exposure controls on the 30D, metering and autofocus modes, as well as customizing camera operations to suit your shooting preferences using Custom Functions.

Camera and Lens Controls

Any professional photographer knows that the most important first step in photography is learning the camera so thoroughly that he or she can operate it in the dark or blindfolded. Only then can camera adjustments be made instinctively and confidently without missing a shot.

You may not think that you need to know your camera that well, but the point is well taken. Knowing your camera inside and out not only instills confidence, but it also allows you to react quickly and get those important shots that you would otherwise miss or that you wish had been better.

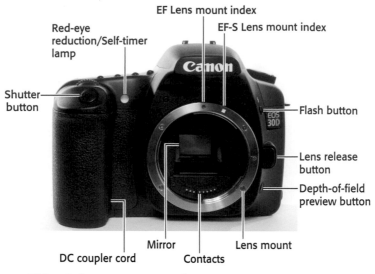

EF Lens mount index

EF-S Lens mount index

Red-eye
reduction/Self-timer
lamp

Shutter
button

Flash button

Lens release
button

Depth-of-field
preview button

Mirror Lens mount

DC coupler cord Contacts

1.1 EOS 30D front camera controls

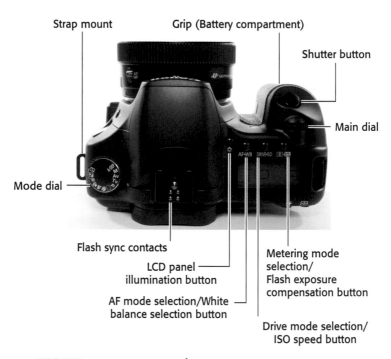

Strap mount Grip (Battery compartment)

Shutter button

Main dial

Mode dial

Flash sync contacts

LCD panel
illumination button

AF mode selection/White
balance selection button

Metering mode
selection/
Flash exposure
compensation button

Drive mode selection/
ISO speed button

1.2 EOS 30D top camera controls

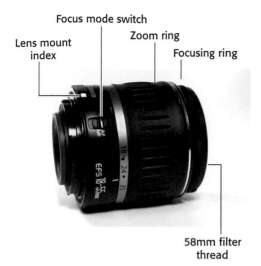

Focus mode switch
Lens mount index
Zoom ring
Focusing ring
58mm filter thread

1.3 Lens controls

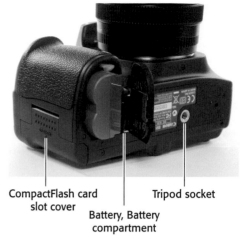

CompactFlash card slot cover
Tripod socket
Battery, Battery compartment

1.4 EOS 30D bottom camera controls

Because of the design, the EOS 30D makes mastering the camera easy and fun. Easy-to-access body controls translate into ease of use, while the full-function features offer exceptional creative control. And internally, Canon's high-resolution CMOS (complementary metal oxide semiconductor) sensor dependably delivers vivid, rich, and crisp images, especially at full resolution.

The following sections help you achieve the goal of mastering the EOS 30D. And remember that the more you use the camera, the faster you'll master it.

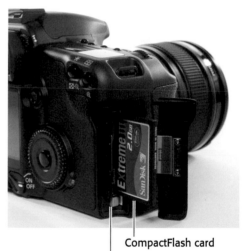

CompactFlash card
CompactFlash card eject button

1.5 EOS 30D CompactFlash compartment

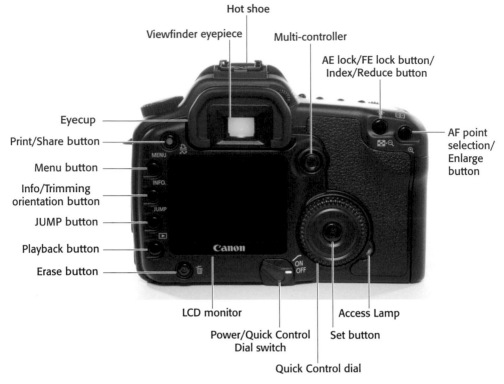

Hot shoe

Viewfinder eyepiece

Multi-controller

AE lock/FE lock button/
Index/Reduce button

Eyecup

Print/Share button

Menu button

Info/Trimming
orientation button

JUMP button

Playback button

Erase button

AF point
selection/
Enlarge
button

LCD monitor

Power/Quick Control
Dial switch

Access Lamp

Set button

Quick Control dial

1.6 EOS 30D rear camera controls

Rear camera controls

You use the rear camera controls most often. The EOS 30D offers shortcut buttons that are handy for making quick adjustments as you're shooting.

LCD panel

On the top-right of the camera is an LCD panel that shows everything you need to know about exposure settings, frames remaining, battery status, and camera settings. This panel replicates many of the displays that you also see in the viewfinder.

Viewfinder display

On the EOS 30D, the pentaprism viewfinder displays approximately 95 percent of the vertical and horizontal coverage. In addition to displaying the scene you're shooting, the

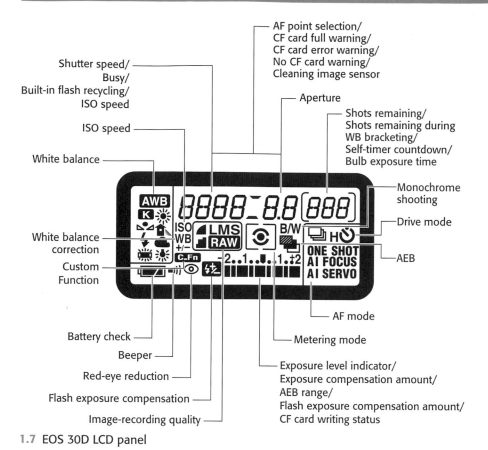

AF point selection/
CF card full warning/
CF card error warning/
No CF card warning/
Cleaning image sensor

Shutter speed/
Busy/
Built-in flash recycling/
ISO speed

Aperture

Shots remaining/
Shots remaining during
WB bracketing/
Self-timer countdown/
Bulb exposure time

ISO speed

White balance

Monochrome
shooting

Drive mode

White balance
correction

Custom
Function

AEB

Battery check

Beeper

AF mode

Red-eye reduction

Metering mode

Flash exposure compensation

Image-recording quality

Exposure level indicator/
Exposure compensation amount/
AEB range/
Flash exposure compensation amount/
CF card writing status

1.7 EOS 30D LCD panel

viewfinder displays the essential shooting information you need.

Auto Focus (AF) points are etched in the focusing screen. If you manually change AF points, the viewfinder highlights AF points as you rotate the Multi-controller. The selected AF points are displayed in red on the focusing screen when you press the shutter button halfway down. The spot metering circle is etched in the center of the matte focusing screen.

To ensure that the viewfinder image and focusing screen elements are adjusted for your vision, you can adjust the diopter from -3 to +1 diopter. Simply rotate the diopter control, located to the right of the viewfinder eyecup, clockwise or counter-clockwise until the AF points shown in the viewfinder are sharp.

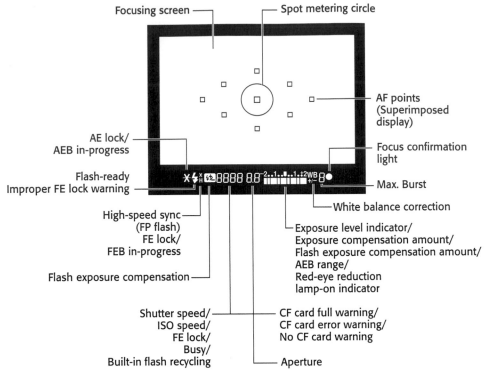

Focusing screen

Spot metering circle

AF points (Superimposed display)

AE lock/ AEB in-progress

Focus confirmation light

Flash-ready Improper FE lock warning

Max. Burst

White balance correction

High-speed sync (FP flash) FE lock/ FEB in-progress

Exposure level indicator/ Exposure compensation amount/ Flash exposure compensation amount/ AEB range/ Red-eye reduction lamp-on indicator

Flash exposure compensation

Shutter speed/ ISO speed/ FE lock/ Busy/ Built-in flash recycling

CF card full warning/ CF card error warning/ No CF card warning

Aperture

1.8 EOS 30D viewfinder display

Programmed Modes

For quick shots, the programmed Basic Zone modes and Full Auto mode are convenient and easy to use. In the programmed modes, the camera automatically sets all the settings, but you can provide some control over the way the picture looks by specifying the type scene you're shooting.

Basic Zone modes

The Basic Zone modes are quick and easy to use because you set the camera to the type scene that you're shooting, and the camera automatically sets the exposure for you.

For example, if you want a softly blurred background for a portrait, you can select

Portrait mode and the camera sets a wide aperture (f-stop), which allows the subject in the foreground to be sharp, but the background blurred.

In Basic Zone modes, the camera automatically sets the Image quality to JPEG, although you can select the level of JPEG quality. The camera also automatically selects the following settings in all Basic Zone modes:

✦ Automatic ISO selection

✦ sRGB color space

✦ Auto white balance

✦ Evaluative metering

✦ Auto flash depending on the light.

Full Auto mode

In Full Auto mode, the camera automatically sets the exposure. Because the camera does everything, this is a good mode to use for quick snapshots. However, this is not always true because the camera defaults to using the flash, even in scenes where you may not want to use the flash. And in low-light scenes, the camera may select high ISO that can introduce digital noise in the image. In Full Auto mode, the camera sets AI (Focus AF) with automatic auto-focus point (AF) selection, Single-shot (one-image-at-a-time) drive mode, and Standard Picture Style.

Portrait mode

In Portrait mode, the EOS 30D sets a wide aperture (small f-stop number) that makes the subject stand out against a softly blurred background. The EOS 30D also switches to Portrait Picture Style to enhance the subject's skin tones. This mode works well for quick portraits in good light. In low-light scenes, the camera automatically fires the flash, which may or may not be the effect you want in the portrait. In Portrait mode, the camera automatically selects One-shot autofocus and automatic auto-focus point (AF) selection, and Low-speed continuous drive mode at 3 fps.

1.9 This image was taken in Full Auto mode. The camera's automatic exposure was ISO 100, f/16 at 1/160 sec.

1.10 This image was taken in Portrait mode. The camera's automatic exposure was ISO 100, f/4, 1/1000 sec.

As with other programmed modes, you can use scene modes for a variety of other types of subjects. For example, Portrait mode works well for nature and still-life photos indoors and outdoors. If the camera detects insufficient light, the flash fires automatically.

Landscape mode

In Landscape mode, the EOS 30D chooses a narrow aperture to ensure that both background and foreground elements are sharp and that the fastest shutter speed possible, depending on the amount of light in the scene, is used. This mode works well not only for landscapes, but also cityscapes, portraits of large groups of people, and for some tabletop photography such as architectural models.

1.11 This image was taken in Landscape mode. The camera's automatic exposure was ISO 100, f/10 at 1/400 sec.

In lower light, the camera uses slower shutter speeds to maintain a narrow aperture for good depth of field, and it may increase the ISO. As the light fades, watch the viewfinder or LCD panel to monitor the shutter speed and ISO. If the shutter speed is 1/30 second or slower, or if you're using a telephoto lens, be sure to steady the camera on a solid surface or use a tripod. In Landscape mode, the camera automatically sets One-shot autofocus with automatic auto-focus point (AF)

selection, Single-shot drive mode, Flash-off mode, and Landscape Picture Style

Close-up mode

In Close-up mode, the EOS 30D allows a close focusing distance and provides the same basic results as Portrait mode but chooses one-shot drive mode rather than low-speed continuous drive mode. You can enhance the close-up effect of a close-up image further by using a macro lens. If you're using a zoom lens, zoom to the telephoto end of the lens.

All lenses have a minimum focusing distance that varies by lens. For the best images, focus at the lens's minimum focusing distance. In Close-up mode, the camera automatically sets One-shot autofocus with automatic auto-focus point (AF) selection,

1.12 This image was taken in Close-up mode. The camera's automatic settings were ISO 100, f/5.6 at 1/1600 sec.

Single-shot drive mode, Automatic flash with the option to turn on red-eye reduction, and Standard Picture Style.

Sports mode

In Sports mode, the EOS 30D freezes subject motion by setting a fast shutter speed. While this mode is designed for action and sports photography, you can use it in any scene where you want to suspend motion such as the motion of a moving child or a pet. In addition to sports, this can be a useful mode for shooting news events, weddings and receptions, and some editorial assignments with a telephoto lens.

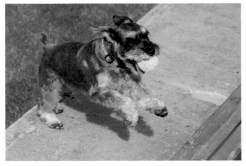

1.13 This image was taken in Sports mode. The camera's automatic settings were ISO 400, f/7.1 at 1/1600 sec.

In this mode, the EOS 30D automatically focuses on the subject and tracks the subject's movement until good focus is achieved, which is confirmed with a low beep. If you continue to hold the shutter button down, the camera maintains focus for continuous shooting. In Sports mode, the camera automatically sets AI Servo autofocus with automatic auto-focus point (AF) selection, High-speed continuous drive mode at 5 fps, Flash off, and Standard Picture Style.

Night Portrait mode

In Night Portrait mode, the EOS 30D uses the flash to correctly expose the person

combined with a slow synch speed to correctly expose the background. With a longer exposure such as this, the subject should remain still during the entire exposure to avoid blur. Be sure to use a tripod or set the camera on a solid surface to take night portraits.

This mode is best used when people are in the picture rather than for general night shots because the camera blurs the background somewhat as it does in Portrait mode. For night scenes without people, use Landscape mode and a tripod. In Night Portrait mode, the camera automatically sets One-shot autofocus with automatic auto-focus point (AF) selection, Single-shot drive mode, automatic flash with the ability to turn on red-eye reduction, and Standard Picture Style.

Flash Off mode

In Flash Off mode, the EOS 30D does not fire the built-in flash or an external Canon Speedlite regardless of how low the scene light is. In low-light scenes using Flash Off mode, be sure to use a tripod. This is the mode to use in scenes where flash is prohibited and when the subject is out of range of flash coverage. In Flash Off mode, the camera automatically sets AI focus AF with automatic auto-focus point (AF) selection, single-shot.

Creative Zone modes

Creative Zone modes offer automatic, semi-automatic, or manual control over some or all exposure settings. This zone includes two automatic modes, Program AE and A-DEP, which offer both automation and creative opportunities. The other three Creative Zone modes, Aperture-priority AE, TV Shutter-priority AE, and Manual exposure mode, put full or partial creative control in your hands.

Program AE mode

Program AE mode, shown as P on the Mode dial, is a fully automatic but shiftable mode. When you shift the aperture or shutter speed, the camera automatically adjusts the other setting (aperture or shutter speed) to maintain the same or equivalent exposure.

Note To learn about exposures and maintaining the same, or equivalent, exposure, see Chapter 3.

This mode allows you to control depth of field and/or shutter speed with a minimum of manual adjustments. For example, if the camera sets the aperture at f/8, but you want to soften background using a wide aperture. By holding down the shutter button halfway and turning the Main dial, you can shift the programmed exposure settings, and use a wide aperture, such as f/4.0 or f/2.8, while the camera automatically adjusts shutter speed to maintain the same exposure value.

You cannot shift the program if you are using a flash. And, the camera automatically cancels program shifts and reverts to the automatic settings after you take a picture.

1.14 This image was taken in Program AE mode. The camera's automatic settings were ISO 100, f/4.0 at 1/1000 sec.

A-DEP mode

A-DEP, or Automatic Depth of Field, mode automatically sets the exposure to achieve the optimum depth of field (range of sharpness) between near and far subjects. This is a handy mode for photos where subjects are positioned at staggered distances: One subject is close to the camera, and the other subjects are each at successively farther distances from the camera. A-DEP mode automatically detects near and far subject distances, and sets the aperture to achieve extensive depth of field to keep all subjects in sharp focus.

1.15 This image was taken in A-DEP mode. The camera's automatic settings were ISO 100, f/54.0 at 1/800 sec.

In A-DEP mode, you can select all settings except AF points and autofocus mode, which is automatically set to one-shot. The camera does not automatically switch to AI Servo or AI Focus if the subjects move.

Cross-Reference You can learn more about depth of field in Chapter 3.

To use A-DEP mode, first make sure the lens is set to AF because A-DEP doesn't work with the lens set to manual focus. Turn the Mode dial to A-DEP. Pressing the shutter button halfway down chooses the AF points.

You can also press the depth-of-field preview button on the front of the camera for a preview of the depth of field.

Aperture-priority AE mode

Aperture-priority AE mode, shown on the camera Mode dial as Av, allows you to set the aperture (f-stop), while the camera automatically chooses the appropriate shutter speed.

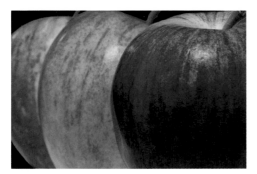

1.16 This image was taken in Aperture-priority AE mode. The exposure was ISO 100, f/9, 1/400 sec.

 Cross-Reference To learn about aperture, see Chapter 3.

Tip You can preview the depth of field for an image by pressing the depth-of-field preview button on the front of the camera. When you press the button, the lens diaphragm closes to the aperture you've set so you can see the range of acceptable focus.

For most day-to-day shooting, you'll care most about your ability to control the depth of field, and that makes Aperture-priority AE mode the mode of choice for most photographers.

To use Aperture-priority mode, turn the Mode dial to Av. Aperture values are displayed in the viewfinder in 1/3-stop increments. Turn the Main dial to set the aperture. If "30" blinks in the viewfinder, the image will be underexposed. If "8000" blinks, the image will be overexposed.

Shutter-priority AE mode

Shutter-priority AE mode, shown as Tv on the Mode dial, allows you to set the shutter speed. In this mode, you set the shutter speed, and the camera automatically chooses an appropriate aperture. The shutter speeds that you can choose from and freeze subject action depend on the light in the scene. In low-light scenes without a flash, you may not be able to get a fast enough shutter speed to freeze the action.

1.17 This picture was taken in Shutter-priority AE mode. The exposure was ISO 100, f/22, 1/30 sec.

The EOS 30D features an electronic, focal-plane shutter with speeds from 1/8000 to 30 sec. in 1/3- and 1/2-stop increments, and a Bulb setting, a setting where the shutter remains open until you release the shutter button. Flash sync speed for most Speedlites and studio strobes is 1/125 sec. or slower, although high-speed sync (FP flash) is available for sync speeds faster than 1/250 sec. The sync speed for non-Canon flash units is 1/250 sec. or slower.

 Cross-Reference To learn about shutter speeds, see Chapter 3.

Advantages of Program AE Mode

For any photographer who likes control and the convenience of some automation, Program AE mode is worth considering. Program AE gives you more control than Full Auto mode. Below are the settings that you can control in Program AE mode that you cannot control in Full Auto mode.

✦ **Shooting settings.** AF mode and AF point selection, drive mode, ISO, metering mode, program shift, exposure compensation, AEB, AE lock, depth-of-field preview, clear all camera settings, Custom Function and Clear All Custom Functions, and sensor cleaning.

✦ **Built-in flash settings.** Flash on/off, FE lock, flash exposure compensation.

✦ **EX-series Speedlite settings.** Manual/stroboscopic flash, high-speed sync (FP flash), FE lock, flash ration control, flash exposure compensation, FEB, second-curtain sync, and modeling flash.

✦ **Image-recording settings.** RAW, RAW+JPEG Large selection, choice of Picture Styles, color space, white balance, custom white balance, white balance correction, white balance bracketing, and color temperature setting.

To use Shutter-priority AE mode, turn the Mode dial to Tv. Then turn the Main dial to the shutter speed that you want. Time values are shown in the viewfinder in 1/3-stop increments. The camera sets the aperture automatically.

Manual mode

Manual mode, as the name implies, allows you to set both the aperture and the shutter speed based on the light meter reading displayed in the viewfinder. Because it takes more time to set both the aperture and shutter speed, Manual mode is useful in scenes where you want to intentionally overexpose or underexpose the image. Otherwise, the semi-automation of Tv and Av modes is preferred.

However, Manual mode is helpful in difficult lighting situations when you want to override the automatic settings the camera sets in either Av Aperture-priority AE or Tv Shutter-priority AE modes and in situations

where you want consistent exposures across a series of photos, such as for a panoramic series.

To use Manual mode, turn the Mode dial to M. Set the Power/Quick Control dial to the uppermost position. Turn the Main dial to set the shutter speed, and then turn the Quick Control dial to set the aperture you want. Then press the shutter halfway to meter the subject, and rotate the Quick Control dial and/or Main dial until the indicator under the exposure level meter in the viewfinder is in the center.

Select a drive mode

Drive modes determine how many shots the camera takes at a time. The EOS 30D has four drive modes that are appropriate in different shooting situations: Single-shot, High-speed continuous, Low-speed continuous, and Self-timer/Remote control. In the Basic Zone, the EOS 30D automatically

chooses the drive mode based on the mode you choose. In all Creative Zone modes, you can choose the drive mode.

Single-shot mode

As the name implies, Single-shot drive mode allows you to make one picture when you press the shutter-release button. Single-shot mode is useful for subjects that remain still, such as when photographing a portrait (excluding children), a still life, and some nature and landscape subjects.

In Basic Zone modes, the EOS 30D automatically switches to Single-shot drive mode in Full Auto, Landscape, Close-up, Night Portrait, and Flash Off modes.

High-speed and Low-speed continuous modes

The EOS 30D also offers two continuous drive shooting options:

✦ High-speed continuous that allows a maximum of 5 frames per second (fps)

✦ Low-speed continuous that offers a maximum of 3 fps

You don't have to wait for the buffer to empty all images to the media card before you can continue shooting. After a continuous burst sequence, the camera begins offloading pictures from the buffer to the card, and as offloading progresses, you can take additional pictures.

When the buffer is filled, the word "busy" blinks in the viewfinder until enough images are offloaded to continue shooting. You can continue to keep the shutter button depressed, and the camera shoots as the buffer has available space.

The maximum burst rate depends on the image format and quality settings. Table 1.1 shows the relationship with approximate burst rate for a 512MB CF card using High-speed continuous drive mode. Results vary based on ISO speed, Picture Style, and CF card speed.

Table 1.1
Image Format/Quality and Maximum Burst Rate

Image Format/Quality Setting	Approximate Maximum Burst Rate
JPEG (Large/Fine)	30
RAW	11
RAW + JPEG (Large/Fine)	9

Metering Modes

To make a good exposure, the camera has to know the amount of light that illuminates the subject or scene. To determine this, the camera's light meter measures the amount of light in the scene, and, based on the ISO, the camera calculates the aperture and shutter speed combinations required to make the standard exposure. On the EOS 30D, Canon's 35-zone through-the-lens (TTL) Evaluative metering is linked to the

currently selected AF point. The EOS 30D offers four metering modes that are differentiated by how much of the scene the meter uses to take the reading:

✦ Evaluative metering (linked to any AF point)

✦ Partial metering (approximately 9 percent of the viewfinder at the center)

✦ Spot metering (approximately 3.5 percent of the center of the viewfinder)

✦ Center-weighted average metering

Although you cannot manually switch among metering modes in Basic Zone modes, you can set the metering modes in all of the Creative Zone modes. In Basic Zone modes, the EOS 30D always uses Evaluative metering.

To set the EOS 30D to a metering mode, press the Metering mode button on the top of the camera, and rotate the Main dial until the icon for the metering mode you want appears in the LCD panel. The Partial metering mode icon is an empty circle. The Evaluative metering icon is a black dot in a partial circle, the Spot metering icon is a black dot in a rectangle, and the Center-weighted Averaging metering icon is an empty rectangle. The next sections explain these modes in more detail.

Evaluative metering

Evaluative metering, the default metering mode on the EOS 30D, analyzes light from the entire viewfinder area to calculate exposure. Canon's 35-zone Evaluative metering system is linked to the autofocus system. The meter

1.18 This picture was taken using Evaluative metering.

analyzes the point of focus and automatically applies compensation if surrounding areas are much lighter or darker than the point of focus. To determine exposure, the camera analyzes subject position, brightness, background, front lighting, and backlighting to determine the proper exposure.

Evaluative metering produces excellent exposures in average scenes that include an average distribution of light, medium, and dark tones, and it functions well even in backlit conditions. However, in scenes where there is a large expanse of predominately light or dark areas, the metering averages the tones to middle gray, thereby rendering snow scenes and large expanses of dark water as gray. In these situations,

you can use exposure compensation to increase or decrease exposure by one to two stops for scenes with predominately light or dark tones, respectively.

Partial metering

Partial metering meters from the center-most 9 percent of the viewfinder. Partial metering is handy in backlit or side lit scenes where you want to ensure that the main subject is properly exposed, although spot metering is also a good option in those types of scenes.

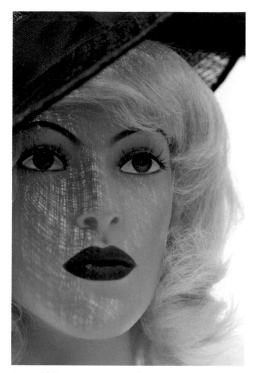

1.20 This picture was taken using Spot metering.

viewfinder area. This is a very precise metering method that is best used when exposure for a specific area of the subject or scene is critical. In general shooting situations where specific exposure is not critical, Spot metering does not consider the overall scene, and the results may not be what you want.

1.19 This picture was taken using Partial metering.

Spot metering

The Spot metering mode evaluates the subject using the centermost 3.5 percent of the

Center-weighted average metering

Center-weighted average metering gives more weight to the area of the scene within the center area of the viewfinder. The center area encompasses a slightly larger area than used with Partial metering. Then the camera averages the reading for the entire scene.

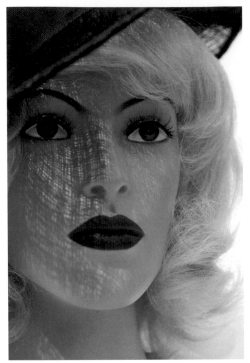

1.21 This picture was taken using Center-weighted average metering.

Exposure Compensation

In scenes with large expanses of white or dark areas, you can use exposure compensation to override the camera's default exposure. This is convenient for snowscapes and ocean and lake scenes. Exposure compensation resets the camera's standard exposure setting by the amount of compensation (in partial or whole f-stops) that you choose.

For example, if you're taking a picture of a snow scene, setting positive exposure compensation adds light to produce white snow instead of gray. In this situation, a positive compensation of +1 to +2 f-stops does the trick.

Conversely in scenes with predominately dark tones, you can set a negative exposure compensation of -1 to -2 to get true dark tones. Exposure compensation is also useful when you want to maintain detail in highlight areas other than specular highlights.

Exposure compensation is set in 1/3-stop increments up to +/- 2 stops. Whatever exposure compensation amount you set is used until you change the exposure back to standard exposure indicated by the exposure level indicator in the viewfinder.

You can set exposure compensation by following these steps:

1. **Switch to any Creative Zone mode except Manual, and set the Power/Quick Control Dial switch to the uppermost position.**

2. **Press the Shutter button halfway down, and check the exposure level indicator in the viewfinder or on the LCD panel, and then rotate the Quick Control dial to the left to set negative exposure compensation or to the right to set positive exposure compensation.** Exposure compensation remains in effect until you set it back to the center position on the exposure level indicator.

Tip *After you've set exposure compensation, it's easy to inadvertently change the setting by mistakenly turning the Quick Control dial. To avoid this, set the Power switch to the On position instead of to the uppermost position.*

Auto Exposure Bracketing

With Auto Exposure Bracketing (AEB), you can take three pictures at three different exposures: one picture at the standard exposure, one picture at an increased (lighter) exposure, and another picture at a decreased (darker) exposure. AEB, a favorite technique of film photographers for years, is a way to ensure that at least one exposure in a series of three images is acceptable. And with the advent of digital photography, AEB is a way to capture a high-dynamic range scene that exceeds the dynamic range of the sensor. By capturing two or more exposures metered for highlights, midtones, and shadows, photographers can later composite the exposures in Photoshop to maintain highlight detail, clean shadow detail, and properly exposed midtones.

You can set AEB in 1/3-stop increments up to +/- 2 stops for three successive exposures. AEB is extremely useful for getting the best exposure in tricky lighting.

While exposure bracketing isn't necessary in all scenes, it's a good technique to use in scenes that are difficult to set up or that can't be reproduced and in scenes with contrasty lighting, such as a landscape with a dark foreground and much lighter sky area.

AEB can't be used with the flash or when the shutter is set to Bulb.

Here's how AEB works in the different drive modes:

✦ In the continuous and Self-Timer drive modes, pressing the Shutter button once automatically takes three bracketed exposures.

✦ In single-image mode, you have to press the shutter three separate times to get three bracketed exposures.

✦ If the custom function (C.Fn) 12 mirror lockup is turned on, then the drive mode is automatically single-image mode even if the camera is set to continuous drive mode. Custom functions are discussed later in this chapter.

In either case, the camera takes the standard exposure first, the decreased exposure second, and then the increased exposure.

AEB settings are temporary. If you change lenses, replace the CF card or battery, or turn off the camera, the AEB settings are cancelled. You can also use AEB in combination with *exposure compensation*.

Table 1.2 shows examples of AEB. Bracketing here is set in 1-stop increments.

Table 1.2
Auto Exposure Bracketing

	Aperture	Shutter Speed
Standard Exposure	f/8	1/125 sec.
Decreased Exposure	f/11	1/250 sec.
Increased Exposure	f/5.6	1/60 sec.

On the EOS 30D, you can set AEB by following these steps:

1. **Press the Menu button.** If the Shooting menu (red) is not displayed, press the Jump button until it is displayed.

2. **Rotate the Quick Control dial to select AEB, and then press the Set button.** The camera activates the exposure level indicator.

3. **Rotate the Quick Control dial to set the AEB amount, and then press the Set button.** Each turn sets AEB in 1/3rd-stop increments above and below the standard exposure.

4. **Press the shutter button lightly to dismiss the menu.** The camera displays the AEB level on the exposure level indicator in the LCD panel and in the viewfinder. The AEB setting remains in effect until you turn off the camera or change lenses or memory cards.

To cancel AEB, you can repeat Steps 1 and 2, and then rotate the Quick Control dial until the indicators move back to the middle mark on the exposure level indicator. Then press the Set button. Or just turn the camera off and back on again.

AE Lock

With the EOS 30D, the exposure and the focus are locked simultaneously by pressing the shutter button halfway down. However, there are times when you don't want to meter on the same area where you set the focus. For example, if a subject is lit by a spotlight, the brightest light may fall on the subject's cheek or nose. Metering and setting the exposure for the brightest area maintains detail in the brightest area, but that isn't where you want the focus. You want to focus on the subject's eyes. In short, you have to de-couple the autofocusing from the metering, and you can do this by using auto-exposure or AE lock.

However, there are a couple of situations worth noting with AE lock:

✦ If the AF mode is One-Shot AF or AI Focus AF and you're using Evaluative metering, then pressing the shutter button halfway automatically sets AE lock at the same point when focus is set.

✦ In Creative Zone modes, the AE lock differs depending on the AF point and metering mode selected as shown in Table 1.3.

Table 1.3
AE Lock with Metering Modes and Auto-Focus Point Selection

Metering Mode	AF Point Selection	
	Automatic AF Point Selection	**Manual AF Point Selection**
Evaluative*	AE lock is applied at the AF point selected that achieved focus.	AE lock is applied at the AF point.
Partial	AE lock is applied at the center AF point.	
Spot		
Center-Weighted Average		

* If the lens is set to Manual focus (MF), AE lock is set to the center AF point.

You can set AE lock by following these steps:

1. **Focus on the part of the scene that you want to expose correctly.**

2. **Continue to hold the Shutter button halfway down as you press and hold the AE Lock button on the back right side of the camera.** An asterisk is displayed in the viewfinder indicating that the exposure is locked.

3. **Move the camera to recompose the shot, press the shutter halfway to focus on the subject, and then take the picture, continuing to hold down the AE Lock button.** As long as you continue holding down the AE lock button, you can take additional pictures using the locked exposure.

To set Bulb exposure, follow these steps:

1. **Set the Power switch to the uppermost position to enable use of the Quick Control dial and set the Mode dial to M (Manual).**

2. **Rotate the Main dial to select buLB, the setting next to "30."**

3. **Rotate the Quick Control dial to select the aperture you want.** The aperture is shown in the viewfinder and in the LCD panel.

4. **Press the shutter button halfway down to focus on the subject, and then press it completely and hold it down for the desired length of time.** The elapsed exposure time (from 1 to 999 sec.) is displayed in the LCD panel.

Bulb Exposure

As old as cameras themselves, Bulb exposure allows the shutter to remain open as long as the shutter button is completely depressed. Using Bulb, you can make pictures of fireworks, star trails, and other extremely low-light scenes.

In long exposures, digital noise can become more obvious. You can set custom function 2 (C.Fn-02, Long exp. Noise reduction) to Auto or On to reduce noise in long exposures. You should also use a remote control such as Remote Switch RS-80N3 or Timer Remote Controller TC-80N3 to reduce the possibility for camera movement during bulb exposures.

Note — *Custom Functions are discussed later in this chapter.*

Evaluating Exposure

Getting an accurate exposure is critical to getting a good image, but you may be wondering how you can judge whether an image is accurately exposed at the time you take the picture. On the EOS 30D, you can evaluate the exposure immediately after you take the picture by looking at the image histogram.

If you're new to digital photography, the concept of a histogram may also be new. A histogram is a bar graph that shows grayscale brightness values in the image from black (level 0) to white (level 255) along the bottom. The vertical axis displays the number of pixels at each location.

Naturally, some scenes cause a distribution of values that are weighted more toward one side of the scale or the other. For example, in scenes that have predominately light

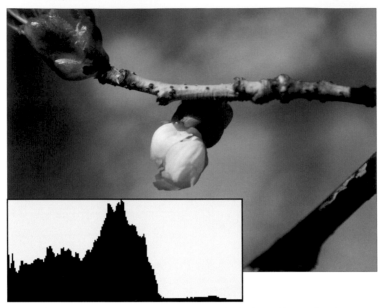

1.22 The tones in this image are primarily dark as shown by the weighting of pixels to the left side of the histogram.

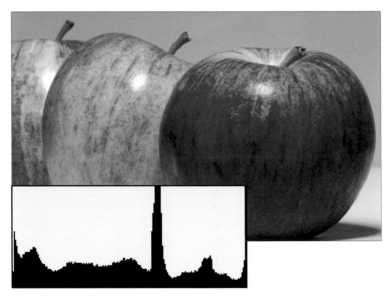

1.23 Despite the bright tones in the foreground in this image, the distribution of tonal values is relatively even across the histogram.

1.24 The tones in this image are primarily light as shown by the weighting of pixels to the right side of the histogram.

tones, the pixels are weighted toward the right side of the histogram. But in average scenes, the goal of good exposure is to have the values, or tones, with a fairly even distribution across the entire graph and, in most cases, to avoid having pixels crowded against the far left or right side of the graph.

It is important to know that half of the tonal values in an image are contained in the first f-stop of bright tones. In an image with a six-stop dynamic range (12-bits per channel per pixel for a possible 4,096 levels in each channel), the first f-stop contains 2,048 levels while the second f-stop contains 1,024 levels, the third f-stop contains 512 levels, the fourth f-stop contains 256 levels, the fifth f-stop contains 128 levels, and the sixth f-stop, the darkest shadows, contains only 64 levels.

This means that with RAW images, you should expose toward the right side of the histogram to get the maximum levels from a capture. In other words, check the histogram to ensure that the exposure maintains highlight detail (pixels should not be slammed against the right side of the graph), but also to ensure that there is no empty space between the right edge of the histogram and where the pixels begin.

During image playback, you can press the Info button twice to display the image with a histogram. This display also has a highlight alert that flashes to show areas of the image that are overexposed (or areas that have no detail in the highlights). Although the histogram is based on the JPEG image rather than RAW, if you're shooting RAW capture, you can evaluate the exposure and retake the picture if the highlights are blown or

Selecting and Evaluating an Image Histogram

The histogram is a graph that shows the distribution of brightness levels across the bottom of the graph and the number of pixels at each level. On the EOS 30D, you can choose whether the Histogram displays luminance or the Red, Green, and Blue (RGB) channels. A brightness histogram allows you to see the exposure bias and the overall tone reproduction of the image. If the histogram shows pixels slammed against the far left or right side of the graph, then you'll likely experience underexposure or overexposure and subsequent loss of detail in the shadows and highlights, respectively.

An RGB histogram shows the distribution of brightness levels of each of the three channels that are displayed separately. These displays help you evaluate the color's saturation, gradation, and white balance bias of each channel. In this display, the horizontal axis shows how many pixels exist for each color brightness level while the vertical axis shows how many pixels exist at that level. More pixels to the left indicate that the color is darker and more prominent, while more pixels to the right indicate that the color is brighter and less dense. If pixels are slammed against the left or right side, then color information is either lacking or over-saturated with no detail, respectively.

Although both histograms display vital information to evaluate the image, choosing to display either luminance or color depends on what's important in the shooting situation. For a situation such as a wedding or a fashion shoot where color reproduction is critical, the RGB histogram is most useful and convenient as the default display. But for outdoor shooting, photojournalism, and stock shooting, the luminance display is likely the better default to choose for the histogram display.

shadow areas are solid black (the pixels are pushed against the left side of the scale).

You can set the 30D to display either Brightness (or luminance) or RGB color levels during image playback.

To set the type of histogram displayed, follow these steps:

1. **Press the Menu button.**

2. **If the Playback (blue) menu isn't displayed, press the JUMP button until it is displayed.**

3. **Rotate the Main dial to highlight Histogram, and then press the Set button.** The camera displays the Histogram options.

4. **Rotate the Main dial to choose RGB or to reset the camera to Brightness if RGB was previously chosen, and then press the Set button.**

Autofocus Modes

The success of a picture depends as much on crisp focus as it does on good exposure. In addition to keeping the camera steady, getting tack-sharp focus depends on three factors: the resolving power of the lens (or its ability to render fine details sharply), the resolution of the image sensor, and the resolution of the printer (if you print the image).

For sharp focus in quick shooting situations, autofocus speed is equally important.

Autofocus speed depends on factors such as the size of the lens and the speed of the lens focusing motor, the speed of the auto-focus sensor in the camera, and how easy or difficult the subject is to focus on.

Three AF modes are available: One-Shot AF for still subjects, AI Servo AF for moving subjects, and AI Focus AF that switches from One-Shot AF to AI Servo AF if the subject begins to move. For most shooting situations, the EOS 30D's wide-area AI (artificial intelligence) autofocus (AF) system — a system tied closely to the camera's drive modes — provides acceptable results.

In Basic Zone modes, the camera automatically chooses the AF mode and the AF point or points. You can choose the AF mode in all Creative Zone modes except A-DEP, where the AF mode is set to one-shot and AF points are automatically selected.

Table 1.4 shows which mode is selected in each drive and exposure mode.

Table 1.4
Autofocus and Drive Modes

Drive Mode	Focus Mode		
	One-Shot AF	**AI Servo AF**	**AI Focus AF**
One-Shot Shooting	The camera must confirm accurate focus before you can take the picture. After focus is achieved, it is locked as long as the shutter is pressed halfway down. Exposure is locked as well with Evaluative metering.	Focus tracks a moving subject, and exposure is set when the picture is taken. Predictive AF allows the camera to track a subject that approaches or retreats from the camera at a steady rate and predicts the focusing distance just before the picture is taken. If the AF point is automatically selected, the camera uses the center AF point and tracks the subject as it moves across AF points. If the AF point is manually selected, the camera uses the selected AF point to track the subject.	Automatically switches between One-Shot AF and AI Servo AF based on the subject movement or lack of movement.

Continued

Table 1.4 *(continued)*			
Drive Mode		*Focus Mode*	
	One-Shot AF	**AI Servo AF**	**AI Focus AF**
High-Speed and Low-Speed Continuous Shooting	Same as previous during continuous shooting. In both continuous shooting modes, focusing is not achieved during continuous shooting.	Same as previous with autofocus continuing during continuous shooting in either high-speed or low-speed shooting modes.	

To set the AF mode, follow these steps:

1. **Set the lens to AF mode.** You cannot set or change the AF mode if the lens is set to manual focus (MF).

2. **Set the Mode dial to a Creative Zone mode except A-DEP.**

3. **Press the AF-WB button.**

4. **Rotate the Main dial until the AF mode you want is displayed.** Rotating the dial cycles through modes in this sequence: One Shot (One-Shot AF), AI Focus (AI Focus AF), and AI Servo (AI Servo AF).

Understanding AF Point Selection

The EOS 30D uses a wide-area artificial intelligence (AI) Auto Focus (AF) system with 9 autofocus (AF) points. An AF point determines the area of the subject that is in sharpest focus. In Basic Zone modes, the camera automatically selects the autofocus point or points. In Creative Zone modes except A-DEP, you can select the autofocus point. When no focus point is selected, the camera automatically determines the focus point by analyzing the scene and determining which AF point is over the closest part of the subject. The camera shows the selected AF point in red in the viewfinder.

Although wide-area AI Focus AF is handy, it weights focus to the part of the subject that is nearest the lens. This area of the subject may or may not be what you want in sharpest focus. For example, in a close-up portrait, the closest area the subject to the lens may be the nose, but you want to focus on the eyes. You can shift your position slightly to try to force the camera to reset focus on the eyes, or you can switch to a Creative Zone mode (except A-DEP) and set the focus point manually — the most reliable way to ensure accurate focus on the part of

1.25 Nine autofocus points, shown in the viewfinder, are selectable in Creative Zone modes except A-DEP mode.

the subject that you want rendered in sharpest focus.

The autofocus system is reliable, but it can fail if subjects are in low light, if subjects are low in contrast or monotone in color, or when other objects overlap the main subject. For this reason, be sure to confirm in the LCD that the camera selected the best autofocus point. If you still can't get sharp focus, you can switch the lens to manual focus (MF) and turn the focusing ring manually to focus on low-contrast, dim, or monotone subjects.

In One-Shot AF, you cannot release the shutter until focus is established. In AI Servo AF, you can release the shutter whether or not the subject is in focus because the focus subsequently catches up with the subject's movement.

To manually select the AF point, follow these steps:

1. **Set the Mode dial to any Creative Zone mode except A-DEP.**

2. **Press the shutter button halfway, and then press the AF Point Selector button on the back right side of the camera.** The currently selected AF point is displayed in the viewfinder and on the LCD panel.

3. **As you watch in the viewfinder, turn the Main dial until the AF point you want is highlighted in the viewfinder.** The camera moves through the AF points in the direction that you turn the dial. You can also use the Multi-controller located next to the LCD to select the AF point. The Multi-controller moves left, right, up, and down through the AF points

according to the direction you press the controller.

4. **Press the Shutter button halfway down to focus on the subject and lock the focus, and then take the picture.** Or, if you want to recompose the scene, continue pressing the Shutter button halfway down, move the camera to recompose the shot, and then press the Shutter button completely.

Tip *In close focusing situations, and at times when the subject can't be reliably focused on with the autofocus system, you can switch to MF. You can use manual focusing of the lens in both Basic Zone and Creative Zone modes.*

Viewing and Image Playback

The ability to see the picture immediately after you take it is one of the primary benefits of using digital photography. On the EOS 30D, you can not only view images after you take them, but you can also magnify images to verify that the focus is sharp, display multiple images stored on the memory card, display the image with a histogram showing the tonal distribution, display images as a slideshow, and display the image along with the exposure settings.

The first image playback that you see is right after you take a picture, when it is displayed on the LCD. The default setting is 2 seconds, which is hardly enough time to move the camera from your eye in time to catch the image preview. The display time is intentionally set to a short amount of time to maximize battery life, but given the excellent

performance of the battery, a longer display time of 4 to 8 seconds is more useful. You can change the display time on the Playback menu. You also can select the Hold option for review that displays the image until you press the Shutter button to dismiss it.

To change the initial image playback review time, follow these steps:

1. **Press the Menu button.**

2. **Press the JUMP button until the Playback (blue) menu is displayed.**

3. **Rotate the Main dial to highlight Review time, and then press the Set button.** The Review time options are displayed.

4. **Rotate the Main dial, and select the Review time option that you want.** If you select Hold, the picture is displayed until you press

the Shutter button to dismiss the display. Viewing images for a longer time also depletes the battery.

5. **Press the Set button to confirm your selection.**

The following sections cover viewing options.

Single-image playback

In Single-image playback, the EOS 30D displays one image at a time on the LCD. If you have multiple pictures on the CF card, you can use the Main dial or the Quick Control dial to move forward and backward through the images.

Playback begins with the most recent image displayed on the LCD. You also can turn either dial counterclockwise to begin viewing the first image on the CF card.

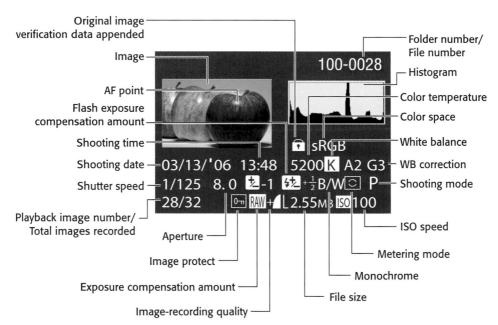

1.26 This diagram shows the information that is shown in single-image mode by pressing the Info button twice.

In this mode, you also can set how little or how much information about the image is displayed along with the image on the LCD. You have three display options:

✦ **Single-image display with no shooting or exposure information.**

✦ **Single-image display with basic information.** This provides the file number, shutter speed setting, aperture, and image number on the CF card as an overlay on the image preview. Press the Info button once to get this display.

✦ **Shooting information displays the file number, histogram, color space, color temperature setting, exposure settings, metering mode, mode setting, image quality, and other information.** In addition, any overexposed areas of the image blink, alerting you that you may want to reshoot using a negative exposure compensation to avoid blowing out detail in the highlight areas. If AF points are set to Display, the AF point that achieved focus in One-Shot AF mode is displayed, or the AF points in AI Servo AF mode are displayed. Press the Info button twice to display full exposure, shooting information, and the histogram.

Tip
You can set the AF points to display by pressing the Menu button, navigating to the Playback (blue) menu, highlighting AF points, and then choosing Display. Then press the Set button to confirm your selection.

Magnified view

Using the magnified view, you can scroll through an image to check image sharp-

ness. You can magnify images 1.5 times to 10 times on the LCD monitor. Then you can use the Main dial or the Quick Control dial to move to the next or previous image maintaining the same magnification and scroll position.

To display an image in magnified view, follow these steps:

1. **Press the Playback button.**

2. **Press the Enlarge button.** The image is magnified from the center. To continue magnifying the view, hold down the Enlarge button until the image is as large as you want or is at the maximum 10 times magnification.

You can then do the following:

• Press the Multi-controller to scroll to another area of the magnified image.

• Rotate the Main dial or the Quick Control dial to move to the next or previous image at the same position and magnification.

3. **Press the shutter button to return to shooting.** To reduce the magnification, press the Reduce button (playback returns to normal).

Tip
You can set image review and playback to Magnified view by setting options in C.Fn-17. See Custom Functions later in this chapter for details.

Index display

The index display is an electronic version of a traditional contact sheet. Index display shows nine thumbnails of images on the CF card. This display is handy when you need to ensure that you have a picture of

Jumping among Images

In all image playback modes, you can press the Jump button to move through images quickly. Press the Jump button, and rotate the Main dial or the Quick Control dial to move through the display 10 images at a time. The EOS 30D is initially set to jump by 10 images at a time, but you can set 100 as the interval of images, or you can choose to jump by date. To change the Jump method, press the Jump button and then press the Set button. Rotate the Main dial or the Quick Control dial to choose to jump by 100 images, or to jump by shot date. If you choose by shot date, pressing the Jump button displays the first image taken on the date.

everyone at a party or event, and it's handy as a way to quickly select a particular image on the media card when the card is full of images.

To turn on the index display, follow these steps:

1. **Press the Playback button.**

2. **Press the AE lock/FE lock/Index button on the back of the camera.** The camera displays images on the CF card nine images at a time. The selected image is displayed with a green border.

3. **Rotate the Main dial to move among individual images.** To display a larger view of a selected image, press the Enlarge button to magnify the image. To return to Index display, press the AE lock/FE lock/Index button again.

4. **Press the JUMP button to display a scroll bar, and then rotate the Main dial or the Quick Control dial to move among sets of nine images.** To return to a single-image selection in Index display, press the Jump button again. To return to single-image display, press the Play button.

5. **To cancel the Index display, press the Shutter button.** The next time you press the Playback button, the display returns to Single-image playback mode.

Tip *In Single-image playback mode, you can press the Jump button to display a scroll bar that allows you to move 10 images forward or backward. And you can press the Set button to choose a different number of images to scroll by.*

Auto Playback

When you want to sit back and enjoy all the pictures on the CF card, the Auto Playback option plays a slide show of images on the card, displaying each image for 3 seconds. This is a great option to use when you want to share pictures with the people you're photographing or as a review to verify that you've taken all the shots you intended to take during a shooting session.

To use Auto Playback, follow these steps:

1. **Press the Menu button.**

2. **If the Playback (blue) menu is not displayed, press the JUMP button until it is displayed.**

3. **Rotate the Main dial or the Quick Control dial to highlight Auto play.** The camera loads images and displays them in the Playback mode display you've chosen. The best way to review images is to have the display set to Single-image. You can pause and restart the slide show by pressing the Set button.

4. **Press the Shutter button lightly to return to shooting.**

Erasing Images

Erasing images is a fine advantage only when you know without a doubt that you don't want the image you're deleting. From experience, however, I know that some images that appear to be mediocre on the LCD often can be salvaged with some judicious image editing on the computer. For that reason, erase images with due caution.

If you want to delete an image, follow these steps:

1. **Press the Playback button on the back of the camera, and rotate the Main dial or the Quick Control dial to navigate to the image you want to delete.**

2. **Press the Erase button, and rotate the Main dial or the Quick Control dial to select Erase (only the displayed image), All (all images on the CF card), or Cancel.**

3. **Press the Set button to erase the image or images.** If you chose All, the camera displays a message asking you to confirm that you want to erase all images.

Rotate the Main dial or the Quick Control dial to select OK, and press the Set button.

4. **When the access lamp goes out, lightly press the Shutter button to continue shooting.**

Protecting Images

On the other end of the spectrum from erasing images is the ability to ensure that images you want to keep do not get accidentally deleted. When you have that perfect or once-in-a-lifetime shot, apply protection to it so you can be sure it doesn't get erased.

Setting protection means that no one can erase the image when using the Erase or Erase All options.

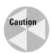 **Caution** *Even protected images are erased if you or someone else formats the CF card.*

You can protect an image by following these steps:

1. **Press the Playback button.** The last image taken is displayed on the LCD.

2. **Rotate the Main dial or the Quick Control dial to move to the image you want to protect.**

3. **Press the Menu button, and then press the JUMP button to select the Playback (blue) menu.**

4. **Rotate the Main dial or the Quick Control dial to select Protect, and press the Set button.** A small key icon appears at the top of protected images. You can use Main dial or the

Quick Control dial to scroll to other images and press the Set button to add protection.

Using the Built-in Flash

Using either the built-in or a Canon EX-series Speedlite, the EOS 30D allows you to make flash images that look more natural than previously possible, and the camera and Speedlite controls allow you to control flash exposure more precisely. In addition, the EOS 30D features a PC sync terminal so that you can use studio strobes with the camera, and the EOS 30D is a standout performer in studio conditions.

The EOS 30D features E-TTL II autoflash that uses evaluative flash metering and preflash for calculating exposure in both automatic and flash exposure compensation modes. The built-in flash has a guide number of 13, which means the flash works at approximately 3.3' at 17 mm and 2.3' at 85 mm using an ISO 100 setting.

The built-in flash recycle time is approximately 3 seconds. The maximum flash sync

1.27 This image was taken using the automatic flash exposure.

speed is 1/250 second, which the camera sets automatically, although in some exposure modes, you (or the camera in automatic modes) can set a slower shutter speed. Flash exposure compensation is +/- 2 stops in 1/3 or 1/2-stop increments.

Why Flash Sync Speed Matters

Flash sync speed matters because if it isn't set correctly, only part of the image sensor has enough time to receive light while the shutter is open. The result is an unevenly exposed image. The EOS 30D doesn't allow you to set a shutter speed higher than the 1/250 sec. flash sync speed unless you're using High-Speed Sync (FP flash) with an external Speedlite. In some modes, you can set shutter speeds slower than the sync speed.

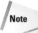 **Tip** *When you use the built-in flash, be sure to remove the lens hood first to prevent obstruction of the flash coverage. And if you use a fast, super-telephoto lens, the built-in flash coverage may also be obstructed.*

Tables 1.5 and 1.6 describe the behavior of the built-in flash and the options in various exposure modes, the ranges of the flash, and flash sync speed and aperture settings. Table 1.7 describes using the built-in flash in Creative Zone modes and in Basic Zone exposure modes that automatically activate the flash.

Note *The range depends on the type lens you use and the ISO. In general, the longer the focal length is, the shorter the distance that the flash covers. And the higher the ISO is, the farther the distance the flash illumination covers.*

1.28 This image was taken using the flash exposure compensation of -1 stop.

Table 1.5
30D Built-in Flash Range* with the EF-S 18-55mm Lens

ISO	18mm	55mm
100	1 to 3.7m (3.3 to 12.1 ft.)	1 to 2.3m (3.3 to 7.5 ft.)
200	1 to 5.3m (3.3 to 17.4 ft.)	1 to 3.3m (3.3 to 10.8 ft.)
400	1 to 7.4m (3.3-24.3 ft.)	1 to 4.6m (3.3 to 15.1 ft.)
800	1 to 10.5m (3.3 to 34.4 ft.)	1 to 6.6m (3.3 to 21.7 ft.)
1600	1 to 14.9m (3.3 to 48.9 ft.)	1 to 9.3m (3.3 to 30.5 ft.)
H (3200)	1 to 21m (3.3 to 68.9 ft.)	1 to 13.1m (3.3 to 43 ft.)

* All distances are approximate.

Table 1.6
30D Built-in Flash Range* with the EF-S 17-85mm Lens

ISO	17mm	85mm
100	1 to 3.3m (3.3 to 10.8 ft.)	1 to 2.3m (3.3 to 7.5 ft.)
200	1 to 4.6m (3.3 to 15.1 ft.)	1 to 3.3m (3.3 to 10.8 ft.)
400	1 to 6.5m (3.3-21.3 ft.)	1 to 4.6m (3.3 to 15.1 ft.)
800	1 to 9.2m (3.3 to 30.2 ft.)	1 to 6.6m (3.3 to 21.7 ft.)
1600	1 to 13m (3.3 to 42.7 ft.)	1 to 9.3m (3.3 to 30.5 ft.)
H (3200)	1 to 18.4m (3.3 to 60.4 ft.)	1 to 13.1m (3.3 to 43 ft.)

* All distances are approximate.

Table 1.7
Creative Zone Exposure Modes with the Built-in Flash

Mode	Using the Flash
P and A-DEP	The camera automatically sets the shutter speed (1/60 to 1/250 sec.) and aperture, and uses full autoflash.
Tv	You set the shutter speed between 30 sec. to 1/250 sec., and the camera automatically sets the aperture.
Av	You set the aperture, and the camera automatically sets the shutter speed (30 sec. to 1/250 sec.). In low-light scenes, slow-sync shooting allows the flash to correctly expose the subject and the longer exposure to correctly expose the background. For longer exposures, always use a tripod or set the camera on a solid surface. You can set C.Fn-03 to a fixed 1/250 sec. if you do not want the camera to set a slow shutter speed.
M	You set both the aperture and shutter speed (bulb or 30 sec. to 1/250 sec.). The flash exposes the subject correctly, and the background exposure is based on the aperture and shutter speed that you choose.

Red-eye reduction

Long the bane of photographers of all skill levels, the red-eye effect has ruined many, many pictures. This ghoulish appearance of the eyes occurs when light from the flash reflects off the subject's retina, making the eyes appear red. Red-eye reduction fires a preflash that helps to constrict the pupil and lessen the effect; however, it cannot eliminate it entirely.

You can use red-eye reduction in all exposure modes except Landscape, Sports, and Flash Off modes. To turn on red-eye reduction, follow these steps:

1. **Press the Menu button, and if the Shooting (red) menu isn't displayed, press the JUMP button until it is displayed.**

2. **Rotate the Main dial or the Quick Control dial to highlight Red-eye On/Off, and press the Set key.**

3. **Rotate the Main dial or the Quick Control dial to select On, and press the Set button to confirm your selection.**

4. **Press the Shutter button to focus on the subject, and ask the subject to look at the preflash light.** After the red-eye reduction light indicator goes off, press the Shutter button completely.

Tip *To reduce the appearance of red eyes, turn on additional lights in the room and move closer to the subject.*

FE lock

One of the most valuable flash features on the EOS 30D is Flash Exposure (FE) lock, which you can use to take a meter reading of the subject using the flash before you make the picture. For example, if you want to ensure that a subject's face isn't overexposed, you can point the center of the frame at the subject, press the shutter halfway down to set and lock the flash exposure for the face, and then recompose the picture and shoot with the locked flash exposure setting.

FE lock also can be used to increase or decrease flash intensity. For example, to increase flash intensity, point the camera to a white object or a subject that is closer to the camera. To decrease flash intensity, point the camera to a dark or farther-away subject.

To use FE lock, follow these steps:

1. **Set the camera to a Creative Zone mode, and then press the Flash button to pop up the built-in flash.**

2. **Focus on the subject by pressing the Shutter button halfway down.** Continue to hold the Shutter button halfway down during the next steps.

3. **Position the center of the viewfinder over the area of the subject where you want to lock flash exposure, and then press the FE lock button.** A preflash fires, FEL is displayed momentarily in the viewfinder, and the flash icon appears in the viewfinder.

Canon EX-series Speedlites and studio strobes

The EOS 30D is compatible with Canon EX-series Speedlites (sold separately) and with third-party flash units. Depending on the EX Speedlite you use, you can use these features with an external Speedlite:

✦ E-TTL II Autoflash is a system that offers improved flash exposure control combined with focusing distance information from the lens to more accurately gage flash intensity, provided that you use a ring-type USM Canon lens.

✦ High-speed sync (FP flash) allows setting a faster sync speed than 1/250 sec.

✦ Flash exposure compensation can be set to + /- 2 stops in 1/3-stop increments.

✦ Flash exposure bracketing (FEB) brackets the flash exposure for three successive shots up to + /- 3 stops at 1/3-stop increments. This function is available only with FEB-compatible Speedlites.

✦ E-TTL II Wireless autoflash with multiple Speedlites allows wireless E-TTL II autoflash with the previous features using the Canon Speedlite transmitter ST-E2, which is sold separately.

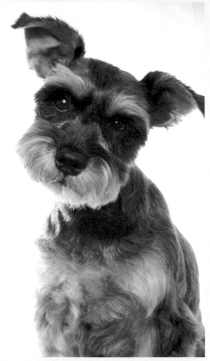

The EOS 30D proves to be an excellent performer in the studio.

✦ A PC terminal located on the left side of the camera allows the use of studio flash units or flash units attached with a sync cord. The terminal has no polarity and works with any sync cord, regardless of polarity. The camera can be used with flash equipment that does not require 250 volts or more.

Note that with EZ/E/EG/ML/TL-series Speedlites, you must use the Speedlite's manual flash mode, and you cannot use the TTL or A-TTL autoflash modes. Also, if an EX-series Speedlite is set to TTL autoflash using the Custom Function, the flash will not fire.

4. **Reposition the camera to compose the shot, and take the picture.**

Tip
In Manual mode, you can experiment with shutter speeds (1/250 sec. and slower) to lighten or darken the scene. The shutter speed controls the overall scene exposure, and the aperture controls the flash exposure. Try experimenting with one or both settings to get the effect you want.

Flash exposure compensation

If you find that FE lock doesn't produce the exposure you want, you can use flash exposure compensation to increase or decrease the flash exposure up to +/- 2 stops in 1/3-stop increments. You can use flash exposure compensation with Creative Zone modes, and the compensation remains in effect until you change it.

Note
If you're using an EX-series Speedlite and set flash exposure compensation on the flash and on the camera, the Speedlite's flash exposure compensation overrides compensation set on the camera.

1. **Set the camera set to a Creative Zone mode, and then press the Flash button to pop up the built-in flash.**

2. **Press the Metering mode selection/Flash exposure compensation button on top of the camera.**

3. **Rotate the Quick Control dial while looking at the LCD panel or in the viewfinder to set a**

negative or positive compensation amount in 1/3-stop increments.

4. **Focus on the subject by pressing the Shutter button halfway down and take the picture.** The flash exposure compensation icon appears in the viewfinder.

Setting Custom Functions

Custom functions enable you to customize camera controls and operation to better suit your shooting style and to save you time. After you set a custom function option, it remains in effect until you change it. Some custom functions are exceptionally handy while others are specific to different situations. For example, if you grow weary of pressing the AF Point Selection button and trying to simultaneously adjust the Multi-controller, then by all means, check out Custom Function 13, where you can assign AF point selection to the Quick Control dial to save time and make your selection more quickly than the standard method.

Note
Canon refers to Custom Functions by using the abbreviation C.Fn-[number].

The EOS 30D offers 19 Custom Functions. Some custom functions are more broadly useful than others, and some are useful for specific shooting specialty areas. Be sure to remember how you have set the custom functions because some options change the behavior of the camera and, in some cases, the lens controls.

✦ **C.Fn-1: SET function when shooting.** Offers options for you

to change the function of the SET button. Choose from: **0.** Default; **1.** Change quality; **2.** Change picture style; **3.** Menu display, or **4.** Image replay.

✦ **C.Fn-2: Long exp. noise reduction.** Allows you to turn noise reduction on or off for long exposures. With noise reduction on, the reduction process takes as long to apply as the exposure. In other words, if the exposure was 1.5 sec., then noise reduction takes 1.5 sec., and you cannot take another picture until the noise reduction process finishes. Choose from:

• **0: Off.**

• **1: Auto.** Applies noise reduction for exposures of 1 sec. or longer if exposure noise is detected.

• **2: On.** Applies noise reduction for all 1 sec. or longer exposures without checking for noise. May reduce noise for exposures that would not have been noise detected and reduced using the Auto option.

✦ **C.Fn-03: Flash sync speed in Av mode.** Enables you to set a faster flash sync speed. Choose from:

• **0: Auto.**

• **1: 1/250 sec. (fixed).** Sets the flash sync speed to 1/250 sec. in Aperture-priority AE mode. The faster synch speed in low light or nightlight allows the background to go dark. Otherwise, the flash sync speed is 1/125 sec.

✦ **C.Fn-04: Shutter/AE lock button.** Changes the function of the AF/AE

lock button. C.Fn-18 also affects this function, and if you set both, the latter operation will not work, except when AF stop is executed after AF start. Choose from:

• **0: AF/AE lock.**

• **1: AE lock/AF.** Allows you to focus and meter separately. Press the AE/AF lock button to focus, and then press the Shutter button halfway to lock exposure (AE).

• **2: AF/AF lock, no AE lock.** In AI Servo AF mode, pressing the AF/AE lock button momentarily stops autofocusing to prevent the focus from being thrown off by an object passing between the lens and the subject. The camera sets exposure at the moment the picture is taken.

• **3: AE/AF, no AE lock.** In AI Servo AF mode, pressing the AF/AE lock button starts and stops the continuous autofocus operation and is handy for subjects that start moving and stop. With this option set, the focus and exposure theoretically are at the optimum point because the exposure is set the moment the image is taken.

✦ **C.Fn-05: AF-assist beam.** Controls whether the autofocus assist light is used by either the built-in flash or by an accessory Speedlite. Choose from:

• **0: Emits.** Both the built-in flash and an accessory Speedlite use the beam to establish focus.

• **1: Does not emit.** Neither the built-in flash nor an accessory

Speedlite uses the beam to establish focus.

- **2: Only external flash emits.** The built-in flash does not use the AF-assist light, but an accessory Speedlite does use the light when necessary, provided that the Speedlite's AF-assist beam Custom Function is not set to Disabled.

✦ **C.Fn-06: Exposure level increments.** Allows you to set the amount to use for shutter speed, aperture, exposure compensation, auto-exposure bracketing, etc. The exposure increment you choose is displayed in the viewfinder and on the LCD as double marks at the bottom of the exposure level indicator. Choose from:

- **0: 1/3-stop.** Sets 1/3 stop as the exposure increment for shutter speed, aperture, exposure compensation, and auto-exposure bracketing changes.

- **1: 1/2-stop.** Sets 1/2 stop as the exposure increment for shutter speed, aperture, exposure compensation, and auto-exposure bracketing changes.

✦ **C.Fn-07: Flash firing.** Allows or prevents an accessory Speedlite and a non-Canon flash connected to the PC terminal to fire. Choose from:

- **0: Fires.** Fires a flash connected to the PC terminal or the built-in flash if needed in Creative Zones.

- **1: Does not fire.** Disables firing of an accessory flash unit (or built-in flash in Creative Zones) connected to the PC terminal,

but does not disable the AF-assist beam from lighting, depending on the C.Fn-05 setting.

✦ **C.Fn-08: ISO expansion.** Enables you to expand the ISO range to "H," equivalent to ISO 3200. Choose from:

- **0: Off.** Prevents you from choosing the "H" ISO, equivalent to ISO 3200 setting.

- **1: On.** Allows you to select the equivalent of ISO 3200 shown as "H" on the LCD panel and in the viewfinder. H is displayed after ISO 1600.

✦ **C.Fn-09: Bracket sequence/Auto cancel.** Allows you to change the sequence for pictures bracketed by shutter speed or aperture, and the file-saving sequence for white-balance bracketing (WB-BKT). Note that when Auto Cancellation is set, bracketing is cancelled as follows:

- **AEB.** When you turn the power switch to Off, change lenses, have flash-ready, replace the battery, or replace the CF card.

- **WB-BKT.** When you turn the power switch to Off or replace the battery or the CF card.

Choose from:

- **0: 0, -, +/Enable; 1: 0, -, and =/Disable.** Starts the bracketing sequence with the standard exposure (AEB) or the standard white balance (WB-BKT). The sequence can be repeated. Note that during bracketing, automatic canceling is disabled if the flash is engaged and the bracketing sequence is cancelled. See Table 1.8.

Table 1.8
AEB, WB-BKT Bracketing Sequence (C.Fn-09)

AEB	*WB Bracketing*	
	Blue/Amber Bias	**Magenta/Green Bias**
0 : Standard exposure	0 : Standard white balance	0 : Standard white balance
- : Decreased exposure	- : More blue	- : More magenta
+ : Increased exposure	+ : More amber	+ : More green

- **2: -, 0, +/Enable.** The bracketing sequence begins with the minus or bluish/magenta bias setting.

- **3: -, 0, +/Disable.** Repeats the bracketing sequence starting with the minus (AEB), or the bluish/magenta bias (WB-BKT) setting. The sequence can be repeated.

✦ **C.Fn-10: Superimposed display.** Allows you to turn off the red flash for the selected AF point in the viewfinder. Choose from:

- **0: On.**

- **1: Off.** Turns off the AF point red flash in the viewfinder, although the AF point is still lit when you select it.

✦ **C.Fn-11: Menu button display position.** Enables you to determine which menu screen is displayed. Choose from:

- **0: Previous (top if power off).** Displays the last menu screen you used. The top menu screen, Quality, is displayed

instead when the power switch is set to Off.

- **1: Previous.** Displays the last menu you used.

- **2: Top.** Always displays the Quality (top) menu.

✦ **C.Fn-12: Mirror lockup.** Turning this option on prevents potential blur as the camera mirror flips up to begin an exposure. Choose from:

- **0: Disable.** Prevents you from selecting mirror up or mirror acts normal.

- **1: Enable.** Allows you to lock the mirror for close-up and telephoto images to prevent mirror reflex vibrations that can cause blur. When this option is enabled, you press the Shutter button once to swing up the mirror, and then press the Shutter button again to make the exposure. With mirror lockup, the drive mode is automatically set to Single-shot. The mirror remains locked for 30 seconds.

Tip *Never point the camera toward the sun during mirror lockup to avoid damaging the shutter curtains.*

✦ **C.Fn-13: AF point selection method.** Allows you to choose which camera controls you use to for selecting the AF point. Choose from:

- **0: Normal.** Press the AF Point Selection button, and then press the Multi-controller to select the AF point (or use the Quick Control Dial).

- **1: Multi-controller direct.** Allows you to select the AF point by using only the Multi-controller. If you press the AF-WB button, this function sets the camera to AF point selection.

- **2: Quick Control Dial direct.** Allows you to select the AF point by rotating the Quick Control dial without first pressing the AF-WB button. Pressing the AF Point Selection button and turning the Main dial sets exposure compensation.

✦ **C.Fn-14: E-TTL II.** Enables you to choose between Evaluative and Average flash exposure. Choose from:

- **0: Evaluative.** Provides fully automatic flash photography in all situations ranging from low light to daylight fill flash.

- **1: Average.** Averages the flash for the entire area being covered and does not apply automatic flash exposure compensation. To use flash exposure

compensation and FE lock, you must set them yourself.

✦ **C.Fn-15: Shutter curtain sync.** Allows you to set whether the flash fires at the beginning or end of an exposure, thereby determining whether light trails come before or after the subject. Choose from:

- **0: 1st-curtain sync.** With a slow shutter speed, the flash fires at the beginning of the exposure, allowing light trails in front of the subject.

- **1: 2nd-curtain sync.** With a slow shutter speed, the flash fires just before the shutter closes, allowing light trails that follow the subject. This function works with an accessory Speedlite whether you have this feature. A preflash is fired for flash metering control after the shutter button is pressed completely, but the main flash fires right before the shutter closes. If the Ex-series Speedlite has this feature, it overrides this Custom Function.

✦ **C.Fn-16: Safety shift in Av or Tv.** Provides automatic shifting of the aperture or shutter speed in cases where sudden shifts in lighting might otherwise cause an improper exposure. Choose from:

- **0: Disable.** Prevents changes in exposure regardless of subject brightness changes.

- **1: Enable.** In Shutter-priority AE (Tv) and Aperture-priority AE (Av) modes, the shutter speed or aperture automatically shifts if the subject brightness suddenly changes. The shift helps

ensure good exposure in shifting light.

✦ **C.Fn-17: Magnified view.** Enables you to view a magnified image display either only during playback or during image review and playback. Choose from:

- **0: Image playback only.** Allows you to magnify images when viewing them only by pressing the Playback button.

- **1: Image review and playback.** Allows you to press the Print/Share button and the Enlarge button. You can also magnify the view in the same procedure as C.Fn-17-0.

✦ **C.Fn-18: Lens AF stop button function.** Enables you to set the AF functions, AE lock, and Image Stabilizer operation. Choose from:

- **0: AF stop.**

- **1: AF start.** Allows autofocus only while the AF stop button is pressed and the camera AF operation is disabled.

- **2: AE lock.** Applies AE lock when the AE lock button is pressed. Choose this option when you want to focus and meter separately.

- **3: AF point.** In manual AF point selection mode, the button switches to automatic AF point selection from manual AF point selection while it is held down. This is handy if you can no longer focus-track a moving subject with a manually

selected AF point in AI Servo AF mode. In automatic AF point selection mode, the button selects the center AF point only while you hold it down.

- **4: ONE SHOT/AI SERVO.** When using One-Shot AF mode, holding down the button switches to AI Servo AF mode. When using AI Servo AF mode, holding down the button switches to One-Shot AF mode.

- **5: IS start.** If the lens's Image Stabilizer (IS) switch is turned on, the Image Stabilizer operates only while you press the button.

 Note *AF stop buttons are offered only on super telephoto lenses.*

✦ **C.Fn-19: Add original decision data.** Provides data to verify that the image is original by displaying an icon when used with the Data Verification Kit DVK-E2. Choose from:

- **0: Off.** Does not append image verification data.

- **1: On.** Appends image data to verify whether the image is original. When an image appended with the verification data is played back, an icon is displayed. To verify whether the image is original, the Data Verification Kit DVK-E2 (sold separately) is required.

To set a Custom Function, follow these steps:

1. **Set the camera to a Creative Zone mode.**

2. **Press the Menu button, and then press the Jump button to go to the Set-up (yellow) menu.**

3. **Rotate the Quick Control dial to highlight Custom Functions (C.Fn), and then press the Set button.** The Custom Functions screen appears.

4. **Rotate the Quick Control dial to select the Custom Function number you want, and then**

press the Set button. The Custom Function option control is highlighted.

5. **Rotate the Quick Control dial to scroll through the options.** When you see the option you want, press the Set button. You can repeat Steps 3 through 5 to set other custom functions.

6. **Press the Menu button to return to the menu.**

Canon EOS 30D Setup

Setting up the Canon EOS 30D is a quick process. Canon has simplified the menus and offered Custom Functions that allow you to customize the control and operation of the camera to suit your shooting style and preferences. The Quick Tour provided an overview of setup on the camera, but this chapter goes into more detail on the setup options and offers tips for ease of operation.

Chances are good that, if you've already done some of the setup tasks, you can skim through the chapter watching for tips that you may have missed in your initial setup. However, a couple of features that are new to the EOS 30D are covered in this chapter, including Canon's new Picture Styles and the ability to set your own custom styles with three user-defined options. Additionally the ability to expand the ISO settings up to an equivalent of 3200, shown as "H" on the camera, is also covered. All of these options are worth exploring in detail, both for workflow and for unique shooting situations.

About the Battery and CF Card

Before you set up the EOS 30D, be sure that the lithium-ion battery (BP-511A) is fully charged. A charging cycle for a new or fully depleted battery is approximately 90 minutes. Be sure to leave the battery in the charger for an hour *after* the red light stops blinking to complete the charging cycle — making

Approximate Shots per Battery Charge

Factory estimates for shots-per-battery charge on normal operating temperatures (68 degrees F/20 degrees Celsius), are 750 to 1,100 shots, depending on flash use. But in freezing or colder temperatures, battery life decreases to 600 to 900 shots per charge.

In practice, you may get fewer shots than Canon predicts, depending on the duration you choose for image review, how long you leave the camera on, whether or not you're shooting, and how much you use the menus. The battery powers not only camera operations such as autofocusing and image review, but also lens operations including focus and image stabilization — all of which ultimately affect the number of shots per battery charge.

When shooting outdoors in cold weather, keep the camera under your coat when you're not shooting. Carrying a spare battery in an inside pocket close to your body to keep it warm is also a good plan.

total charging time approximately 2.5 hours. For long shooting sessions such as weddings and news events, you can consider buying the optional battery grip that holds two BP-511A (or BP-511/512/513) lithium-ion batteries or six AA batteries in the magazine. Because the charger holds only one battery, you may consider buying an extra charger as well.

The camera also offers an AC adapter that is best accessed by opening the battery compartment door and flipping up the rubber covering for the DC coupler plug. To use AC power, you need to buy the optional AC Adapter Kit ACK-E2.

When traveling out of the country, you don't need a separate power transformer for the Battery Charger 9CG-580/CB-5L because it works with a 100 VAC and 240 VAC 50/60 Hz power source. Just be sure to pack a plug adapter for the charger.

When to Use the Main and Quick Control Dials

Before discussing specific setup tasks, it's helpful to know when to use the Main and the Quick Control dials on the EOS 30D. In loose terms, the Main dial is used to set shooting-related settings. The Quick Control dial, however, also can be used for this purpose, provided that you have the Power switch in the uppermost position. And it can be used to select menu options and to set things such as exposure compensation. Also, you can use it to select AF points via C.Fn-13, which is detailed in Chapter 1.

Although in many cases, you can use either dial, Table 2.1 shows a rundown of which dial controls what function or setting.

Table 2.1
Main and Quick Control Dial Selection Functions

Main Dial	Quick Control Dial
Autofocus Mode	**White Balance Mode**
✦ One Shot (locks focus by pressing the shutter halfway down) ✦ AI Focus (locks focus as above but monitors subject for movement) ✦ AI Servo (uses continuous predictive focus)	✦ Auto (AWB) ✦ Daylight ✦ Shade ✦ Cloudy ✦ Tungsten ✦ Fluorescent ✦ Flash ✦ Custom ✦ Kelvin temperature
Metering Mode	**Flash Compensation**
✦ Evaluative ✦ Partial ✦ Spot ✦ Center Weighted Average	✦ Plus/minus 2 EV (exposure values) ✦ 1/2 or 1/2 EV steps using C.Fn-6
Drive Mode	**ISO**
✦ Single shot ✦ Continuous (High) at 5 fps ✦ Continuous (Low) at 3 fps ✦ Self-timer (10-sec. delay)	✦ 100 ✦ 640 ✦ 125 ✦ 800 ✦ 200 ✦ 1000 ✦ 250 ✦ 1250 ✦ 320 ✦ 1600 ✦ 400 ✦ H (3200 using C.Fn-8) ✦ 500

Choosing a Media Card

The EOS 30D accepts CompactFlash (CF) Type I and Type II media cards as well as microdrives. And, because the EOS 30D supports the FAT32 file system, you can use media cards with capacities of 2GB and larger. While microdrives are economical, they contain moving mechanisms much like the hard drive of a computer and these moving mechanisms can be easily damaged by bumping or dropping the microdrive. Conversely, CF cards are virtually indestructible surviving drops, being driven over by a car, and accidentally being washed in the pockets of clothing in washing machines with no loss of images.

Checking Card Speed Ratings...

Media cards are rated by speed and use various designations such as Ultra, Extreme, Write Accelerated, and numeric speed ratings such as 80x. If speed is your main goal, then be sure to review Rob Galbraith's test results on CF cards and microdrives. Rob updates the CF/SD Performance Database periodically. You can find his test results at `http://robgalbraith.com`, and then click the CF/SD link at the upper left. Ultimately, the best card for you is the one that gives you the best mix of speed, capacity, and price.

2.1 Microdrives and CompactFlash Type I and Type II cards can be used in the EOS 30D.

Not all media cards are created equal. In particular, the type and speed of media you use affect the camera's response times for tasks such as writing images to the media card and the ability to continue shooting during that process, the speed at which images are displayed on the LCD, and how long it takes to zoom images on the LCD. The type of file format that you choose also affects the speed of certain tasks — when writing images to the media card, for example. JPEG image files write to the card faster than RAW files or the RAW+JPEG option.

CF cards include a controller and multiple flash-memory chips that determine the performance of the card. The controller determines the speed of communication with the camera and how much data can be written to and read from the card. The flash memory determines how fast data can be transferred to the card. You usually pay a premium for cards that offer the fastest memory.

Currently, CF cards of 2GB and 4GB are common while 8GB cards are gaining popularity. When selecting a CF card or microdrive, you should know that the card speed isn't the only determinant of performance. How the card interacts with the camera to exchange data affects speed and means that cards that are speedy performers when used in one camera may not be as speedy when used in another camera.

CF cards have a limited life span that is measured in write/erase cycles. Even if memory cells go bad or reach their lifespan limit, CF cards are designed to automatically skip bad cells. The life of a card depends on the manufacturer, but it is measured in hundreds of thousands or millions of write/erase cycles.

Using a CF Card

When you get a new card, always format it in the camera as was explained in the Quick Tour. Never format a card on your computer. If you are using CF cards that you've used in other cameras, formatting them in the EOS 30D is also important. Of course, formatting the card erases images, so be sure to off-load all images to the computer before you format the card. In general, you should format media cards every few weeks, and if you've used a media card in another camera, be sure to reformat it in the EOS 30D to ensure proper data structure is set and to clean up the card.

To reformat the card in the camera, follow these steps.

1. **Press the Menu button.**

2. **Press the JUMP button until the Set-up (yellow) menu is displayed.**

3. **Rotate the Quick Control Dial to highlight Format, and then press the Set button.** The camera displays a confirmation screen.

4. **Rotate the Quick Control dial to select OK, and then press the Set button.** The camera erases all images and formats the CF card.

As you take pictures, the LCD panel and viewfinder show the approximate number of images remaining on the media card. The number is approximate because each image varies slightly depending on the ISO setting, the file format and resolution, the parameters chosen on the camera, and the image (different images compress differently).

To avoid shooting without a memory card in the camera, you can set the camera so that you can't shoot unless a memory card is inserted. Just follow these steps.

1. **Press the Menu button.**

2. **Press the JUMP button until the Shooting (red) menu is displayed.**

3. **Rotate the Quick Control dial to highlight Shoot w/o card, and then press the Set button.** The camera displays On and Off options.

Avoid Losing Images

When the camera's red access light is blinking, it means that the camera is recording or erasing image data. When the access light is blinking, do not open the CF card slot cover (which powers down the camera), turn the camera off, attempt to remove the media card, or remove the camera battery. Any of these actions can result in loss of images and damage to the media card and camera. What's more, if you open the media door, you won't hear an audible warning to let you know that you've just lost the image being written as well as any in the camera's buffer. In short, don't open the CF card slot cover if the access light is on.

4. **Rotate the Quick Control dial to select Off, and then press the Set button.**

Setting the Date and Time

Setting the date and time on the EOS 30D ensures that the data that travels with each image file has the correct date and time stamp. This data, commonly referred to as *metadata*, helps you identify when the image was taken and is very helpful when you want to organize your image collection.

Metadata is a collection of all the information about an image, including the filename, date created, size, resolution, color mode, camera make and model, exposure time, ISO, f-stop, shutter speed, lens data, and white balance setting, to name a few. *EXIF*, used interchangeably with metadata, is a particular form of metadata.

To set the date and time on the EOS 30D, follow these steps:

1. **Press the Menu button on the back of the camera.**

2. **Press the JUMP button until the Set-up (yellow) menu is displayed.**

3. **Rotate the Quick Control dial to highlight Date/Time, and then press the Set button.** The camera displays the date and time options with the month option highlighted.

4. **Press the Set button, and then rotate the Quick Control dial to change the month.**

5. **Press the Set button to confirm the change.**

6. **Rotate the Quick Control dial to select the day option, and then press the Set button.**

7. **Rotate the Quick Control dial to change the day, and then press the Set button to confirm the change.** Repeat Steps 6 and 7 to change the year, minute, second, and date/time format options. You can choose to show the date as mm/dd/yy, dd/mm/yy, or yy/mm/dd.

8. **When all options are set, rotate the Quick Control dial to select OK, and then press the Set button.**

Choosing the File Format and Quality

The file format and quality level used to take your pictures determines not only the number of images you can store on the media card, but also the sizes at which you can enlarge and print images taken with the EOS 30D. The setting you choose also determines whether images are stored as JPEGs, in RAW, or both RAW and JPEG format.

Table 2.2 shows the options from which you can choose.

Table 2.2
EOS 30D File Format and Quality

Image Quality	Approximate Recording and Print Sizes	Image Size (Pixels)	Format	Approximate File Size
L (Large/Fine) **L (Large/Normal)**	Records images at approximately 8.2 megapixels, sufficient for making A3-size prints (12″ × 8.6″).	3054 × 2336	JPEG	3.6 MB 1.8 MB
M (Medium/Fine) **M (Medium/ Normal)**	Records images at approximately 4.3 megapixels sufficient for making A5- (8.5″ × 6″) to A4-size (8.3″ × 11.7″) prints.	2544 × 1696		2.2 MB 1.1 MB
S (Small/Fine) **S (Small/Normal)**	Records images at approximately 2 megapixels sufficient for making A5 (8.5″ × 6″) prints.	1728 × 1152		1.2 MB 0.6 MB
RAW	Records images at approximately 8.2 megapixels with no image degradation from compression. Sufficient for printing images at A3 size (12″ × 8.6″) or larger. RAW images must be processed on the computer and cannot be printed directly from the camera.	3054 × 2336	.CR2	8.7 MB
RAW+JPEG	Simultaneously records RAW images at 8.2 megapixels and any of the JPEG sizes. Both the RAW and JPEG images have the same filename and are saved in the same folder. This is a good option to choose when you need to quickly send the client low-resolution proofs of a shoot or to post proofs on your Web site for client viewing. Because the JPEG and RAW filenames are the same, you can have the client choose by filename, and then use the JPEG filename to reference the RAW file for final processing and printing.	3054 × 2336	.CR2 and .jpg	8.7 MB and the JPEG size you've selected

In Basic Zone modes, the EOS 30D automatically sets the recording format to JPEG, although you can choose the level of quality. In Creative Zone modes, you can choose to capture images in JPEG, RAW, or RAW+JPEG format.

JPEG format

JPEG, which stands for Joint Photographic Experts Group, is a *lossy* file format, meaning that it discards some image data during the process of compressing image data stored on the media card as well as during subsequent saves when editing if you edit in JPEG format. Because JPEG images are compressed, you can store more images on the CF card. However, as the compression ratio increases, more of the original image data is discarded and image quality subtly degrades.

Other important things to know about choosing JPEG formats are that, unlike RAW images that allow you to change many settings after the picture is taken, JPEG images are processed by Canon's internal hardware/software before being stored on the media card. JPEG images can be opened in any image-editing program and can be printed directly from the computer.

If you choose the JPEG format, then you can choose among different image sizes and among compression ratios ranging from low (Fine settings) and high (Normal settings).

RAW format

Shooting in RAW format means that data directly from the image sensor is stored on the CF card with minimal in-camera processing. However, unlike JPEG images that can be viewed in any image-editing program and printed directly from the camera, RAW files must be viewed and converted using Canon's Digital Photo Professional program or Adobe's Bridge file viewer and Adobe's Camera Raw plug-in (or other third-party RAW applications). If you've chosen to shoot with the RAW+JPEG option, you can view the JPEG files using any image-editing program.

Capturing RAW images has undisputable advantages. First, RAW data gives you the ultimate flexibility: You can change some camera settings *after* the picture is taken. For example, if you didn't set the correct white balance or exposure, you can change it in a RAW conversion program on the computer. This gives you a second chance to correct underexposed or overexposed images within reason, and to correct the color balance after you take the picture.

Second, you can also do additional processing during the conversion. Depending on the conversion program that you use, you can also reduce color and luminance noise, correct chromatic aberrations, and correct lens vignetting. Third, as RAW conversion programs evolve, you will be able to go back to images taken months or years ago and reprocess them for improved results or with different renderings.

The image quality that you choose affects the maximum burst rate as shown in Table 2.3.

Table 2.3
EOS 30D Image Quality and Maximum Burst Rates

Image Quality	Maximum Burst Rate for High-Speed Continuous Shooting*	Maximum Burst Rate for Low-Speed Continuous Shooting*
L (Large/Fine)	30	37
L (Large/Normal)	55	100
M (Medium/Fine)	50	60
M (Medium/Normal)	100	165
Small (Small/Fine)	105	240
Small (Small/Normal)	220	850**
RAW	11	11
RAW+JPEG	9	9

* Figures are approximate and depend on the speed of the CF card.

** You can continue shooting in continuous shooting mode until the CF card is full.

The maximum number of shots remaining during maximum burst is displayed to the lower-right of the viewfinder. If you pause shooting, the maximum burst rate catches up and the maximum number of shots increases. If you've set white-balance bracketing, the number of images will be fewer than shown here.

To set the image quality of your pictures, follow these steps:

1. **Rotate the Mode dial to a Creative Zone mode.**

2. **Press the Menu button.**

3. **Press the JUMP button to display the Shooting (red) menu.**

4. **Rotate the Quick Control dial to highlight Quality, and then press the Set button.** The image quality options are displayed.

5. **Rotate the Quick Control dial to select the recording quality you want, and then press the Set button.**

6. **Rotate the Mode dial to a Basic Zone mode, and then repeat Steps 2 through 5 to set the JPEG image quality for the Basic Zone modes.** Remember that you are not able to choose RAW when the camera is in a Basic Zone mode.

Setting File Numbering

With the EOS 30D, you can have the camera number images continuously or have it restart numbering each time you change the

media card, or you can choose to manually reset file numbering. File numbering is assigned from 0001 to 9999. Folders numbered from 100 to 999 hold up to 9,999 images each.

With Continuous numbering, images are numbered sequentially using a unique four-digit number from 0001 to 9999. With unique filenames, managing and organizing images on the computer is easy because you can easily ensure that images do not have duplicate filenames. This option is also useful to track the total number of images, or actuations, on the camera. The EOS 30D's default setting is Continuous file numbering.

If you use Auto Reset, both file and folder numbering restarts when you insert a newly formatted CF card. Folder numbers begin with 100, and file numbering begins with 0001, unless the CF card contains a previous image, in which case, numbering begins with the highest file number in the highest numbered folder on the CF card. If you like to organize images by media card, Auto Reset may be a useful option. However, multiple images will have the same filename. This means that you should create separate folders for each off-load and otherwise follow scrupulous folder organization to avoid filename conflicts and potential overwriting of images on the computer.

You also can choose to manually reset numbering. With this option, a new folder is created with the next higher number and the file number restarts with 0001. Subsequent images are saved in the new folder. Whichever file numbering method you previously used (Auto Reset or Continuous) takes effect when you take additional images.

To change the file numbering method on the EOS 30D, follow these steps:

1. **Press the Menu button.**

2. **Press the JUMP button until the Set-up (yellow) menu is displayed.**

3. **Rotate the Quick Control dial to highlight File numbering.**

4. **Press the Set button.** The camera displays the File numbering options.

5. **Rotate the Quick Control dial to select Continuous, Auto Reset, or Manual Reset.**

6. **Press the Set button.**

Choosing a White Balance Option

A white balance setting tells the camera the type of light that is in the scene so that the camera can render white and other colors accurately. The temperature, or color, of light, measured in degrees Kelvin, varies by source and during daylight, by the time of day. The three primary colors, Red, Green, and Blue (RGB), exist in different proportions in different temperatures of light. Setting a white balance option allows the in-camera software to render colors more naturally. When shooting RAW images, you can also readjust the white balance in the image conversion program.

With the EOS 30D, you have various options for setting white balance, depending on whether you're capturing JPEG or RAW images. Table 2.4 provides an overview of the white balance options and when you can use them, depending on the image format and mode you've chosen.

Table 2.4
EOS 30D White Balance Options by Image Format

White Balance Option	JPEG	RAW or RAW+JPEG
Preset white balance settings:	Available.	Available.
Auto (AWB) (3,000 - 7,000 K) ✦ Daylight (approx. 5,200 K) ✦ Shade (approx. 7,000 K) ✦ Cloudy (approx. 6,000 K) ✦ Tungsten (approx. 3,200 K) ✦ Fluorescent (approx. 4,000 K) ✦ Flash (approx. 6,000 K)	In Basic Zone modes, the camera automatically selects AWB.	
Custom white balance. Allows you to photograph a white or gray object that serves as the basis for white balance for one or more images.	Available only in Creative Zone modes.	Available.
Kelvin temperature (2,800 to 10,000 K). Allows you to set the specific color temperature for a scene.*	Available only in Creative Zone modes.	Available.
White balance correction. Similar to using a traditional color-conversion filter, this option allows you to shift color bias toward blue, amber, magenta, or green.	Available only in Creative Zone modes.	Available.
White balance auto bracketing. Bracketed shots include one standard color temperature shot, shot biased with blue/amber, and shot biased toward magenta/green.	Available.	Available.

* This option is best used with a color temperature meter or in scenes where you know the color temperature of the light source.

Note *Chapter 4 provides more detail on light and color temperature.*

The automatic white balance setting evaluates the colors in the scene and makes an educated guess on white balance. AWB works well except in scenes dominated by one or two colors and where no white is present. In general, the best white balance is achieved when you are shooting in the following manners:

✦ **For JPEG images.** Choose one of the preset white balance options, and the option closely matches the actual color temperature in the scene. Or if you know the temperature of the light source, use the color temperature to match it. In some scenes, for example, when shooting in mixed light, white balance bracketing provides some assurance of getting accurate color in one or more shots.

2.2 This studio shot was taken using Auto White Balance (AWB). In the studio and in other venues, AWB tends toward cool tones, and in this case, an obvious blue tint shows up in the background.

2.3 This is the same shot using a custom white balance.

✦ **For RAW images.** Set a Custom white balance, or in the series of images under the same light, shoot one image with a gray card in the scene. In an image-editing program, set the white balance by clicking the gray or white card, and then apply that white balance setting to the other images in the series during image conversion.

To change to a preset white balance option or to set a specific color temperature on the EOS 30D, follow these steps:

1. **Set the Mode dial to a Creative Zone mode.**

2. **Press the AF-WB button.**

3. **Rotate the Quick Control dial until the White Balance option you want is displayed on the LCD panel.**

4. **If you chose K to set the color temperature, press the Menu button.**

5. **Press the JUMP button until the Shooting (red) menu is displayed, and then rotate the Quick Control dial to highlight Color temp.**

6. **Press the Set button, and then rotate the Quick Control dial to set the color temperature that you want.**

7. **Press the Set button.** The color temperature you set remains in effect for the K (Color Temperature) setting until you change it.

8. **Press the shutter button halfway to return to shooting.**

Setting a custom white balance

Mixed light scenes, such as tungsten and daylight, used to drive photographers crazy. Shooting film in these scenes meant that you had to hold your breath and hope for the best. But digital photography changed everything. With the EOS 30D, you can set a custom white balance to get accurate color in mixed light, as well as in any lighting situation. Setting a custom white balance saves time that you'd otherwise spend color correcting images on the computer.

To set a custom white balance, follow these steps:

1. **Set the camera to a Creative Zone mode, and ensure that the Picture Style is not set to Monochrome.**

2. **Position the camera so a sheet of white paper fills the center of the viewfinder, and take a picture.** If the camera cannot focus, switch the lens to MF (Manual Focusing), and focus on the paper. Also ensure that the exposure is neither underexposed nor overexposed.

3. **Press the Menu button.**

4. **Press the JUMP button until the Shooting (red) menu is** displayed, and then rotate the Quick Control dial to highlight **Custom WB.** The camera displays the last image taken and the Custom WB screen.

5. **If necessary, rotate the Quick Control dial to select the image of the white or gray card or paper.**

6. **Press the Set button.** The EOS 30D imports the white balance data from the selected image and displays a message reminding you to set the white balance to Custom WB.

7. **Press the shutter button halfway to dismiss the menu.**

8. **Press the AF-WB button.**

9. **Rotate the Quick Control dial to select Custom WB.** The Custom WB icon is two triangles on their side with a solid rectangle between them. The Custom white balance remains in effect until you change it by setting a new Custom white balance.

Using white balance auto bracketing

White balance auto bracketing helps ensure that one or more images offer accurate color. White balance bracketing captures three images, each with +/-3 shifts in blue/ amber and magenta/green bias from the base white balance setting.

You can use white balance auto bracketing together with auto-exposure bracketing. If you do this, nine images are taken for each shot.

More About White Balance Correction

The EOS 30D enables you to bias the standard white balance in much the same way as you would use color-compensating filters in film photography. In film photography, conversion filters allow you to use film in light for which it isn't balanced. For example, with the correct color conversion filter, you can use daylight film (balanced to 5500 degrees K) in tungsten light (balanced to 3200 degrees K). Without the filter, the pictures will have an orange tint. But with a cooling color-compensating filter, certain wavelengths of light are prevented from passing through to the lens, thereby shifting colors so they are more natural.

On the EOS 30D, compensation is measured in mireds, a measure of the density of a color temperature conversion filter — similar to densities of color-correction filters that range from 0.025 to 0.5. Shifting one level of blue/amber correction is equivalent to five mireds of a color-temperature conversion filter. The shift you set remains in effect until you change the setting back to 0,0.

To set a white balance auto bracketing, follow these steps:

1. **If you have the camera recording set to RAW, reset the image recording to JPEG.**

2. **Press the Menu button on the back of the camera, and then press the JUMP button until the Shooting (red) menu is displayed.**

3. **Rotate the Quick Control dial to highlight WB SHIFT/BKT, and then press the Set button.** The camera displays the WB correction/WB bracketing screen.

4. **Rotate the Quick Control dial to set the bracketing direction and level.** Rotating the dial to the right sets the blue/amber bracketing. Rotating the dial to the left sets the magenta/green bracketing. One or more small boxes are displayed to indicate the level of bracketing up to +/-3 levels in single-level increments. To the right, the camera indicates the bracketing direction and level under BKT.

5. **Press the Set button.**

6. **Take the picture.** The EOS 30D captures the standard white balance first and then the blue and amber bias shots. If a magenta/green bias is set, then the image capture sequence is the standard, then the magenta, and then the green bias images.

The white balance selection blinks in the LCD when bracketing is set. To cancel white balance bracketing, reset the bias to +/-0 and 1 level by repeating Steps 1 through 5.

White balance correction

For anyone familiar with using color-compensation filters, the EOS 30D offers a similar function with its white balance correction. Correction can be shifted toward a blue (B), amber (A), magenta (M), or green (G) bias in up to nine levels measured as mireds, or densities. Each level is equivalent to five mireds of a color-temperature conversion filter. You can set a white balance correction if you're shooting either JPEG or RAW format images.

2.4 This image taken under mixed daylight and tungsten light used standard Auto White Balance with no correction.

2.5 Here the white balance correction is shifted toward amber to warm up the image.

To set White Balance Correction, follow these steps.

1. **Set the camera to a Creative Zone mode.**

2. **Press the Menu button.**

3. **Press the JUMP button until the Shooting (red) menu is displayed.**

4. **Rotate the Quick Control dial to highlight WB SHIFT/BKT, and then press the Set button.** The camera displays the WB correction/WB bracketing screen.

5. **Press the Multi-controller to move the cursor toward a blue, amber, magenta, or green correction.** On the right of the screen,

the SHIFT panel shows the bias and correction amount. For example, A2, G1 shows a two-level amber correction with a one-level green correction.

6. **Press the Set key to confirm the changes.** The shift you set remains in effect until you change it.

To cancel White Balance Correction, repeat Steps 1 through 5, but in Step 5 use the Multi-controller to set the cursor to 0,0, or the center of the graph, and then press the Set button. You also can combine White Balance Correction with White Balance bracketing.

About Picture Styles

Picture Styles are settings that determine the sharpness, contrast, color saturation, and color tone that can be applied to images in the camera or, with RAW images, after capture using Canon's Digital Photo Professional conversion program. For example, when the Monochrome picture style is chosen, filter effects and color toning options can also be applied. In addition, you can modify and register up to three custom Picture Styles by modifying an existing style.

Because Picture Styles are in use on most of Canon's EOS digital SLR cameras, using and/or modifying Picture Styles can help standardize image settings across different cameras, which can make workflow in studio environments more efficient. If you want to see how the new Picture Styles relate to the formerly used Parameters, visit www. canon.co.jp/Imaging/picturestyle/ shooting/index.html.

Table 2.5 provides an overview of Picture Styles.

Table 2.5
EOS 30D Picture Styles

Picture Style	Description	Tonal Curve	Color Saturation	Default Settings*
Standard	Vivid, moderately sharp, crisp	Higher contrast	High saturation	3,0,0,0
Portrait	Enhanced skin tones, soft texture, lower sharpness	Higher contrast	Slightly high saturation	2,0,0,0
Landscape	Vivid blues and greens, high sharpness	Higher contrast	High saturation for greens/blues	4,0,0,0
Neutral	Natural but subdued color. No sharpness applied.	Medium, subdued contrast	Low saturation	0,0,0,0
Faithful	Colorimetrically adjusted to match 5200 K. No sharpness applied.	Medium, subdued contrast	Low saturation	0,0,0,0
Monochrome	Black-and-white or toned** images with slightly high sharpness	Higher contrast	Low saturation; yellow, orange, red, and green filter effects available	3,0

* Settings shown in this sequence: Sharpness, Contrast, Color saturation, Color Tone, Filter effect (Monochrome), and Color toning (Monochrome).

** RAW images captured in Monochrome can be converted to color using the software bundled with the camera. However, JPEG images captured as Monochrome cannot be converted to color.

The following series of images shows the differences in Canon's Picture Styles using the same scene.

Note *Okay, you probably aren't going to use a portrait style for a residential image, but for the sake of illustrating the changes across each style, I'm using a residential image here.*

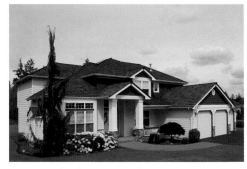

2.6 Standard Picture Style

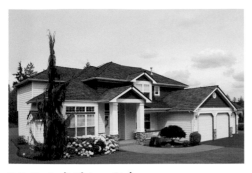

2.7 Portrait Picture Style

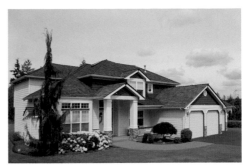

2.10 Faithful Picture Style (best in venues where you know the color temperature is 5,200 K)

2.8 Landscape Picture Style (with a sharper curve and saturated green and blue colors, it is best suited to this kind of image)

2.11 Monochrome Picture Style (with no color filter effect applied)

2.9 Neutral Picture Style

Choosing Picture Styles

You can choose a Picture Style by following these steps:

1. **Set the camera to a Creative Zone mode.**

2. **Press the Menu button.**

3. **Press the JUMP button until the Shooting (red) menu is displayed.**

4. **Rotate the Quick Control dial to highlight Picture Style.** The camera displays the Picture Style screen.

5. **Rotate the Quick Control dial to select the Picture Style you want, and then press the Set button.**

Customizing Picture Styles

You also can modify the settings for a Picture Style and register up to three customized sets as user-defined styles. Settings for Sharpness can be adjusted from 0 to +7. Settings for Contrast and Color saturation can be adjusted in a range of +/-4. Color tone for skin tones can be set to more red (negative settings) to more yellowish (plus settings) to +/-4.

To customize any Picture Style except Monochrome, follow these steps:

1. **Set the camera to a Creative Zone mode.**

2. **Press the Menu button.**

 Note *These steps do not work for customizing monochrome. See the next section for information on the Monochrome setting.*

3. **Press the JUMP button until the Shooting (red) menu is displayed.**

4. **Rotate the Quick Control dial to highlight Picture Style, and then press the Set button.** The camera displays the Picture Style selection screen.

5. **Rotate the Quick Control dial to select a Picture Style except Monochrome, and then press**

the JUMP button. The camera displays the Detail set. screen.

6. **Rotate the Quick Control dial to select one of the settings, for example, Sharpness, and then press the Set button.**

7. **Rotate the Quick Control dial to set the level that you want for the setting, and then press the Set button.**

8. **Rotate the Quick Control dial to select the next setting that you want to modify, and then press the Set button. Repeat Steps 6 and 7 to change the setting. Continue the process until all of the settings are adjusted.**

9. **Press the Menu button.** The camera displays the Picture Style selection screen with modified settings shown in blue.

 Note *To return to the default settings for a Picture Style, follow Steps 1 through 4 – except in Step 4 rotate the Quick Control dial to select Default set., which is at the bottom left of the Detail set. screen. Press the Set button to reset the style to the default settings.*

Customizing Monochrome Picture Style

To customize the Monochrome Picture Style, follow these steps.

1. **Set the camera to a Creative Zone mode.**

2. **Press the Menu button.**

3. **Press the JUMP button until the Shooting (red) menu is displayed.**

About Monochrome Filter and Toning Effects

There are five Monochrome filter options to choose from, including the option for no filter:

✦ **Yellow.** The Yellow Monochrome filter makes skies look natural with clear white clouds.

✦ **Orange.** The Orange filter darkens the sky and adds brilliance to sunsets.

✦ **Red.** The Red filter darkens a blue sky and makes fall leaves look brighter and crisper.

✦ **Green.** The Green filter makes tree leaves look crisp and bright.

✦ **Monochrome.** Setting the Monochrome Contrast setting to a positive setting increases the effect of the filter effect.

You can also choose to have a toning effect applied in the camera when taking Monochrome images. The Toning effect options include None, Sepia (S), Blue (B), Purple (P), and Green (G).

4. **Rotate the Quick Control dial to highlight Picture Style, and then press the Set button.** The camera displays the Picture Style selection screen.

5. **Rotate the Quick Control dial to select Monochrome, and then press the JUMP button.** The camera displays the Detail set. screen.

6. **Rotate the Quick Control dial to select the setting you want to change, and then press the Set button.**

7. **Rotate the Quick Control dial to adjust the setting**

8. **Repeat steps 6 through 7 until all the changes are made.**

9. **Press the JUMP button to return to the Picture Style menu, and then press the Set button again or press the Shutter button to begin shooting.**

 Note

If you want to reset the Monochrome Picture Style to the default settings, follow Steps 1 through 5. Then rotate the Quick Control dial to choose Default set. at the bottom of the Detail set. screen and then press the Set button to restore default settings.

Creating a customized Picture Style

You can also save up to three styles that you define yourself. To create a style you begin with one of the existing styles, and then set the Sharpness, Contrast, Saturation, and Color Tone to suit your preferences. User-defined styles are handy if you have multiple camera bodies in the studio, and you want to ensure consistency among the cameras.

To save user-defined Picture Style, follow these steps:

1. **Press the Menu button.**

2. **Press the JUMP button until the Shooting (red) menu is displayed.**

3. **Rotate the Quick Control dial to highlight Picture Style, and then press the Set button.** The camera displays the Picture Style selection screen.

4. **Rotate the Quick Control dial to highlight User Def. 1/2/3, and then press the JUMP button. The camera displays the settings screen.**

5. **To change the base setting of Standard Picture Style, press the Set button, rotate the Quick Control dial until the base style that you want is displayed, and then press the Set button.**

6. **Rotate the Quick Control dial to select one of the settings, for example, Sharpness, and then press the Set button.**

7. **Rotate the Quick Control dial to set the level that you want for the setting, and then press the Set button.**

8. **Press the Menu button to register the style.** The camera displays the Picture Style selection screen. The camera displays the base Picture Style to the right of User Def. 1/2/3 and shows changed settings in blue.

9. **Press the Set button.**

Note *To undo the changes to a User-Defined style, repeat Steps 1 through 7 and move the settings for each option back to zero.*

Choosing a Color Space

The EOS 30D offers a choice of two color spaces: sRGB and Adobe RGB. A color space defines the range of colors that can be reproduced. The Adobe RGB color space contains more colors, which is better for inkjet and commercial printing. Adobe RGB images have much more subdued color and saturation than images taken with sRGB. The sRGB color space encompasses fewer colors, but colors appear to be brighter and more saturated than with Adobe RGB. sRGB is well suited for images displayed on the Web or to send in e-mail.

The choice of color space should be made to enhance your overall color workflow. It is always best to capture as much data, including color, in an image as possible, making Adobe RGB the better choice for high-quality images. It is always possible to convert images to sRGB in an image-editing program if you want to display a copy of the image on the Web or in e-mail.

Image filenames captured in Adobe RGB are appended with _MG_. The ICC profile is not appended to the file. ICC is an abbreviation for the International Color Consortium, which promotes the use and adoption of open, vendor-neutral, cross-platform color management systems.

To change the color space on the EOS 30D, follow these steps.

1. **Set the camera to a Creative Zone mode.**

2. **Press the Menu button.**

3. **Press the JUMP button until the Shooting (red) menu is displayed.**

4. **Rotate the Quick Control dial to highlight Color space, and then press the Set button.** The camera displays the color space options.

5. **Rotate the Quick Control dial to select the color space you want, either sRGB or Adobe RGB.**

6. **Press the Set button.**

Setting ISO and Extended-Range ISO

An ISO setting sets the sensor's apparent sensitivity to light by increasing the signal amplification. The higher the ISO number, the more "sensitive" the sensor is to light and the shorter the time and narrower the aperture necessary to make an exposure. Conversely, the lower the ISO number, the less "sensitive" the sensor is to light and the longer the time required and the wider the aperture needed to make an exposure.

The EOS 30D offers an ISO range from 100 to 1600 in the default settings and up to the 3200 ISO via the ISO expansion in Custom Function 8 (C.Fn-08). ISO can be set in 1/3-stop increments, and the currently selected ISO setting is displayed (not in the

viewfinder-right, thanks) as well as on the LCD. In Basic Zone modes, the ISO is automatically set between 100 and 400. You can set the ISO to any of the available settings in Creative Zone modes.

 Cross-Reference *Custom Functions are discussed in detail in Chapter 1.*

As with all digital cameras, the higher the ISO is, the greater the likelihood that digital noise, unwanted color, and luminance artifacts will be introduced into the image, particularly in the shadow areas. In practice, the digital noise depends on your tolerance level. Also note that the camera's overall dynamic range, the difference between the lightest and darkest values in an image, at ISO settings higher than 800 decreases from approximately 8 Exposure Values (EV) to approximately 6 EV.

The set of images here shows selected ISO settings. All images were shot in RAW format and processed in Canon's Digital Photo Professional. No noise reduction has been applied.

 Cross-Reference *To set expanded ISO, see Chapter 1.*

To set the ISO on the EOS 30D, follow these steps:

1. **Set the camera to a Creative Zone mode.**

2. **Press the DRIVE-ISO button.** The camera displays the current ISO setting on the LCD panel.

3. **Rotate the Quick Control dial until the ISO setting you want is displayed in the LCD panel or in the viewfinder.**

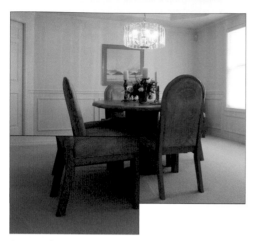

2.12 Taken at ISO 100, f/11, 1/5 sec.

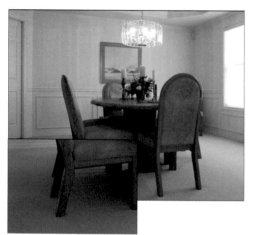

2.13 Taken at ISO 400, f/11, 1/8 sec.

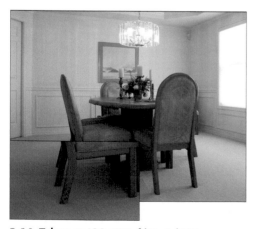

2.14 Taken at ISO 800, f/11, 1/800 sec.

2.15 Taken at ISO 1600, f/11, 1/30 sec.

2.16 Taken at H, expanded ISO setting, equivalent to ISO 3200, f/11, 1/60 sec.

Exposure, Composition, Lighting, and Lenses

Reviewing the Elements of Exposure

What can you expect from the EOS 30D in terms of exposure? That's what this chapter helps you determine. Also, if you're new to photography or if you're returning after some time away from shooting, this chapter is also a helpful refresher on the elements of exposure. Additionally, the information in this chapter helps you build a foundation from which you can expand your skills and creative options.

You can control the exposure elements discussed in this chapter when you use the Creative Zone modes Tv, Av, M (Manual), and P (Program AE) on the EOS 30D. In Basic Zone modes, the camera automatically sets exposure elements.

3.1 The 30D offers excellent creative control and responsiveness. Taken at ISO 100, f/25, at 1/125 sec. with the Canon EF 100mm f/2.8 L Macro lens.

Finally, this chapter also covers exposure as it directly relates to using the EOS 30D in various venues so that you have a head start on knowing what to expect from the camera.

The Four Elements of Exposure

Exposure is a precise combination of four elements, all of which are related to light. Each element depends on the others to create a successful result. If the amount of one element changes, then the other elements must be increased or decreased proportionally to get a successful result.

These four elements are discussed in detail in this chapter:

✦ **Light.** The starting point of exposure is the amount of light that's available in the scene to make a picture. In some cases, the amount of available light in a scene can't easily be changed. So, for now, consider the amount of light in the scene as fixed for the purposes of this chapter.

✦ **Sensitivity.** Sensitivity refers to the amount of light that the camera's image sensor needs to make an exposure or to the sensor's sensitivity to light: Does the sensor need lots of light or a little light to make the exposure? Sensitivity is measured in ISO rating. In digital photography, choosing an ISO setting determines how sensitive the image sensor is to light.

✦ **Intensity.** Intensity refers to the strength or amount of light that reaches the image sensor. Intensity is controlled by the aperture, or f-stop, an adjustable opening on the lens that allows more or less light to reach the sensor.

✦ **Time.** Time refers to the length of time that light is allowed to reach the sensor. Time is controlled by the shutter speed.

The EOS 30D in the field

In general terms, you think of good exposure as an image with detail in the highlights and shadows. In other words, a good exposure is one in which the highlights are not blown out and the shadows are not blocked up. Getting the ideal exposure depends on the dynamic range of the camera, or its ability to hold detail in highlights and shadows, even in contrasty light. The EOS 30D delivers approximately an 8-stop dynamic range at 100 to 400 ISO. However, the range drops off in extended range ISO (equivalent to ISO 3200).

Sensitivity: The role of ISO

ISO is an abbreviation for International Organization of Standards, which measures, tests, and sets standards for many (technologies) photographic products, including the rating or speed for film, which has, in turn, been applied to equivalents for the sensitivity of digital image sensors. So, in short, the ISO is a rating that describes the sensitivity of the image sensor to light.

The higher the ISO number, the less light that's needed to make a picture; conversely, the lower the ISO number, the more light that's needed to make a picture.

On the EOS 30D, the ISO sequence encompasses ISO 100, 125, 160, 200, 250, 320, 400, 500, 640, 800, 1000, 1250, and 1600, and H (equivalent to 3200) using extended ISO via C.Fn-08.

3.2 In bright light, you can set a low ISO such as 100 to get fast shutter speeds even at narrow apertures. Taken in bright sunlight at ISO 100, f/11, at 1/125 sec. using a Canon EF 24-105mm L IS f/4.0 lens.

Tip *Each ISO setting is twice as sensitive to light as the previous setting. For example, ISO 800 is twice as sensitive to light as ISO 400. As a result, the sensor needs half as much light to make an exposure at ISO 800 as it does at ISO 400.*

ISO contributes to overall image quality in several areas, including these: sharpness, saturation, contrast, and digital noise or lack thereof.

Low ISO settings provide images with good sharpness, saturation, and contrast. Of course, a longer shutter speed is needed, and your ability to handhold the camera and get a sharp picture is more limited.

In low-light scenes, you can switch to a fast (high) ISO setting. This allows faster shutter speeds that help reduce the risk of blur if the subject moves or from handshake as you press the shutter.

However, because increasing the ISO setting amplifies the analog signal (even though they are called digital cameras, the image sensors still have analog sections), increasing the ISO amplifies the noise. Noise in digital images is analogous in some ways to film grain. In digital photography, noise is comprised as luminance and color, or chroma, noise. Luminance noise looks similar to grain in film. Chroma noise, which varies by color channel, appears as mottled color variations, depending on the frequency texture of the noise. Chroma noise shows up in images as colorful pixels scattered about, particularly in the shadow areas of the image.

Checking for Digital Noise

If you choose a high ISO setting, you can check for digital noise by zooming the image to 100 percent in an image-editing program. Look for flecks of color in the shadow and midtone areas that don't match the other pixels and for areas that resemble the appearance of film grain.

Programs such as Noise Ninja, www.picturecode.com, and NeatImage, www.neatimage.com, or NIK Dfine, www.niksoftware.com, can reduce noise with a minimum of detail softening. If you shoot in RAW images, programs including Adobe Camera Raw, offer noise reduction during RAW conversion.

Regardless of the type, digital noise degrades overall image quality by overpowering fine detail in foliage and fabrics, reducing sharpness and color saturation, and giving the image a mottled look. Digital noise increases with high ISO settings, long exposures, underexposure, and high temperatures.

The tolerance for digital noise varies by photographer and sometimes by assignment. For example, some applications such as newspaper printing tolerate higher noise levels than commercial publications such as magazine advertisements. The performance of the EOS 30D is illustrated in the photos here. For most commercial applications, ISO 100 to 400 provides noise that is unobjectionable for most applications. ISO 800 shows evidence of noise that can be tamed in noise reduction or RAW image conversion programs. For higher ISO settings, the noise level generally is equivalent to that seen at ISO 800. For long exposures, you can also enable a Custom Function (C.Fn-02: Long exp. noise reduction) to reduce digital noise in exposures of 1 second or longer. This option doubles the length of exposure time, but the noise is virtually imperceptible. See Chapter 1 for details on setting Custom Functions.

 You can see comparisons of ISO settings in an interior scene in Chapter 2.

To change the ISO, follow these steps:

1. **Choose a mode in the Creative Zone.**

2. **Press the DRIVE-ISO button, and then rotate the Quick Control dial to select the ISO.**

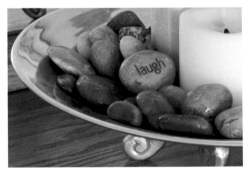

3.3 Long-exposure noise reduction effectively eliminates noise in this image. Exposure for this image was ISO 100, f/22, 15 seconds.

Intensity: The role of the aperture

The lens aperture (the size of the lens opening) determines the amount, or intensity, of light that strikes the image sensor. Aperture is shown as f-stop numbers, such as f/2.8, f/4, f/5.6, f/8, and so on.

Wide aperture

Smaller f-stop numbers, such as f/2.8, set the lens to a large opening that lets more light reach the sensor. A large lens opening is referred to as *wide* aperture. At wide apertures, the amount of time the shutter stays open to let light into the camera is decreased.

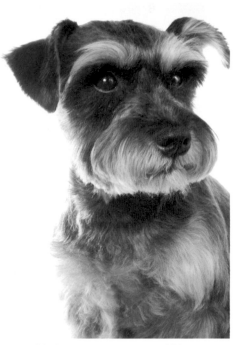

3.4 In this image, an aperture of f/22 allowed good sharpness back to front despite the camera being close to the subject. Taken at ISO 100, f/22, 1/125 sec. using a Canon EF 50mm f/1.4 USM lens.

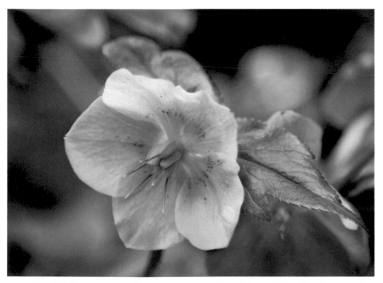

3.5 For this image, a wide aperture of f/4.0 blurred the background, bringing focus to the flower. Taken at ISO 100, f/4, at 1/30 sec.

Narrow aperture

Larger f-stop numbers, such as f/16, set the lens to a small opening that lets less light reach the sensor. A small lens opening is referred to as a *narrow* aperture. At narrow apertures, the amount of time the shutter stays open to let light into the camera is increased.

Choosing an aperture

Your choice of aperture depends on several factors. If you want to avoid blur from camera shake or subject motion in lower light, choose a wide aperture (smaller f-number) so that you get the faster shutter speeds. If you're using a telephoto (long) lens and you want to handhold the camera, choosing a wide aperture such as f/2.8 or f/4.0 helps achieve the fast shutter speed you need to handhold longer lenses.

Of course, an important consideration in choosing an aperture is to control the depth of field, discussed in the next section, in your images.

In the Creative Zone modes, you can control the aperture by switching to Aperture-priority AE, P, or Manual mode. Just turn the Mode dial to Av, P, or M to change to these modes. In Aperture-priority AE mode, you set the aperture and the camera automatically sets the correct shutter speed. In P mode, you set the aperture, and the camera sets the shutter speed and shifts the program as you change aperture for an equivalent exposure. In Manual mode, you set both the aperture and the shutter speed based on the reading from the camera's light meter. The light

meter shows a scale, the exposure level indicator, in both the viewfinder and the LCD panel that indicates over-, under-, and correct exposure based on the aperture and shutter speed combination.

Cross-Reference *You can learn more about exposure modes in Chapter 1.*

To set the aperture on the EOS 30D, follow these steps.

1. **Turn the Mode dial to Av (Aperture-priority AE) or M (Manual mode).** You also can change the aperture in P (Program AE mode), but in this mode, the camera also adjusts the shutter speed to achieve an equivalent exposure.

2. **In Av mode, rotate the Main dial until the f-stop you want appears on the LCD panel or in the viewfinder.** The camera automatically sets the correct shutter speed.

3. **In Manual mode, hold the AF point selection/Enlarge button as you rotate the Main dial to select the aperture.** Then rotate the Quick Control dial to set the appropriate shutter speed. The maximum aperture value depends on the lens you're using.

Note *If "30" blinks in the viewfinder, turn the Main dial to select a wider aperture to avoid underexposure. If "8000" blinks in the viewfinder, turn the Main dial and select a narrow aperture to avoid overexposure.*

What Is Depth of Field?

Depth of field is the zone of acceptably sharp focus in front of and behind a subject. Aperture is the main factor that affects depth of field, although camera-to-subject distance and focal length affect depth of field as well. Depth of field is as much a practical matter — based on the light available to make the picture — as it is a creative choice to enhance the content of the image.

Shallow depth of field

Images where the background is a soft blur and the subject is in sharp focus have a shallow depth of field. Shallow depth of field is tradition for many formal portraits, for some still-life images, for most food photography, for low-light sports, and for some stadium venues. To get a shallow depth of field,

choose a wide aperture such as f/2.8, f/4, or f/5.6. The subject will be sharp, and the background will be soft and non-distracting.

Extensive depth of field

Pictures with acceptably sharp focus from front to back have extensive depth of field. Extensive depth of field is required for images such as pictures of large groups of people, landscape, architecture, and interior images. To get extensive depth of field, choose a narrow aperture, such as f/8 or f/11 or narrower.

When you choose a narrow aperture such as f/16, a longer shutter speed is required to ensure that enough light reaches the sensor for a correct exposure. Conversely, with wide apertures, a shorter shutter speed, given the same ISO, is required for the exposure.

While aperture is the most important factor that affects the range of acceptably sharp

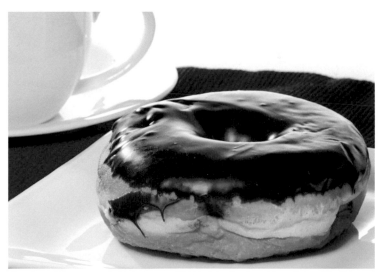

3.6 An extensive depth of field in this image shows the coffee cup in reasonably sharp focus in the background. The exposure for this image was ISO 100, f/22, 1/125 sec. using a Canon EF 100mm f/2.8 Macro USM lens.

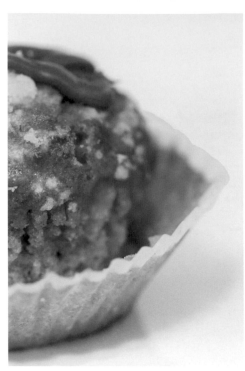

3.7 A very shallow depth of field is created here by combining a close camera-to-subject distance, a telephoto lens, and a wide aperture. The exposure for this image was ISO 100, f/ 3.2, 1/40 sec. using a Canon EF 100mm f/2.8 Macro USM lens.

focus in a picture, other factors also affect depth of field:

✦ **Camera-to-subject distance.** At any aperture, the farther you are from a subject, the greater the depth of field is. If you take a scenic photo of a distant mountain, the foreground, midground, and background will be acceptably sharp. If you take a portrait and the camera is close to the subject, only the subject will be acceptably sharp.

✦ **Focal length.** Focal length, or angle of view, is how much of a scene the lens "sees." From the same shooting position, a wide-angle lens takes in more of the scene than a telephoto lens and produces more extensive depth of field. A wide-angle lens may have a 110-degree angle of view, while a telephoto lens may have only a 12-degree (narrow) view of the scene.

 For more information on focal length, see Chapter 6.

Because the EOS 30D has a 1.6 focal multiplication factor, you might assume that the depth of field would match the lens aperture at the magnification factor. For example, if you're shooting with the Canon EF 100mm f/2.8 Macro lens, it's the equivalent of a 160mm lens, and you might expect a rendering of the background equivalent to a 160mm lens. That, however, is not the case because the focal length does not change. The multiplication factor affects the effective angle of view, but not the depth of field.

Time: The Role of Shutter Speed

Shutter speed controls how long the curtain in the camera stays open to let light from the lens strike the image sensor. The longer the shutter stays open, the more light reaches the sensor (at the aperture you set). Shutter speed affects your ability to get a sharp image in low light while handholding the camera and the ability to freeze motion or show it as blurred in a picture.

3.8 To show the motion of the top as it lost momentum, a shutter speed of 1/6 sec. was used. Taken at ISO 100, f/13, 1/6 sec. using a Canon EF 24-105mm, f/2.8, IS, USM lens set to 105mm.

When you increase or decrease the shutter speed by one full setting, it doubles or halves the exposure. For example, twice as much light reaches the image sensor at 1/30 second as at 1/60 second.

Shutter speed determines whether you can freeze a moving subject or allow it to be blurred in the picture. For example, you can adjust shutter speed to freeze a basketball player in midair, or adjust it to show the motion of water cascading over a waterfall. As a general rule, to stop motion, set the shutter speed to 1/60 second or faster. To show motion as a blur, try 1/30 second or slower, and use a tripod.

Note *The EOS 30D offers an electronically controlled, focal-plane shutter with settings in 1/2 or 1/3-stop increments. Shutter speeds, shown in fractions of a full second in the LCD panel and the viewfinder, include from Bulb (the shutter stays open until you close it by releasing the shutter button), and 30 to 1/8000 sec.*

Tip *The EOS 30D offers dark-frame reduction for exposures of 30 sec. and longer. The camera exposes the shot, and then takes a second exposure of equal duration with the shutter closed. It then subtracts pixel noise and any hot pixels from the first exposure to create a cleaner, long-exposure image. Be sure that you have a good charge on the battery for these kinds of shots. You can enable noise reduction (dark-frame reduction) for exposures of 1 sec. or longer using C.Fn-02. See Chapter 1 for more details on setting Custom Functions.*

If you shoot in Creative Zone modes using Shutter Priority or Manual mode, you can set the shutter speed. In Manual mode, you set both the shutter speed and the aperture independently.

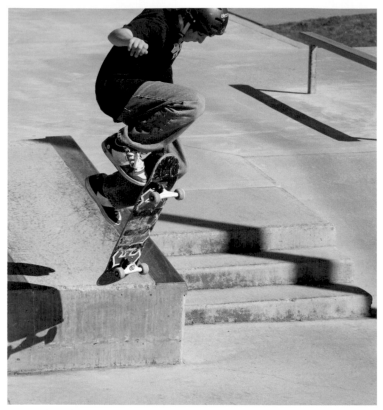

3.9 A fast shutter speed of 1/1600 sec. stopped the action of this skateboarder. Taken at ISO 400, f/7, 1/1600 sec. using a Canon EF 24-105mm, f/2.8, IS, USM lens set to 105mm.

To set the shutter speed, follow these steps:

1. **Turn the Mode dial to Tv (Shutter-Priority AE) or M (Manual).**

2. **Rotate the Main dial until the shutter speed you want appears on the LCD panel or in the viewfinder.** In Shutter-Priority AE mode, the camera automatically sets the aperture based on the shutter speed you choose.

3. **In Manual mode, rotate the Quick Control dial to set the correct aperture based on the exposure level indicator scale shown in the viewfinder and on the LCD panel.**

Tip *As a guideline, never handhold a camera at a shutter speed slower than the inverse of the focal length of the lens. For example, with a 100mm lens, don't handhold the camera at shutter speeds slower than 1/100 second. And, with long telephoto lenses, you should always use a monopod or tripod.*

Equivalent Exposures

Cameras require a very specific amount of light to make a good exposure. As you have seen, after the ISO is set, two factors determine the amount of light that makes the exposure: the size of the lens opening (aperture or f-stop) and the shutter speed. Set a wide aperture, and you can use a fast shutter speed. But switch to a small aperture (f-stop), and you must use a slower shutter speed.

Many combinations of aperture (f-stop) and shutter speed produce exactly the same exposure; in other words, the same amount of light will expose the image. For example, an exposure setting of f/22 at 1/4 second is equivalent to f/16 at 1/8 second, f/11 at 1/15, f/8 at 1/30, and so on. The exposures are the same because you decrease the amount of exposure time as you change to the next larger aperture.

Tip *To maintain an equivalent exposure automatically, use P (Program AE mode). In this mode, you can set the aperture or shutter speed, and the camera automatically sets the other exposure element to maintain an equivalent exposure — Tv and Av work this way too. In this mode, you can also control the AF point and the white balance.*

The camera's light meter measures the amount of light reflected from the subject. The meter uses this information to calculate the necessary exposure, depending on the ISO, aperture size, and shutter speed. If you change the aperture, the camera recalculates the amount of time needed for the

exposure. Change the shutter speed, and the camera's meter determines what aperture is required for a correct exposure.

Putting It All Together

ISO, aperture, shutter speed, and the amount of light in a scene are the essential elements of photographic exposure. On a bright, sunny day, you can select from many different f-stops and still get fast shutter speeds to prevent image blur. You have little

3.10 Practicing with aperture, shutter speed, and ISO combinations is the best way to learn how they work together to create the effect that you want. Taken at ISO 100, f/5.6 at 1/100 sec. using a Canon EF 16-35mm, f/2.8L USM lens.

need to switch to a high ISO for fast shutter speeds at small apertures.

As it begins to get dark, your choice of f-stops becomes limited at ISO 100 or 200. You need to use wide apertures, such as f/4 or wider, to get a fast shutter speed. Otherwise, your images will show some blur from camera shake or subject movement.

Switch to ISO 400 or 800, however, and your options increase and you can select narrow apertures, such as f/8 or f/11, for greater depth of field. The higher ISO allows you to shoot at faster shutter speeds to reduce the risk of blurred images, but it increases the chance of digital noise.

Working with Light

The common thread in getting good detail and accurate color is light — its color, direction, quality, and intensity. To get the best images, you need to understand the basic characteristics of light and how you can use light to your advantage. For some readers, this chapter is a refresher, and for others, it provides a basic foundation for exploring the use and characteristics of light further.

In general, think of light as a painter thinks about a color palette. You can use the qualities of light to set the mood; control the viewer's emotional response to the subject; reveal or subdue the subject's shape, form, texture, and detail; and render scene colors as vibrant or subdued. Light has fascinated photographers since the inception of photography, and the fascination is no less compelling today than it was then.

Color Hues

Few people think of light as having color until the color becomes obvious, such as at sunrise and sunset when the sun's low angle causes light to pass through more of the earth's atmosphere, creating visible and often dramatic color. But regardless of the time of day, natural light has color, and each color of sunlight renders subjects differently. Likewise, household bulbs, candlelight, flashlights, and electronic flashes have distinctive colors.

The human eye automatically adjusts to the changing colors of light so that white appears white, regardless of the type of light in which we view it. Digital image sensors are not, however, as adaptable as the human eye. When the EOS 30D is set to Daylight (or auto white balance), it renders color in a scene most accurately in the light at noon on a sunny cloudless day. But at the same setting, it does not render color as accurately at sunset or sunrise because the color temperature of light has changed.

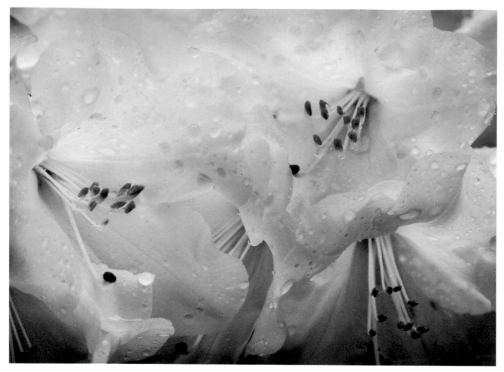

4.1 A rainy day provided this photo opportunity of rhododendrons. Taken at ISO 100, f/8, 1/100 sec. using a Canon EF 180mm f/3.5L Macro USM lens.

Different times of day and light sources have different color temperatures. Color temperature is measured on the Kelvin scale and is expressed in degrees K. So for the camera to render color accurately, the white balance setting must match the specific light in the scene.

When learning about color temperatures, keep in mind this general principle: The higher

Color Temperature Isn't Atmospheric Temperature

Unlike air temperature that is measured in degrees Fahrenheit (or Celsius), light temperature is based on the spectrum of colors that is radiated when a black body is heated. Visualize heating an iron bar. As the bar is heated, it glows red. As the heat intensifies, the metal changes to yellow, and with even more heat, it glows blue-white. In this spectrum of light, color moves from red to blue as the temperature increases.

Thus color temperature becomes confusing because we think of "red hot" as being significantly warmer than someone who has turned "blue" by being exposed to cold temperatures. But in the world of color temperature, blue is, in fact, a much higher temperature than red. That also means that the color temperature at noon on a clear day is higher (bluer) than the color temperature during a fiery red sunset. And the reason that you care about this is because it affects the color accuracy of your pictures.

the color temperature is, the cooler (or bluer) the light; the lower the color temperature is, the warmer (or yellower/redder) the light.

Table 4.1 shows Kelvin scale ranges for a sunny, cloudless day. These are, of course, general measures. The color temperature of natural light is affected by atmospheric conditions such as pollution and clouds. An overcast day shifts the color of light toward the cool end of the scale, measuring between 6,000 and 7,000 degrees K.

 Cross-Reference *If you use RAW capture, you can adjust the color temperature precisely using Canon's Digital Photo Professional RAW conversion program. See Appendix A for details on using this program.*

Additional artificial light sources and their color temperatures are shown in Table 4.2 for general reference.

Table 4.1
Selected Light Color Temperatures

Time of Day	Range in Degrees Kelvin	EOS 30D Setting and Approximate Corresponding Temperature
Sunrise	3,100 to 4,300	Auto (AWB): 3,000 to 7,000 or specify the temperature in degrees Kelvin (K)
Midday	5,000 to 7,000	Daylight: 5,200
Overcast or cloudy sky	6,000 to 8,000	Cloudy, twilight, sunset: 6,000
Sunset	2,500 to 3,100	AWB or cloudy, twilight, sunset: 6,000
Studio strobes	4,500 to 6,000	Daylight, flash, set a custom white balance, or specify the temperature in degrees Kelvin (K)

Table 4.2
Selected Artificial Light Color Temperatures

Light Source	Color Temperature in Degrees Kelvin
Fluorescent (daylight)	6500
Fluorescent (cool white)	4300
Photoflood	3400
Tungsten-halogen	3200
Fluorescent (warm white)	3000
Household lamps	2500-2900
Candle flame	2000

On the EOS 30D, setting the white balance tells the camera the general range of color temperature of the light so that it can render white as white, or neutral, in the final image. The more faithful you are in setting the correct white balance setting or using a custom white balance, the less color correction you have to do on the computer later.

The Colors of Light

Like an artist's palette, the color temperature of natural light changes throughout the day. By knowing the predominant color temperature shifts throughout the day, you can adjust settings to ensure accurate color, to enhance the predominant color, and, of course, to use color creatively to create striking photos.

Sunrise

In predawn hours, the cobalt and purple hues of the night sky dominate. But as the sun inches over the horizon, the landscape begins to reflect the warm gold and red hues of the low-angled sunlight. During this time of day, the green color of grass, tree leaves, and other foliage is enhanced, while earth tones take on a cool hue. Landscape, fashion, and portrait photographers often use the light available during and immediately after sunrise.

Although you can use the AWB setting, you get better color if you set a custom white balance, which is detailed in Chapter 1. If you are shooting RAW images, you also can adjust the color temperature precisely in Canon's Digital Photo Professional RAW conversion program.

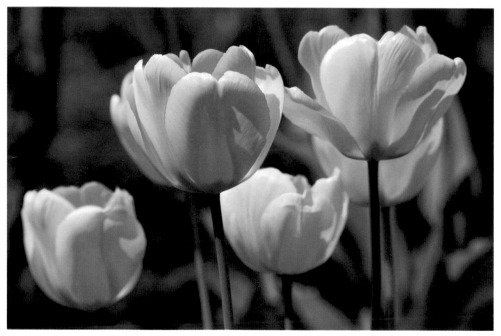

4.2 Bright angled sunlight created a vibrancy and brilliance to these tulips at a park. Taken at ISO 100, f/5.6, 1/800 sec. using a Canon EF 100mm f/2.8 USM lens.

Midday

During midday hours, the warm and cool colors of light equalize to create a light the human eye sees as white or neutral. On a cloudless day, midday light often is considered too harsh and contrasty for many types of photography, such as portraiture. However, midday light is effective for photographing images of graphic shadow patterns, flower petals and plant leaves made translucent against the sun, and images of natural and man-made structures.

For midday pictures, the Daylight white balance setting on the EOS 30D is a reliable choice. If you take portraits during this time of day, use the built-in flash or an accessory flash to fill dark shadows. You can set flash exposure compensation in 1/3- or 1/2-stop increments to get just the right amount of fill light using either the built-in flash or an accessory Speedlite.

 Cross-Reference *For more details on flash exposure compensation, see Chapter 1.*

Sunset

During the time just before, during, and just following sunset, the warmest and most intense color of natural light occurs. The predominantly red, yellow, and gold light creates vibrant colors, while the low angle of the sun creates soft contrasts that define and enhance textures and shapes. Sunset colors create rich landscape, cityscape, and wildlife photographs.

For sunset pictures, the Cloudy white balance setting is a good choice. If you are shooting RAW images, you also can adjust the color temperature precisely in Canon's

4.3 This tulip was backlit by bright midday sun revealing the transparency of the petals. Taken at ISO 100, f/5.6 at 1/800 sec. using a Canon EF 100mm, f/2.8 Macro USM lens.

Digital Photo Professional RAW conversion program.

 Cross-Reference *See Appendix A for details on using the Digital Photo Professional program.*

Diffused light

On overcast or foggy days, the light is diffused and tends toward the cool side of the color temperature scale. Diffusion spreads light over a larger area, making it softer and usually reducing or eliminating shadows. Light can be diffused by clouds; an overcast sky; atmospheric conditions including fog,

mist, dust, pollution, and haze; or objects such as awnings or shade from trees or vegetation.

Even in bright light, you can create a diffuse light by using a *scrim*, a panel of cloth such as thin muslin or other fabric, stretched tightly across a frame. The scrim is held between the light source (the sun or a studio or household light) and the subject to diffuse the light.

Diffused light creates saturated color, highlights that are more subdued than in open light and shadows that are softer. Diffused light is excellent light for portraits.

Because overcast and cloudy conditions commonly are between 6,000 and 8,000 degrees K, the Cloudy, twilight, sunset white

balance setting on the EOS 30D works adequately for overcast and cloudy conditions.

Tip *To learn more about light, visit Canon's Web site at* www. canon.com/technology/s_ labo/light/003/01.html.

Electronic flash

Most on-camera electronic flashes are balanced for the neutral color of midday light, or 5,500 to 6,000 degrees K. Because the light from an electronic flash is neutral, in the correct intensities, it reproduces colors accurately.

Flash obviously is useful in low-light situations, but it also is handy outdoors where fill-flash eliminates shadow areas caused by

4.4 The diffused light of a foggy day created a sense of multi-dimensionality to this scene. Taken at ISO 100, f/10, 1/40 sec. using a Canon EF 70-200mm f/2.8L IS, USM lens set to 105mm.

strong top lighting and provides detail in shadow areas for backlit subjects.

On the EOS 30D, the Flash white balance setting, which is set to 6,000 K, is the best option because it reproduces colors with high accuracy.

Tungsten light

Tungsten is the light commonly found in household lights and lamps. This light is warmer than daylight and produces a yellow/orange cast in photos that, in some cases, is valued for the warm feeling it lends to images.

Setting the EOS 30D to the Tungsten white balance setting retains a hint of the warmth of tungsten light while rendering colors with good accuracy. If you want neutral colors, set a custom white balance, or if you know the temperature of the bulbs, set the temperature using the K white balance option.

Fluorescent and other light

Commonly found in offices and public places, fluorescent light ranges from a yellow to a blue-green hue. Fluorescent light produces a green cast in photos when the white balance is set to daylight or auto.

Other types of lighting include mercury-vapor and sodium-vapor lights found in public arenas and auditoriums that have a green/yellow cast in unfiltered/uncorrected photos. You should set a custom white balance on the EOS 30D in this type of light or shoot a white-balance card so that you can balance to neutral during RAW-image conversion.

 Tip *You can learn more about setting custom white balance and using white or gray reference cards at* www.cambridgeincolour.com/tutorials/white-balance.htm.

Under fluorescent light, set the camera to the White fluorescent light setting (4,000 K). In stadiums, parking lots, and similar types of light, you may want to set a custom white balance.

Light from fire and candles creates a red/orange/yellow cast. In most cases, the color cast is warm and inviting and can be modified to suit your taste on the computer.

Metering Light

Your camera's reflective light meter sees only gray. Objects that you see as neutral gray, an even mix of black and white, reflect 18 percent of the light falling on them and absorb the rest of the light. In a black-and-white world, objects that you see as white reflect 72 to 90 percent of the light and absorb the remainder. Objects that you see as black absorb virtually all of the light. All other colors map to a percentage or shade of gray. Intermediate percentages between black and white reflect and absorb different amounts of light.

In color scenes, the light and dark values of color correspond to the swatches of gray on the grayscale. A shade of red, for example, has a corresponding shade of gray on a grayscale. The lighter the shade, the more light it reflects.

The camera's reflective light meter (which measures light that is reflected back to the camera from the subject) assumes that

everything is 18 percent gray. The meter expects to see an average scene, one that contains a balance of dark and light tones. In average scenes, the camera's meter produces an accurate rendition of what the human eye sees. However, in scenes with large expanses of snow, white sand, and black objects, you often get pictures with gray snow or gray graduation gowns that should have been black.

Colored surfaces reflect some color onto nearby objects. For example, if you photograph a person sitting in the grass, green is reflected into the subject. The closer the subject is to the grass, the more green is reflected in the subject's face. Similarly, photographing a subject under an awning or near a colored wall also results in that color reflecting onto the subject. The amount of reflectance depends on the proximity of the subject to the color and the intensity of the color. It's a good idea to keep this in mind when setting a custom white balance. Alternatively using a neutral gray or white card can make color correction easier.

So you must be aware not only of the color of the primary light, but also of surrounding structures that reflect onto the subject. Reflected color, of course, can make getting correct color in the image difficult. To avoid or minimize corrections, move the subject away from the surface that is reflecting onto the subject.

Additional Characteristics of Light

Photographers often describe light as harsh or soft. Harsh light creates shadows with well-defined edges. Soft light creates shadows with soft edges. There are traditional uses for each type of light. Understanding the effect of each type of light before you begin shooting is the key to using both types of light, and variations in between, effectively.

Hard/harsh light

Hard light is created when a distant light source produces a concentrated spotlight effect — such as, light from the sun in a cloudless sky at midday, an electronic flash, or a bare light bulb. Hard light creates dark, sharp-edged shadows as well as a loss of detail in highlights and shadows.

For example, portraits taken in harsh overhead light create dark, unattractive shadows under the eyes, nose, and chin. This type of light also is called contrasty light. Contrast is measured by the difference in exposure readings (f/stops) between highlight and shadow areas. The greater the difference is, the higher the contrast. Because hard light is contrasty, it produces well-defined textures and bright colors. Hard light is best suited for subjects with simple shapes and bold colors.

To soften hard light, you can add or modify light on the subject by using a fill flash or a reflector to bounce more light into shadow areas. In addition, you can move the subject to a shady area or place a scrim (diffusion panel) between the light and the subject. For landscape photos, you can use a graduated neutral density filter to help compensate for the difference in contrast between the darker foreground and brighter sky.

Soft light

Soft light is created when clouds or other atmospheric conditions diffuse a light

4.5 This image was made using studio strobes that were set up to provide bright, even illumination to emphasize the texture of the chopped nuts on the cake frosting. Taken at ISO 100, f/18, 1/125 sec. using a Canon EF 100mm, f/2.8 Macro USM lens.

source, such as the sun. Diffusion not only reduces the intensity (quantity) of light, but it also spreads the light over a larger area (quality). In soft light, shadow edges soften and transition gradually, texture definition is less distinct, colors are less vibrant than in harsh light, detail is apparent in both highlights and shadow areas of the picture, and overall contrast is reduced.

When working in soft light, consider using a telephoto lens and/or a flash to help create separation between the subject and the background. Soft light is usually well suited for portraits and macro shots, but it is less than ideal for travel and landscape photography. In these cases, look for strong details and bold colors, and avoid including an overcast sky in the photo.

Directional light

Whether natural or artificial, the direction of light can determine the shadows in the scene. Dark shadows on a subject's face under the eyes, nose, and chin result from hard, top light. You can use both the type and direction of light to reveal or hide detail, add or reduce texture and volume, and help create the mood of the image.

✦ **Front lighting.** Front lighting is light that strikes the subject straight on. This lighting approach produces a flat effect with little texture detail and with shadows behind the subject, as seen in many snapshots taken with an on-camera flash.

✦ **Side lighting.** Side lighting places the main light to the side of and at the same height as the subject. One side of the subject is brightly lit, and the other side is in medium or deep shadow, depending on the lighting setup. This technique is often effective for portraits of men, but it is usually considered unflattering for portraits of women.

However, a variation of side lighting is *high-side lighting*, a classic portrait lighting technique where a

4.6 Soft sunset light illuminated this pansy. Taken at ISO 100, f/8, 1/60 sec. using a Canon EF 100mm, f/2.8 Macro USM lens.

light is placed to the side of and higher than the subject.

✦ **Top lighting.** Top lighting, as the term implies, is light illuminating the subject from the top, such as you'd find at midday on a sunny,

cloudless day. This lighting produces strong, deep shadows. This lighting direction is suitable for some subjects, but it usually is not appropriate for portraits.

However, a variation on top lighting is *butterfly* or *Paramount* lighting, a technique popularized by classic Hollywood starlet portraits. Butterfly lighting places the key light high, in front of and parallel to the vertical line of the subject's nose to create a symmetrical, butterfly-like shadow under the nose.

✦ **Backlighting.** Backlighting is light that is positioned behind the subject. This technique creates a classic silhouette, and depending on the

4.7 Partial backlighting calls attention to the single cherry blossom in this image. Taken at ISO 100, f/8, 1/400 sec. using a Canon EF 24-105mm f/4.0L IS USM lens set to 105mm.

angle, also can create a thin halo of light that outlines the subject's form. Although a silhouette can be dramatic, the contrast obliterates details in both the background and subject. A fill flash can be used to show detail in the subject.

In addition, backlighting often produces lens flare displayed as bright, repeating spots or shapes in the image. Flare also can show up in the image as a dull haze or unwanted rainbow-like colors. To avoid lens flare, use a lens hood to help prevent stray light from striking the lens, or change your shooting position.

Tip

Although you may not be able to control the light, especially natural outdoor light, consider these items that may improve your shot:

✦ *Move the subject.*

✦ *Change your position.*

✦ *Use a reflector or scrim.*

✦ *Use a filter or change white balance settings to balance color for or enhance the light.*

✦ *Wait for better light or a light color that enhances the subject or message of the picture.*

Brush Up on Composition

Although the technical aspects of an image are important, image content and composition carry equal or greater weight. After all, a technically questionable image with a compelling subject and composition always aces a technically perfect image with a mundane subject and uninteresting composition. In this section of the book, you can brush up on composition guidelines and principles.

5.1 Composition is a skill that intrigues and challenges even the most experienced photographers. Taken at ISO 100, f/22, 1/125 sec. using a Canon EF 180mm, f/3.5L Macro USM lens.

Composition Basics

Composition is the aspect of photography that many photographers strive to master. Mastering composition, however, remains a challenge for many photographers. Composition principles can help you design an image, but in the end, your personal aesthetic is the final judge. After all, for every rule of composition, there are galleries filled with pictures that break the rules, and they succeed famously.

Composition can range from strikingly simple to complex, filled with layers of content and meaning. Most photographers would agree that simple compositions are best. Simple compositions offer the advantage of being easy for the viewer to "read," a characteristic that often makes images stronger than more complex compositions.

As a photographer, your eyes, your thoughts, and your sensibilities reveal and interpret each scene for the viewer. It's your job to combine your visual and emotional perceptions of a scene with the objective viewpoint of the camera. For practice, begin by standing back and evaluating all elements in the scene. Gradually narrow your view to see as the camera sees. With this exercise, you'll see isolated vignettes within the scene. Then continue this exercise by looking closely within the vignette to identify dominant elements, colors, patterns, and textures and think about how you can use them organize the visual information in the picture.

And before you begin shooting, ask and answer for yourself these questions:

✦ Why am I taking this picture?

✦ What do I want to tell the viewer with this picture, or what's the story?

If you don't ask and answer these questions, you run the risk of taking a picture that is visually difficult to read, and that has no message or content. Distilling the image to the message that you want to convey is the first and most important step in creating a well-composed image.

When you know the message or story of the image, some of the traditional composition guidelines detailed in this chapter can help you complete the picture.

5.2 This child's toy is an excellent example of simplicity in composition. Taken at ISO 100, f/22, 1/125 sec. using a Canon EF 180mm, f/3.5L Macro USM lens.

Understanding symmetry

Perfectly symmetrical compositions, images that are the balanced side to side or top to bottom, create a sense of balance and stability, but they also are often viewed as boring compositions. The human eye seeks symmetry and balance, and when it finds that symmetry, the interest in the composition diminishes. Further, symmetrical compositions usually offer less visual impact and intrigue than asymmetrical photos. There are several ways to achieve good symmetry in your photography.

Working with balance and tension

Balance is a sense of "rightness" in a photo. A balanced photo doesn't appear to be too heavy (lopsided) nor too off center. To create balance, you should evaluate the visual weight of colors and tones (dark is heavier than light), and placement (objects placed toward an edge appear heavier than objects placed at the center of the frame) in the scene. Then arrange the elements to create a visual balance — or a harmony when objects have equal visual strength.

5.3 The symmetry of this image, while intriguing, becomes too predictable to hold the viewer's interest.

5.4 The design of this city hall building provides strong lines and contrasting planes that give the image visual interest. Taken at ISO 100, f/11, 1/80 sec. using a Canon EF 16-35mm, f/2.8L, USM lens set to 17mm.

Contrasting balance is tension, or a state of imbalance or visual contrasts. Tension is created by having dissimilar objects of different sizes in the image. For example, having two people on one side of the frame and a tree on the other side creates visual contrast by its dissimilarity in size and shape. The tension can be resolved through the use of color and brightness in subjects and objects so that because of a bright or dark color one element gains attention.

Knowing what lines convey

Because lines have symbolic significance, you can use them to bolster communication, to direct focus, and to organize visual elements. For example, you can place a subject's arms in a way that directs attention to the face. You can use a gently winding river to guide the viewer's eye through a landscape photo. You can use a strong diagonal beam in an architecture shot to increase the sense of the building's strength.

Lines traditionally covey these meanings:

- ✦ **Horizontal.** Imply stability and peacefulness.
- ✦ **Diagonal.** Create strength and dynamic tension.
- ✦ **Vertical.** Imply motion and strength.
- ✦ **Curved.** Symbolize grace and movement.
- ✦ **Zigzag.** Convey a sense of action.
- ✦ **Wavy.** Imply peaceful movement.
- ✦ **Jagged.** Create tension.

Filling the frame

Just as an artist would not leave part of a canvas blank or filled with extraneous details, you should try to fill the full image frame with elements that support the message. If you ask the questions suggested earlier, the answers will help you decide how much of the scene you want to include in the frame. Every element you include should support and reveal more about the subject.

Try to eliminate surrounding elements that would distract the viewer's attention. Depending on the assignment or goal of the shoot, environmental elements also may need to be included for a lifestyle image or environmental portrait.

Checking the background

In any picture, the elements behind and around the subject become as much a part of the photograph as the subject, and occasionally more so because the lens tends to compress visual elements. As you compose the picture, check all areas in the viewfinder or LCD for background and surrounding objects that, in the final image, seem to merge with the subject, or that compete with or distract from the subject.

The classic example of failing to use this technique is the picture of a person who appears to have a telephone pole or tree growing out of the back of his head. To avoid this type of background distraction, move the subject or change your position.

5.5 This image demonstrates how filling the frame focuses attention on the subject without surrounding elements for distraction. Taken at ISO 100, f/4 at 1/40 sec. using a Canon EF 100mm, f/2.8 Macro USM lens.

Using the rule of thirds

A standard composition technique in photography is the rule of thirds. Imagine that a tic-tac-toe grid is superimposed on the viewfinder. The grid divides the scene into thirds vertically and horizontally. Often, the most interesting compositions are those that place the subject at one of the points of intersection or along one of the lines on the grid.

If you're taking a portrait, you might place a subject's eyes at the upper-left intersection point. In an outdoor photo, you can place the horizon along the top line to emphasize the foreground detail, or along the bottom line to emphasize a dramatic cloud formation. Using this type of grid also helps create

a sense of dynamic imbalance and visual interest in the picture.

In practice, you can use the following suggestions when composing different image types:

✦ If your main point of interest is a static spot, try placing the main point of interest at any one of the intersecting dividing lines.

✦ If the main point of interest is horizontal, or it is a horizon, try placing it along one of the horizontal dividing lines.

✦ If the main point of interest is vertical, try placing it along one of the vertical dividing lines.

5.6 This image roughly shows the grid you might envision when using the rule of thirds.

A similar approach is the Greek golden mean. Begin by drawing a line diagonally from the top-left corner of the frame to the bottom-right corner. Then draw a perpendicular line from the bottom-left corner to where it intersects with the diagonal line. Then draw a perpendicular line from the top-right corner of the frame to where it intersects with the diagonal line. These two points of intersection show where the center of interest should lie, particularly in portraits.

Composing with Color

Depending on how colors are used in a photo, they can create a sense of harmony and balance, or they can make bold, stimulating visual statements. To use colors in composition, remember that complementary colors are colors opposite each other on a color wheel, such as green and red or blue and yellow. Harmonizing colors are adjacent to each other on the color wheel, such as green and yellow or yellow and orange.

If you want a picture with strong visual punch, use complementary colors of approximately equal intensity in the composition. If you want a picture that conveys peace and tranquility, use harmonizing colors.

The more that the color of an object contrasts with its surroundings, the more likely it is that the object will become the main point of interest. Conversely, the more uniform the overall color of the image, the more likely it is that the color will dictate the overall mood of the image.

5.7 Bold colors create the visual interest and strength of this image. Taken at ISO 100, f/5.6, 1/800 sec. using a Canon EF 100mm, f/2.8 USM lens.

5.8 In this image, the red tulips form a visual frame for the yellow tulip in the midground. Taken at ISO 100, f/8, 1/400 sec. using a Canon 100mm, f/2.8 Macro USM lens.

The type and intensity of light both affect the intensity of colors and, consequently, the composition. Overcast weather conditions, haze, mist, and fog reduce the vibrancy of colors. These conditions are ideal for creating pictures with harmonizing, subtle colors. Vice versa, on a bright, sunny day, color is intensified and is ideal for composing pictures with bold color contrasts.

Photographers often borrow a technique from painters — putting a subject within a naturally occurring frame, such as a tree framed by a barn door or a distant building framed by an archway in the foreground. The frame may or may not be in focus, but to be most effective, it should add context or visual interest to the image.

Controlling Focus and Depth of Field

Because the human eye is drawn first to the sharpest part of the photo, be sure that the sharpest point of focus is on the subject, or part of the subject you want to emphasize, for example, a person's eyes. This focus establishes the relative importance of the elements within the image.

Differential focusing controls the depth of field or the zone (or area) of the image that is acceptably sharp. In a nutshell, differential focusing works like this: The longer the focal length is (in other words, a telephoto lens

or zoom setting) and the wider the aperture (the smaller the f-stop number), the less the depth of field (or the softer the background). Conversely, the wider the focal length and the narrower the aperture are, the greater the depth of field.

You can use this principle to control what the viewer focuses on in a picture. For example, in a picture with a shallow depth of field, the subject stands in sharp focus against a blurred background. The viewer's eyes take in the blurred background, but they return quickly to the much sharper area of the subject. You can virtually eliminate distractions behind the subject by using a very shallow depth of field.

To control depth of field, you can use the techniques listed in Table 5.1 separately or in combination with each other.

5.9 Changing your point of view can mean getting a new perspective by moving above the subject, shifting to a very low position, or moving to a side angle position. Taken at ISO 100, f/25, 1/125 using a Canon EF 100mm, f/2.8, Macro, USM lens.

Table 5.1
Depth of Field

To decrease depth of field (blur the background)	*To increase the depth of field (sharpen the appearance of the background)*
Choose a telephoto lens or zoom setting.	Choose a wide-angle lens or zoom setting.
Choose a wide aperture, for example, f/1.4 to f/4.	Choose a narrow aperture, for example, f/11 to f/22.
Move closer to the subject.	Move farther away from the subject.

Additional Composition Techniques

In addition to the traditional guidelines, you can compose images using strong textures, repeated patterns and geometric shapes, and color repetition or contrasts to compose images. These elements can create a picture themselves, or you can use them to create visual motion that directs the eye or supports the subject.

Other techniques to keep in mind include:

✦ **Change your point of view.** Instead of routinely photographing subjects at eye level, try changing the viewpoint. For example, if you photograph a subject from a position lower than eye level, the subject seems powerful, while a position higher than eye level creates the opposite effect.

✦ **Use tone and contrast.** You can use contrast — the difference in light and dark tones in a photograph — to set off your subject. A small, white flower appears more distinct against a large, dark wall than it does against a bright, light-colored wall.

5.10 The clouds over the mountains, the contrast and tones of the mountains, and the framing of dark clouds at the top of this frame provide a sense of depth. Taken at ISO 100, f/9 at 1/500 sec. using a Canon EF 70-200mm, f/2.8 IS, USM lens set to 145mm.

✦ **Define space and perspective.**
You can control the perception of space in pictures by changing the distance from the camera to the subject, selecting a telephoto or wide-angle lens or zoom setting, changing the position of the light, and changing the camera position. For example, camera-to-subject distance creates a sense of perspective and dimension so that when the camera is close to a foreground object, background elements in the image appear smaller and farther apart. A wide-angle lens also makes near objects seem proportionally larger than midground and background objects.

✦ **Use leading lines.** Naturally occurring lines in an image can be used to lead the viewer's eyes from the foreground to the background. This technique is often used in landscape photos where the lines of a railroad track converge on a distant horizon, or a gracefully curving river meanders into the distance. But the technique is equally useful in portraits and other types of photography. For example, in a portrait, you can position the subject's arms and hands so that they lead the viewer's eyes to the subject's face.

Knowing the rules provides a good grounding for well-composed pictures, but Henri Cartier-Bresson summed it up best when he said, "Composition must be one of our constant preoccupations, but at the moment of shooting it can stem only from our intuition, for we are out to capture the fugitive moment, and all the interrelationships involved are on the move. In applying the Golden Rule, the only pair of compasses at the photographer's disposal is his own pair of eyes" (from *The Mind's Eye* by Henri Cartier-Bresson).

Selecting and Using Lenses

T he lens is the eye of the camera, so don't underestimate the importance of quality lenses. With a high-quality lens, pictures have stunning detail, high resolution, and snappy contrast. Conversely, low-quality optics produce marginal picture quality.

This chapter takes a look at the lenses available to help you make decisions about which additional lenses you'd like to add to your system for the type of photography you most enjoy.

Understanding the Focal Length Multiplication Factor

The EOS 30D image sensor is 1.6 times smaller than a traditional 35mm film frame. It is important to know the sensor size because it not only determines the size of the image, but it also affects the angle of view of the lenses you use. A lens's angle of view is how much of the scene, side-to-side and top-to-bottom, that the lens includes in the image.

The angle of view for all lenses you use on the Canon EOS 30D is narrowed by a factor of 1.6 times at any given focal length, giving an image equal to that of a lens with 1.6 times the focal length. That means that a 100mm lens on a 35mm film camera becomes the equivalent to a 160mm on the EOS 30D. Likewise, a 50mm normal lens becomes the equivalent of an 80mm lens, which is equivalent to a short telephoto lens on a full-35mm-frame size.

Note *The EF-S 18-55mm lens is usable only on the smaller image size cameras, including the EOS 30D, due to a redesigned rear element that protrudes back into the camera body.*

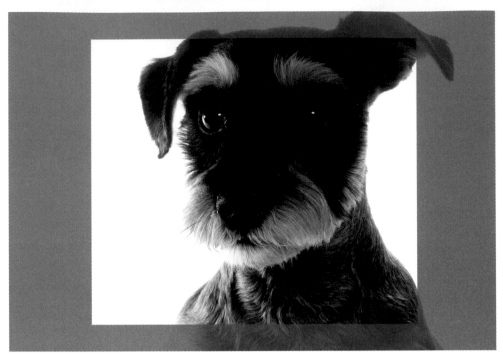

6.1 This image shows the approximate difference in image size between a 35mm film frame and the Canon EOS 30D. The smaller image size represents the EOS 30D's image size.

This focal-length multiplication factor works to your advantage with a telephoto lens because it effectively increases the lens's focal length (although technically the focal length doesn't change—that's why I qualified it with "effectively"). And because telephoto lenses tend to be more expensive than other lenses, you can buy a shorter and less expensive telephoto lens and get 1.6 times more magnification at no extra cost.

The focal length multiplication factor works to your disadvantage with a wide-angle lens because the sensor sees less of the scene when the focal length is magnified by 1.6. But, because wide-angle lenses tend to be less expensive than telephoto lenses, you can buy an ultra-wide 14mm lens to get the equivalent of an angle of view of 22mm.

Because telephoto lenses provide a shallow depth-of-field, it seems reasonable to assume that the conversion factor would produce the same depth-of-field results on the EOS 30D that a longer lens gives. That isn't the case, however. Although an 85mm lens on a full-35mm-frame camera is equivalent to a 136mm lens on the EOS 30D, the depth of field on the EOS 30D matches the 85mm lens, not the 136mm lens.

This depth-of-field principle holds true for enlargements. The depth of field in the print is shallower for the longer lens on a full-frame camera than it is for the EOS 30D.

Lens Choices

Lenses range in focal lengths (the amount of the scene included in the frame) from fisheye to super telephoto and are generally grouped into three main categories: wide angle, normal, and telephoto. There are also macro lenses that serve double-duty as either normal or telephoto lenses as well as offering macro capability.

Wide angle

Wide-angle lenses offer a wide view of a scene. Lenses shorter than 50mm are commonly considered wide angle on full-frame 35mm image sensors. For example, 16mm and 24mm lenses are wide angle. A wide-angle lens also offers sharp detail from foreground to background, especially at narrow apertures such as f/22. The amount of reasonably sharp focus front to back in an image is referred to as *depth of field*.

 Cross-Reference *Depth of field is discussed in more detail in Chapter 3.*

Normal

Normal lenses offer an angle of view and perspective very much as your eyes see the scene. On full 35mm-frame cameras, 50mm to 55mm lenses are considered normal lenses. Normal lenses provide extensive (wide?-yes) depth of field (particularly at *narrow apertures*) and are compact and versatile.

Telephoto

Telephoto lenses offer a narrow angle of view, enabling close-up views of distant scenes. On full 35mm-frame cameras, lenses with focal lengths longer than 50mm are considered telephoto lenses. For example, 80mm and 200mm lenses are telephoto

6.2 The EOS 30D offers even more creative options with the selection of Canon lenses including the EF and EF-S series.

6.3 A wide-angle lens captures the action of this scene as a float plane is moved to the water for takeoff. This image was taken with a zoom lens set to 40mm, which is equivalent to 64mm on the EOS 30D. As a result of the focal length multiplication factor on the 30D, less of the scene is included than would be on a full-frame camera.

lenses. Telephoto lenses offer shallow depth of field and provide a softly blurred background, particularly at wide apertures, and a closer view of distant scenes and subjects.

Macro

Macro lenses are designed to provide a closer lens-to-subject focusing distance than non-macro lenses. Depending on the lens, the magnification ranges from half-life size (0.5x) to 5x magnification. Thus, objects as small as a penny or a postage stamp can fill the frame, revealing breathtaking details that are commonly overlooked or not visible to the human eye. By contrast, non-macro lenses typically allow maximum magnifications of about one-tenth life size (0.1x). Macro lenses are single focal-length lenses that come in normal and telephoto focal lengths.

6.4 A normal lens captures the size relationships of various items in the scene much as your eyes see them. This picture was taken with a 50mm lens.

6.5 The Canon EF 70-200mm f/2.8L, IS, USM telephoto zoom lens brought this farm and mountain scene closer. The exposure was ISO 100, f/9, 1/400 sec.

6.6 A macro lens captures extreme close-ups such as this picture of a cinnamon roll that was taken with a Canon EF 100mm f/2.8 Macro USM lens. The exposure for this image was ISO 100, f/5.6 at 1/10 sec.

About Zoom Lenses

In addition to the basic lens categories, you can also choose between zoom and single-focal-length (also called prime) lenses. Zoom lenses offer a range of focal lengths in a single lens allowing you the equivalent of having three or four single-focal length lenses in one lens. In addition, zoom lenses are able to maintain focus during zooming. Zoom lenses are available in wide-angle and telephoto ranges.

For example, in a wide-angle zoom lens with two lens groups, the first group has negative refraction (divergence), and the second group has positive refraction (convergence). The lens is designed with retro-focus construction. Further, to solve various limitations of this design, to keep the lens size compact, and to compensate for aberrations with fewer lens elements, most lenses use a multi-group zoom with three or more movable lens groups.

Some zoom lenses are slower than single-focal length lenses, and getting a fast zoom lens usually comes at a higher price. In addition, some zoom lenses have a variable aperture which means that the minimum aperture changes at different zoom settings (discussed in the following sections).

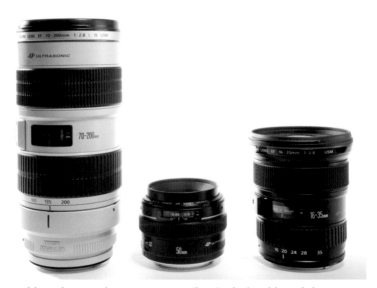

6.7 Although zoom lenses are versatile, single-focal-length lenses are often smaller and lighter. The Canon EF 50mm f/1.4 lens, shown in the center, is one of the lightest and still most versatile lenses in Canon's lineup.

Zoom lens advantages

The obvious advantage of a zoom lens is the ability to quickly change focal lengths, and image composition, without changing lenses. In addition, only two or three zoom lenses are needed to encompass the focal range you use most often for everyday shooting. For example, carrying a Canon EF-S 17-55mm IS USM lens and a Canon EF 55-200mm f/4.5-5.6 II USM lens, or a similar combination of L-series lenses, provides the focal range needed for most everyday shooting.

Of course, a zoom lens also offers the creative freedom of changing image composition with the turn of the zoom ring — all without changing your shooting position or changing lenses. Most mid-priced and more expensive zoom lenses offer high-quality optics that produce sharp images with excellent contrast.

Zoom lens disadvantages

Although zoom lenses allow you to carry around fewer lenses, they tend to be heavier than their single-focal-length counterparts. Mid-priced, fixed-aperture zoom lenses tend to be *slow*, meaning that with maximum apertures of only f/4.5 or f/5.6, they call for slower shutter speeds that limit your ability to get sharp images when handholding the camera.

Some zoom lenses have variable apertures. If a variable-aperture f/4.5 to f/5.6 lens has an aperture of f/4.5 at the widest focal length, it has an aperture of f/5.6 at the telephoto end. Unless you use a tripod or your subject is stone still, your ability to get a crisp picture in lower light at f/5.6 will be questionable.

 Cross-Reference *For a complete discussion on aperture, see Chapter 3.*

More expensive zoom lenses offer a fixed and fast maximum aperture, meaning that with maximum apertures of f/2.8, they allow faster shutter speeds that enhance your ability to get sharp images when handholding the camera. But the lens speed comes at a price: The faster the lens is, the higher the price.

About Single Focal Length Lenses

Long the mainstay of photographers, single-focal-length lenses offer only one focal length. Single-focal-length lenses such as Canon's venerable EF 50mm f/1.4 USM lens, EF 100mm f/2.8 Macro USM, and other lenses are also called prime lenses. To change image composition, you must move closer to or farther from your subject, or change lenses. Single-focal-length lenses are typically fast lenses that do not offer Image Stabilization (IS), and that offer excellent sharpness and contrast.

Depending on the lens type, Canon single-focal-length lenses offer aspherical, fluorite, UD glass, super UD glass, and high-refraction glass for optical clarity, sharpness, and image performance. Multiple coatings help prevent ghosting and provide accurate color balance. Lenses are analyzed to ensure that the *bokeh*, or out-of-focus area of the image, appears natural and pleasing. All Canon lenses offer the option of full-time manual focus as well as Ultrasonic motors (USM) for quiet operation of the autofocus drive mechanism.

Single-focal-length lens advantages

Unlike zoom lenses, single-focal-length (prime) lenses tend to be fast with maximum apertures of f/2.8 or wider. Wide apertures allow fast shutter speeds, and that combination allows you to handhold the camera in lower light and still get a sharp image. Compared to zoom lenses, single-focal-length lenses are lighter and smaller.

In addition, many photographers believe that single-focal-length lenses are sharper and provide better image quality overall than zoom lenses.

Single-focal-length lens disadvantages

Most prime lenses are lightweight, but you need more of them to cover the range of focal lengths needed for everyday photography, although some famous photographers

used only one prime lens. Single-focal-length lenses also limit the options for on-the-fly composition changes that are possible with zoom lenses.

Using Wide-Angle Lenses

A wide-angle lens is great for capturing scenes ranging from large groups of people to sweeping landscapes, as well as for taking pictures in places where space is cramped.

When you shoot with a wide-angle lens, keep these lens characteristics in mind:

✦ **Extensive depth of field.**
 Particularly at small apertures such as f/8 or f/11, the entire scene, front to back, will be in reasonably sharp focus. This characteristic gives you slightly more latitude

6.8 Wide-angle zoom lenses such as the Canon EF 16-35mm f/2.8L USM lens are ideal for the smaller sensor size of the EOS 30D. Here the lens is set to 26mm to capture the front of a local winery. Taken at ISO 100, f/8, 1/60 sec.

for less-than-perfectly focused pictures.

✦ **Narrow, fast apertures.** Wide-angle lenses tend to be faster (meaning they have wide apertures) than telephoto lenses. These lenses are good candidates for everyday shooting even when the lighting conditions are not optimal.

✦ **Distortion.** Wide-angle lenses can distort lines and objects in a scene, especially if you tilt the camera up or down when shooting. For example, if you tilt the camera up to photograph a group of skyscrapers, the lines of the buildings tend to converge and the buildings appear to fall backward (also called *keystoning*). You can use this wide-angle lens characteristic to creatively enhance a composition, or you can avoid it by moving back from the subject and keeping the camera parallel to the main subject. Some wide-angle lenses also can produce images that tend to be soft along the edges.

Tip *To avoid keystoning, you can insert a small bubble level on the hot shoe to ensure that the camera is level. Keystoning and other lens distortions can often be corrected during photo editing; however, it is always better to avoid problems when shooting than fixing problems afterward.*

✦ **Perspective.** Wide-angle lenses make objects close to the camera appear disproportionately large. You can use this characteristic to move the closest object farther forward in the image, or you can move back from the closest object to reduce the effect. Wide-angle lenses are not suitable for close-up

portraits because they exaggerate the size of facial features closest to the lens.

Tip *If you're shopping for a wide-angle lens, look for aspherical lenses. These lenses include a non-spherical element that helps reduce or eliminate optical flaws to produce better edge-to-edge sharpness and reduce distortions.*

Using Telephoto Lenses

Choose a telephoto lens to take portraits and to capture distant subjects such as birds, buildings, wildlife, and landscapes. Telephoto lenses such as 85mm and 100mm are perfect for portraits, while longer lenses (300mm to 800mm) allow you to keep a safe distance while photographing wildlife. When you use a telephoto lens with a wide aperture such as f/4.0, the shallow depth of field can make near objects much less obvious.

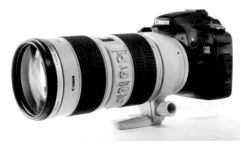

6.9 Telephoto lenses are larger and heavier than other lenses, but a good telephoto zoom lens is indispensable for photographers. This 70-200mm lens also features Image Stabilization, IS (a Canon trademark), that helps counteract slight movement when handholding the camera.

When you shoot with a telephoto lens, keep these lens characteristics in mind:

✦ **Shallow depth of field.** Telephoto lenses magnify subjects and provide a very limited range of sharp focus. At wide apertures, such as f/4, you can reduce the background to a soft blur. Because of the extremely shallow depth of field, pay attention to careful focus. Canon lenses include full-time manual focusing that you can use to fine-tune the camera's autofocus.

✦ **Narrow coverage of a scene.** Because the angle of view is narrow with a telephoto lens, much less of the scene is included in the image. You can use this characteristic to exclude distracting scene elements from the image.

✦ **Slow lenses.** Mid-priced telephoto lenses tend to be slow; the widest aperture is often f/4.5 or f/5.6, which limits the ability to get sharp images without a tripod in all but the brightest light. And because of the magnification factor, even the slightest movement is exaggerated.

✦ **Perspective.** Telephoto lenses tend to compress perspective, making objects in the scene appear stacked together.

If you're shopping for a telephoto lens, look for those with low-dispersion lens elements that help reduce distortion and improve sharpness. Image Stabilization further counteracts blur caused by handholding the camera.

Using Normal Lenses

A normal lens is a great walk-around lens for everyday shooting. On a 35mm film

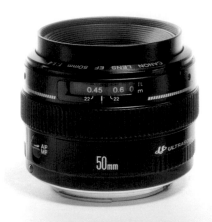

6.10 A normal lens is small and light. It provides an angle of view similar to that of the human eye.

camera, it is 50mm, but on the EOS 30D, a 35mm lens is closer to normal when the focal-length conversion factor is considered.

Normal lenses are lightweight and offer fast apertures. In addition, normal lenses seldom have issues with optical distortion, and they produce pictures with a pleasing perspective. Normal lenses are reasonably priced and offer sharp images with excellent contrast.

Using Macro Lenses

Macro lenses open a new world of photographic possibilities by offering an extreme level of magnification. In addition, the reduced focusing distance allows beautiful, moderate close-ups as well as extreme close-ups of flowers and plants, animals, raindrops, and everyday objects.

Normal and telephoto lenses offer macro capability. Because these lenses can be

used both at their normal focal length as well as for macro photography, they do double-duty.

Canon offers macro lenses in the following focal lengths:

✦ 50mm, f/2.5 Compact Macro (0.5x magnification). A Life-Size Converter EF is also available for the EF 50mm Compact Macro lens.

✦ EF-S 60mm f/2.8 Macro USM lens (1:1 magnification).

✦ 100mm f/2.8 Macro USM and 180mm f/3.5L Macro USM (1:1 magnification).

✦ MP-E 65mm f/2.8 Macro Photo (1x-5x magnification).

When you shoot with a macro lens, keep these characteristics in mind:

✦ **Extremely shallow depth of field.** At 1:1 magnification, the depth of field is less than 1mm at maximum aperture. The shallow depth of field makes focusing critical; even the slightest change to the focusing ring can throw the picture out of focus.

✦ **High magnification.** With extremely high magnification, any movement causes blur. Always use a tripod and cable release or remote to release the shutter.

If you're buying a macro lens, you can choose lenses by focal length or by magnification. If you want to photograph moving subjects such as insects, choose a telephoto lens with macro capability. Moving subjects require special techniques and much practice.

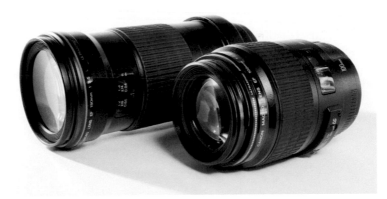

6.11 Canon offers several macro lenses including the EF 180MM f/3.5L Macro USM that offers 1x (life-size) magnification and a minimum focusing distance of 0.48m/1.6 ft. This focusing distance is great for small objects such as insects where a longer working distance is desirable. Also shown here is the Canon EF 100 f/2.8 Macro, USM lens.

 Cross-Reference *For ideas on using macro lenses, see Chapter 7.*

Based on focal length and magnification, choose the lens that best suits the kinds of subjects you want to photograph.

Extending the Range of Any Lens

For relatively little cost, you can increase the focal length of any lens by using an *extender*. An extender is a lens set in a small ring mounted between the camera body and a regular lens. Canon offers two extenders, a 1.4x and 2x, that are compatible with L-series Canon lenses. Extenders can also be combined to get even greater magnification.

For example, using the Canon EF 2xII extender with a 600mm lens doubles the lens's focal length to 1200mm before applying 1.6x. Using the Canon EF 1.4II extender increases a 600mm lens to 840mm.

 Tip *At longer focal lengths, it is critical to stabilize the camera on a tripod.*

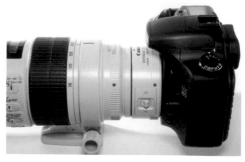

6.12 Extenders, such as this Canon EF 1.4 II mounted between the camera body and the lens, extend the range of L-series lenses. They increase the focal length by a factor of 1.4x, in addition to the 1.6x focal-length conversion factor inherent in the camera.

Extenders generally do not change camera operation in any way, but they do reduce the light reaching the sensor. The EF 1.4xII extender decreases the light by one f-stop, and the EF 2xII extender decreases the light by two f-stops. And, in addition to being fairly lightweight, the obvious advantage of extenders is that they can reduce the number of telephoto lenses you carry.

Techniques for Great Photos

A World of Subjects

I n this section of the book, you can explore a wide variety of photography specialty areas and subjects and see real examples of how the EOS 30D performs in the field with each subject.

Action and Sports Photography

With a burst rate of between approximately 30 and 11 frames with smart buffering in High-speed Continuous Drive mode, the 30D allows for fast-action shooting, and the focal length multiplication factor of 1.6x brings the action close in with telephoto lenses. For example, using the Canon EF 70-200mm f/2.8L IS USM lens effectively provides a 112-320mm equivalent focal length. And with shutter speeds ranging from 1/8000 to 30 sec., the camera offers ample opportunity to either freeze or show action.

Of course, the difference in technique is primarily a result of shutter speed. Fast shutter speeds freeze motion, and slow shutter speeds show motion as a blur. In addition, with a slow shutter speed, if you move or pan the camera to follow the subject, you can blur background elements while keeping part of the subject in reasonably good focus.

Inspiration

Sports photography encompasses the entire range of sports activities from volleyball and skiing to car racing. Action subjects cover an even broader range — everything from children playing to puppies romping in the yard to people walking on the street.

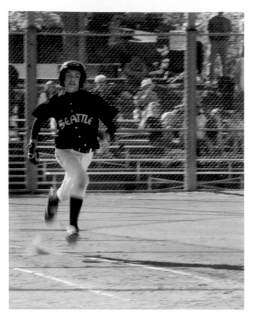

7.2 The juxtaposition of players running in different directions plays off the static baseman to the left of the frame. Taken at ISO 100, f/11 at 1/50 sec. using Normal Picture Style and Aperture-priority mode with a Canon EF 70-200mm f/2.8L IS USM set to 200mm.

7.1 For this shot, a relatively slow shutter speed shows blurred motion. Taken at ISO 100, f/11 at 1/60 sec. using Standard Picture Style and Aperture-priority mode with a Canon EF 70-200mm f/2.8L IS USM set to 200mm.

As you take sports and action photos, it's important to master the techniques of freezing or showing blurred motion and capture the emotion and sense of being "in the moment."

Taking action and sports photographs

7.3 Panning, used here, is a technique that is often effective to enhance the sense of speed and motion.

Table 7.1
Action and Sports Photography

Setup	**In the Field:** The image in figure 7.3 was taken at a bike trail. I set the camera on High-speed Continuous Drive mode to help ensure that I got the fastest frame rate possible.
	Additional Considerations: Find a good shooting position with a colorful, non-distracting background. If you are shooting athletes, set up the camera and pre-focus on a spot where they will pass. Then as the athletes enter the frame, press the shutter button. Or you can pan, or move, the camera with the athlete's motion to blur the background. In bright light, setting a negative exposure compensation of -1 or -2 Exposure Values (EV) can help avoid blowing detail from highlight areas in the image.
Lighting	**In the Field:** This was taken in late afternoon sunlight with a narrow aperture and slow shutter speed to blur motion.
	Additional Considerations: Moderate light is ideal for showing action blur, although motion blur shows in bright light as well.
Lens	**In the Field:** Canon EF 70-200mm f/2.8L IS USM lens set to 70mm.
	Additional Considerations: The lens you choose depends on the subject you're shooting. If a telephoto lens is appropriate for the shot, it provides a greater softness to the background and to the blur if you're panning.
Camera Settings	**In the Field:** RAW capture, Aperture-priority AE mode with the white balance set to Daylight, High-speed Continuous Drive mode.
	Additional Considerations: To control shutter speeds, use Shutter-priority AE mode and set it to 1/30 second or slower. In mixed-light situations, I recommend using AWB or setting a custom white balance for venues such as stadiums you shoot in frequently, or shooting a gray card and for RAW capture, and balancing the image series from the gray card.
Exposure	**In the Field:** ISO 100, f/25, 1/25 sec., Aperture-priority AE mode.
	Additional Considerations: You may need to experiment to get the shutter speed that shows motion blur and the f-stop that gives you the depth of field you want. You can generally show motion blur at 1/30 second and slower shutter speeds.
Accessories	At slower shutter speeds a tripod or monopod ensures that the subject is sharp.

Action and sports photography tips

✦ **Capture the thrill.** Regardless of the technique you choose to shoot action photos, set a goal of showing the emotion, thrill, speed, or excitement of the scene in your pictures. You want the kind of picture where people look at it and say, "Wow!"

✦ **Take a high shooting position.** Move back to the fourth or fifth row at sporting events, and use the additional height to your advantage. Leave room enough for your monopod or tripod. If you have a lens extender, take a few test shots with and without the extender to see whether the loss of light is worth the extended focal length (for example, a 2x extender costs you two f-stops). This loss of light may mean that you can't get a fast enough shutter speed to freeze motion.

✦ **Find a well-lit spot and wait.** If lighting varies dramatically across the sports field and you find it difficult to continually change the exposure or white balance, find the best-lit spot on the playing field or court, set the exposure for that lighting, and then wait for the action to move into that area.

✦ **Experiment with shutter speeds.** To obtain a variety of action pictures, vary the shutter speed between 1/30 and 1/1000 second. At slower shutter speeds, part of the subject will show motion, such as a player's arm swinging.

✦ **Shoot locally.** If you're new to shooting sports, consider photographing high school and local amateur events. These are good places to hone your reflexes and composition. And usually you will be under fewer restrictions, be able to get closer to the athletes, and have fewer fans to contend with.

Architectural and Interior Photography

Architecture mirrors the culture and sensibilities of each generation. New architecture reflects the hopeful aspirations of the times, while older structures often are valued for the nostalgic memories they evoke. For photographers, photographing both new and old architecture provides rich photo opportunities to update portfolios and as a specialty area for commercial work.

Architectural photography is photographing a sense of place and space. The challenge with the EOS 30D, given the smaller sensor size, is getting the scope of the exterior or interior. Canon offers a range of wide-angle lenses, including the ultra-wide 14mm prime lens, which gives the equivalent of approximately 22mm on the EOS 30D to wide-angle zoom lenses such as the EF-S 10-22mm f/3.5-4.5 USM designed for the smaller sensor size, or the L-series 16-35mm f/2.8 USM, which is equivalent to 25-56mm on the EOS 30D. Edge sharpness is always important to watch for, so if you

About Wide-Angle Distortion

Both wide-angle and telephoto lenses are staple lenses in architectural photography. When you use a wide-angle lens at close shooting ranges, and especially when the camera is tilted upward, the vertical lines of buildings converge toward the top of the frame. You can correct the distortion in an image-editing program, or you can use a tilt-and-shift lens, such as the Canon TS-E24mm f/3.5L, that corrects perspective distortion and controls focusing range. Shifting raises the lens parallel to its optical axis and can correct the wide-angle distortion that causes the converging lines. Tilting the lens allows greater depth of focus by changing the normally perpendicular relationship between the lens's optical axis and the camera's sensor.

To use a tilt-and-shift lens, you set the camera so that the focal plane is parallel to the surface of the building wall. As the lens is shifted upward, it causes the image of the wall's surface to rise vertically, thus keeping the building shape rectangular.

routinely allow extra space on the left and right edges, the widest angle prime and zoom lenses are the best choices for architectural and interior photography.

Tip *When foreground elements mirror the architecture, be sure to include them in the composition. For example, if a nearby metal sculpture echoes the glass and steel design of the building, include all or part of the sculpture for foreground interest.*

If you're new to architectural shooting, choose a building and spend time studying how light at different times of the day transforms the character of the building. Look for structural details and visual spaces that create interesting shadow plays, reflections, and patterns as they interact with other subsections of the structure. Most importantly, architectural photographers must play well with the marketing team and deliver images that visually communicate the client's message and goal.

Most buildings are built for people, and people contribute to the character of the building. In a compositional sense, people provide a sense of scale in architectural photography, but more importantly, they imbue the building with a sense of life, motion, energy, and emotion.

7.4 This is one of a series of exterior and interior shots of a newly constructed city hall. Taken at ISO 100, f/8 at 1/50 sec., Normal Picture Style using Aperture-priority AE mode and the Canon EF 16-35mm f/2.8L lens set to 16mm (equivalent to 25.6mm).

7.5 Using bright midday sun at this California hotel, I took a high shooting position to get the broad sweep of the hotel and kept the camera level with the building to avoid distortion. Taken at ISO 100, f/16 at 1/125 sec. using Aperture-priority AE mode and the Canon EF 24-70mm f/2.8L USM lens set to 25mm.

The umbrella of architectural photography includes interior photography of both commercial and private buildings and homes. Light also plays a crucial role in creating compelling interior images. Portable strobe packs and multiple wireless flash units can supplement interior lighting. It's also possible to get pleasing interior shots by using existing room lighting and window lighting.

Inspiration

Go inside buildings and look for interior design elements that echo the exterior design. Then create a series of pictures that explain the sense of place and space. Find old and new buildings that were designed for the same purposes — courthouses, barns, cafes and restaurants, libraries, or train stations, for example. Create a photo story that shows how design and use have changed over time. As you shoot, study how the building interacts with surrounding structures. See if you can use juxtapositions for visual comparisons and contrasts.

7.6 I used the stone features in this waiting area as a thematic element throughout a series of images on this building. Taken at ISO 100, f/2.8 at 1/15 sec. using Aperture-priority AE mode and a Canon EF 16-35mm f/2.8L USM lens set to 16mm.

As you consider buildings and interiors, always try to verbalize what makes the space distinctive. When you can talk about the space, you can begin to think about ways that will translate your verbal description into visual terms. Many new structures include distinctive elements such as imported stone, crystal abstract displays, and so on. Be sure to play up the unique elements of exteriors and interiors. Very often, you can use these features as a theme that runs throughout a photo story.

Taking architectural and interior photographs

7.7 This shot of the new Redmond, WA City Hall served as an establishing shot for a series of interior and exterior images of the building.

Table 7.2
Architectural and Interior Photography

Setup	**In the Field:** One of the compelling architectural elements of the city hall building shown in figure 7.7 is the imported granite that comprises one side of the building. The other side is contrasted by a reflecting pool with large crystals suspended over the pool. The granite wall is the most compelling feature, so I concentrated my main shots on the granite wall. **Additional Considerations:** Study the building or space and look for the best details. Will details be best pictured straight on or from the side? Can you isolate repeating patterns that define the style? Consider contrasting ultra-modern buildings with older, nearby buildings. Frame architectural images carefully to include only the detail or structures that matter in the image.

Continued

Table 7.2 *(Continued)*

Lighting	**In the Field:** Scheduling considerations put the shooting at midday — not the best time to show off the warm tones of the granite. However, the light emphasized the oblique angles of the building — part of its distinctive design. A warming filter can also be added in Photoshop to warm the cool shadows of the granite.
	Additional Considerations: Older buildings often look especially good photographed in golden late-afternoon light, but you can also take advantage of sunny weather to show off the bold details and angular design of modern buildings. For mirrored buildings, reflections cast by nearby sculptures, passing clouds, and passing people can sometimes add interest.
Lens	**In the Field:** Canon EF-S 18-55mm lens zoomed to 16mm.
	Additional Considerations: Zoom lenses are helpful in isolating only the architectural details that you want while excluding extraneous objects such as street signs. If you use a wide-angle lens and want to avoid distortion, keep the camera on a level plane with the building and avoid tilting the camera up or down. Alternately, you can use a tilt-and-shift lens, or you can correct lens distortion in Adobe Photoshop.
Exposure	**In the Field:** ISO 100, f/11, 1/100 sec., Aperture-priority mode, Standard Picture Style, RAW capture mode.
	Additional Considerations: In high-dynamic range scenes, try multiple exposures using either bracketing or by metering and capturing separate images for highlights, midtones, and shadows, and then composite the images in Photoshop to get a greater dynamic range than the sensor can provide. If you use this technique, be sure to use a tripod and keep the camera in the exact same position throughout the bracketed shots. Otherwise, the three images will not register when you combine them in Photoshop.
Accessories	A polarizing filter is an excellent way to reduce or eliminate glare from glass and mirrored building surfaces. In addition, it also enhances color contrast.

Architectural photography tips

✦ **Emphasize color and lines.** If the building you're photographing features strong, vivid colors, emphasize the colors by shooting in bright midday sunlight. Find a shooting position that allows you to show off the dynamic lines and shapes of the building or interior.

✦ **Use surrounding elements to underscore the sense of place and space.** For example, a

university building's design that incorporates gentle arches might be photographed through an archway leading up to the entrance. Or if the area is known for something such as an abundance of dogwood trees, try including a graceful branch of blossoms at the top and side of the image to partially frame the structure. Keep surrounding elements to a minimum to avoid distraction from the main subject.

✦ **Try A-DEP mode.** If your photograph shows a succession of buildings from an angle that puts them in a stair-stepped arrangement, use A-DEP mode to get the optimal depth of field.

✦ **For low-light and night exterior and interior shots, turn on long-exposure noise reduction using C.Fn-02.** Immediately after the initial exposure, the camera creates a dark frame to reduce noise. Using this feature slows down the shooting process, but it provides the best insurance against objectionable levels of digital noise in images.

✦ **Check out the American Society of Media Photographers Web site at** www.asmp.org. The ASMP has a special interest group for architectural photography that includes a guide for working with architectural photographers.

Black-and-White Photography

In 100-plus-year-old tradition, black-and-white photography remains one of the most popular renderings for images, whether film or digital. Whether you work in fine-art, wedding, or portraiture photography, clients will inevitably want black-and-white images, and as an artist, the draw of black-and-white is compelling for photographers as well.

For the uninitiated, creating black-and-white photos would seem to be as easy as desaturating a color image. However, creating black-and-white images requires a different way of viewing a scene. Instead of looking at color contrast, the photographer who aims for classic black-and-white images must judge scenes in terms of textures, tonal ranges, forms, and shapes and remain oblivious to the distraction of colors. And in the studio, lights become brushes to heighten or subdue the form, shape, and substance of the subject by controlling the levels of contrast with light.

7.8 This image of a black-and-silver miniature Schnauzer was converted to black and white in Canon Digital Photo Professional. Taken at ISO 100, f/22, 1/125 sec using a Canon Ef 50mm, f/1.4 lens.

Thanks to RAW processing, you can create extremely high-quality black-and-white images using conversion programs such as Canon's Digital Photo Pro or Adobe Camera Raw. And in the process, you can apply the look of traditional filters such as red, yellow, orange, green, and blue to enhance and distinguish among colors in the image. For example, using a green filter lightens green in the image.

 Cross-Reference *For more information on using color filters with black-and-white images, see Chapter 2.*

The Canon EOS 30D offers a Monochrome Picture Style with the option to apply color filter effects to the image. And if you are accustomed to using Deep Red or Deep Yellow color filters, you can set a plus contrast setting for the Picture Style to increase the effect of the filter.

If you shoot RAW images, you can convert to the Monochrome picture style during the conversion and apply the filter effects or toning effects at the same time.

Note *When you shoot RAW images in Monochrome Picture Style, you can convert them to color using the program supplied on the Canon installation disk. However, you cannot convert JPEG images captured in Monochrome Picture Style after capture.*

Inspiration

If you want to emphasize the impression of texture, be certain that the focus is tack sharp by using a narrow aperture and a tripod. To emphasize contrast in black-and-white images, look for scenes where there is

excellent tonal contrast between the subject and the background.

In black-and-white photography, you can't rely on color to create the mood of an image. Instead rely on strong lighting and control over the tonal range. Black-and-white photography is uniquely suited for rendering both *high-key* and *low-key* images with stunning effect. High-key images have the majority of tones at the light end of the gray scale and the background, props, and clothing are light and bright, and vice versa for low-key images.

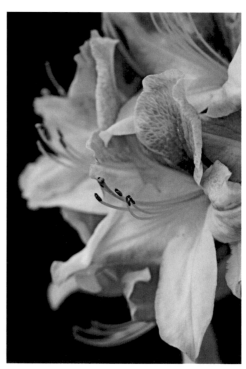

7.9 For this Monochrome shot, I used a Green filter to enhance the greens. Taken at ISO 100, f/5.6, 1/125 sec. using a Canon EF100mm f/2.8 Macro lens.

Taking black-and-white photographs

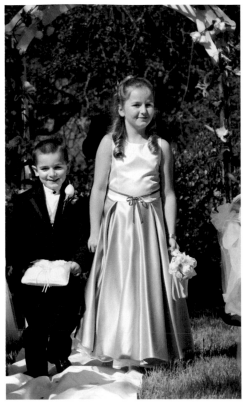

7.10 Black-and-white images are perennially popular with brides.

Table 7.3
Black-and-White Photography

Setup	**In the Field:** The scene for figure 7.10 was a California wedding held outdoors in bright afternoon sunlight. The bride requested that a portion of the images be presented in black-and-white.
	Additional Considerations: Consider carefully the specific challenges of a venue. For example, this area had an unattractive fence in the near background that had to be avoided in the formal shots. You can use a wide aperture to blur the background while maintaining reasonable sharpness.

Continued

Table 7.3

Lighting	**In the Field:** Bright dappled light on the faces of the children and deep shadows made this a difficult exposure. During the recessional, I knew that the flash likely would not recharge fast enough to use fill flash, so I worked to keep detail in the highlights as the subjects moved through a range of dappled lighting. Later, in Photoshop, I used the Shadow/ Highlight feature to lessen deep shadows on the faces.
	Additional Considerations: Take a meter reading on the brightest highlights in the scene, and then use the same minus exposure compensation to shoot later. Some images may be underexposed, but in a situation like a wedding, there isn't time to take three bracketed shots or to change exposure on the fly.
Lens	**In the Field:** Canon EF 24-105mm f/4L IS USM set to 105mm.
	Additional Considerations: A zoom lens is indispensable for action shots where you need to change the zoom setting as the subject moves. The Canon EF 24-105mm f/4L IS USM lens offers a great range for wedding action such as this, and it offers a great focal range for an everyday walk-around lens.
Camera Settings	**In the Field:** RAW capture, Aperture-priority AE mode with the white balance set to Daylight. I converted the RAW image using the Monochrome Picture Style with an orange filter. Deciding which color filter provides the best rendering on the computer after capture is easy.
	Additional Considerations: Many photographers agree that capturing images in color and rendering them as black-and-white in either a RAW conversion program or in Photoshop provides the highest resolution final image. RAW offers the flexibility to render the images however the client prefers after capture.
Exposure	**In the Field:** ISO 100, f/8, 1/320 second.
	Additional Considerations: In the best of cases, the photographer should be able to work with the bride and the wedding coordinator to plan the location and time for the ceremony to help provide the best lighting and space. That wasn't possible for this wedding, so the best approach was to expose to save highlight detail, keeping in mind the half- to full-stop of highlight recovery possible during RAW conversion.

Black-and-white photography tips

✦ **Natural forms, including the human body, lend themselves well to black-and-white photography.** The abstractness of these subjects allows a great deal of latitude in creative lighting approaches, viewpoints, and framing.

✦ **For striking black-and-white images, look for scenes that have a strong division of tones.**

✦ **To emphasize texture in a monochrome image, shoot into the light.** Because this technique produces underexposure in shadow areas, you can make two images, one exposed for the highlights and another exposed for the shadows, and then composite the images in Photoshop.

Business Photography

Given a choice between reading business correspondence that is a solid block of text or reading correspondence that includes illustrative photos, most people would choose the correspondence with photos, and with good reason. Well-placed photos not only illustrate and explain the text, but they also lend credibility and interest to many types of business documents.

Photos that represent a company's branding or those used in advertising are best made by a professional photographer. But routine business correspondence benefits from the addition of clean, well-lit images.

7.11 I used this image of a vintage camera to add interest to my business card.

Inspiration

At the office, photograph new employees; employee milestone events such as anniversaries and retirements; informal company parties; products or projects for internal or external newsletters; and new business or internal project proposals. You can also use pictures to illustrate employee-training materials.

If you are in sales, you can photograph customers with a product they purchased, and then use the image in thank-you promotion pieces such as calendars or cards. Small businesses can use and reuse product images for print and Web promotions, as well as for documenting processes such as product manufacturing.

The most important aspect of business photography is to get a clean, uncluttered shot that shows the subject, whether it is a person or a product, in the best light and with true-to-life color. For small object backgrounds, you can buy folding poster boards at a craft store and set them up on a desk or conference table. For images of people and large objects, find a neutral-color wall with enough space to move the subject 5 to 6 feet away from the wall. This helps lessen dark background shadows if you use the built-in flash.

7.12 Images can be used effectively for all types of business documents such as this self-promotion piece for a mailing.

Taking business photographs

7.13 The image here was a product shot for a small business that was launching Web-based sales.

Table 7.4
Business Photography

Setup	**In the Field:** A white seamless background in figure 7.13 allows the client to expand the background to include text and logos for either print or online use. In most cases, it's a good idea to shoot both vertical and horizontal orientations so that clients have a choice based on how they want to use the images.

Additional Considerations: Simple setups and compositions are the best place to start with business images. You can't go wrong with white, black, or backgrounds for small objects such as this. Be sure to ask your clients if they need space at the top, bottom, or sides of the frame to insert text and other graphics, and then shoot accordingly.

Lighting

In the Field: This shot was lit by four Photogenic Studio Max II strobes; two 320s lit the subject and two 160s, one with a silver umbrella, lit the background. A large silver reflector to camera right filled in the shadows.

Additional Considerations: Watch for lighting that is too contrasty and could be softened by using a softbox on the main light. For a warmer effect, a gold umbrella or gold reflector on the right would be effective.

Lens

In the Field: Canon EF 50 mm f/1.4 lens. I chose this lens for its excellent contrast and sharpness.

Additional Considerations: Your lens choice depends on the subject. For small objects, a normal lens is a good choice, such as the EF-S 60mm f/2.8 Macro USM. If you want to blur the background, choose a telephoto lens, and for large displays, use a wide-angle lens. If you photograph a group of objects or a production process, consider a medium wide-angle lens such as the Canon EF 24-70mm f/2.8L USM lens. For portraits, a short telephoto lens such as the Canon EF 100mm f/2.8 Macro USM gives you a nice head-and-shoulders shot.

Camera Settings

In the Field: RAW capture, Manual mode with a custom white balance.

Additional Considerations: In the studio, you want to control the depth of field, so choose Aperture-priority AE mode and set the white balance to the type of light in the scene.

Exposure

In the Field: ISO 100, f/22, 1/125 sec.

Additional Considerations: In the studio, Manual mode and a strobe synch light meter provide the correct exposure settings, or you may already have a standard exposure for studio product shots that you can use. Outside the studio, set a narrow aperture such as f/8 or f/16 if you want front-to-back sharpness. If the background is distracting, use a wider aperture such as f/5.6 or f/4.0. Set the ISO to 100 or 200, depending on the amount of light available.

Accessories

Silver reflectors are invaluable, especially when you have limited options for controlling existing light. Affordable silver reflectors come in a variety of sizes.

Business photography tips

✦ **Fill shadows.** If you're doing a head-and-shoulders shot of a person, such as a new employee, ask the subject to hold a silver reflector at waist level and tilted to throw light upward slightly to fill in shadows created by overhead lighting. Ask the subject to adjust the reflector position slightly, and watch for the position that best fills shadow areas under the person's eyes, nose, and chin.

✦ **Adjust the setup for the photograph based on its intended use.** For example, if you're taking photos to use on a Web site, keep the composition and the background simple to create a photo that is easy to read at the small image sizes used on the Web. Brighten small-size images just slightly for use on the Web.

✦ **Maintain the same perspective in a series.** In a series of photos, be sure to keep the perspective the same throughout. For example, if you are photographing several products, set up the products on a long table and use the same lens and shooting position for each shot. Also be sure to keep lighting consistent through the succession of shots.

✦ **Look at the colors as a group.** As you set up a photo, consider all the colors in the image. If they do not work well together, change backgrounds or locations to find a better background color scheme for the subject or use a neutral-color background such as a white wall or a poster board.

✦ **Turn off the flash.** If you're photographing small objects, turn off the flash. It is very difficult to maintain highlight detail at close working ranges using a flash. You can supplement light on the object with a desk lamp, if necessary.

Candid Photography

Few photographers can resist the urge to capture pictures of people just as they are—unposed and acting natural. Good candid pictures often become the prize images in your portfolio because, unlike posed portraits, you catch subjects unaware, preoccupied with their private world of thoughts and activities and without their "camera" faces. Capturing candid photos means that you need to fade quietly into the background.

To disappear into the surroundings, you need a lens—preferably a zoom lens—that allows you to change focal length while maintaining your distance. You also need to be able to shoot quickly to capture

7.14 This is an outtake image from an editorial shoot showing a nursery manager caring for plants during a normal workday. The image captures her relaxed and caring around the plants that she loves. Taken at ISO 100, f/5.6, 1/100 sec. in overcast light using a Canon EF 24-105mm, f/4.0L USM lens set to 40mm.

the subject's expression or activity as it changes. Therein lays the importance of being prepared and patiently staying with the subject to capture the truest expressions and reactions.

> **Note** *When shooting on assignment or when shooting a wedding or event, look for unstaged shots that provide more context or detail for the story. Often, these images reveal the nature and character of the event or subject, and they can provide behind-the-scenes insights that staged images typically do not show.*

Inspiration

Downtown streets filled with people going about their daily routines also offer endless opportunities for candid photography. Other excellent opportunities can be found at concerts, parades, airports, and parks.

Taking candid photographs

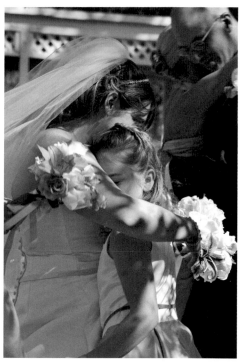

7.16 This photo illustrates an unstaged shot that captures both the bride and the groom interacting with their family members after the wedding ceremony.

7.15 This candid shot of a musician was taken at a pause between songs. Taken at ISO 1250, f/4 at 1/15 sec., handholding the camera with the Canon EF 24-105mm f/4L IS USM lens set to 105mm.

Table 7.5
Candid Photography

Setup	**In the Field:** During a wedding, there are few chances for a photographer to take a breath even after the recessional shots are completed. In this case, I turned the camera to follow the bride and groom as they greeted the wedding party after the recessional. The quick shot in figure 7.16 shows both the bride and groom in a completely unstaged way interacting with the family.
	Additional Considerations: If possible, choose a shooting position that provides a clean background, or shoot using a wide aperture to blur background distractions or frame tightly. If you must change positions, be quiet to avoid distracting the subject or giving away your candid shooting.
Lighting	**In the Field:** Bright dappled sunlight provided its own set of challenges for this scene. In some cases, you have to accept the lighting and do the best you can to hold detail in important areas of the subject/scene.
	Additional Considerations: Lighting for candid shots can run the gamut. Watch for highlight areas on the subject's face, and use Auto-Exposure Lock to ensure that highlights are not blown out if there's time to use it without missing the shot.
Lens	**In the Field:** Canon EF 24-105mm f/4L IS USM with the lens set to 100mm.
	Additional Considerations: A zoom lens is indispensable for candid shots. Typically, a telephoto zoom offers the focal range necessary for you to remain at a distance yet fill the frame with the subject.
Camera Settings	**In the Field:** RAW capture, Aperture-priority AE mode with white balance set to Daylight.
	Additional Considerations: Try controlling the depth of field by choosing Aperture-priority AE mode. If the light is low, switch to Shutter-priority AE mode and keep the shutter speed at 1/30 second or faster. Be sure to set the white balance to match the type of light in the scene.
Exposure	**In the Field:** ISO 100, f/8, 1/100 sec.
	Additional Considerations: In low-light scenes, switch to Shutter-priority AE mode and set the shutter to 1/30 or 1/60 second. At 1/30 second, you may get some blur if the subject moves, which can add interest to the image. In good light, switch to Aperture-priority AE mode, set the ISO at 100, and select a moderate to wide aperture.

Candid photography tips

✦ **Be patient and be prepared to shoot quickly.** Patience is a hallmark of candid photography. And, be sure to carry a spare, charged battery with you.

✦ **Change lenses as you watch and wait to survey the overall look of the scene.** Have alternate lenses nearby and easy to grab for quick lens changes.

✦ **Because using a flash gives away your candid shooting, try switching to wide apertures in low-light scenes.** Set the camera to Aperture-priority AE mode, and turn the Main dial to set the aperture at f/3.5 or f/2.8.

Child Photography

Perhaps no specialty area is as satisfying and challenging as child photography. It is satisfying because it is a singular opportunity to capture the innocence, fun, and curiosity of unspoiled (so to speak) kids, and it is challenging because success depends on engaging the child so that you can reveal the child's sense of innocence, fun, and curiosity. Even more important than having the right camera is having the right props, toys, personality, and patience — all of which are key to making a location or studio session successful.

Lighting can range from simple natural outdoor lighting or window light to more complex studio light. In either case, the goal is to wrap the child in soft, open light that also provides the shadow necessary for modeling of the face. Lateral lighting from an outdoor setting or a window light works well, and then you can add a fill light via either an off-camera flash or portable strobe on the shadow side of the subject. High-key lighting is effective for both babies and young children as well as for mother-baby portraits.

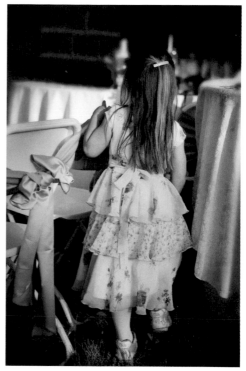

7.17 In addition to traditional portraits, you can get excellent candid shots of children either during a shooting session or at events such as weddings. Taken at ISO 100, f/2.8, 1/750 sec. using a Canon EF 24-70mm f/2.8L USM lens set to 70mm.

Inspiration

Child photography is one of the areas where you can let the child inspire you.

Because so much of the session depends on the disposition of the child, if you can establish a good rapport with the child and allow yourself to go with the flow of the

child's activity, you can often get much better images than if you try to pose him or her. In other words, let the child do what comes naturally as long as he or she remains safe.

Not all child portraits have to show a sunny, smiling child, although at least some should. Emotions can also make compelling images that parents can identify with and cherish in years to come.

Taking child photographs

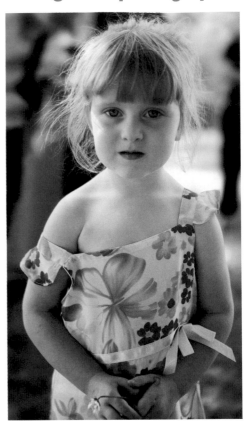

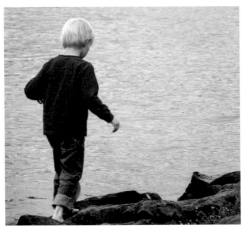

7.18 Choose locations for photographing kids based on the child's interests or favorite places. Taken at ISO 100, f/11, 1/125 sec. using a Canon 70-200mm f/2.8L IS USM lens set to 140mm.

7.19 A cute little girl with a wilted dandelion that she had faithfully carried in her hand all afternoon creates a simple but poignant portrait.

Table 7.6
Child Photography

Setup	In the Field: The image in figure 7.19 was set up when the child stopped me and asked me to take her picture. How could I say no? The background was distracting with people milling about. Even a wide aperture wouldn't blur them enough, so I counted on post-capture editing to blur the background more.

Lighting

In the Field: Very late afternoon light filtered from the side lit this scene.

Additional Considerations: Regardless of where you photograph kids, be sure they have room to move and interact with parents and with you. When shooting in a studio, be sure that all lighting stands and gear are secured with sandbags or on an overhead railing. Ground-level lights are, from a child's point of view, fair game for playing hide-and-seek, doing acrobatics, and engaging in other activities that only young minds can dream up.

Lens

In the Field: Canon EF 24-70mm f/2.8L USM lens.

Additional Considerations: In the studio and in some outdoor locations, a long lens and wide aperture provide the soft background that you want. The versatile Canon EF 70-200mm f/2.8L IS USM is a perennial favorite. The Canon EF 100mm f/2.8 Macro USM and the EF 85mm f/1.2 II USM lenses are also good candidates for kid and adult portraiture.

Camera Settings

In the Field: RAW capture, Aperture-priority AE mode with the white balance set to AWB.

Additional Considerations: As the light fades, switch to Shutter-priority AE mode to help ensure subject sharpness. Image stabilization (IS) lenses give you approximately one additional f-stop latitude than non-IS lenses, and that f-stop is worth the price, especially at weddings.

Exposure

In the Field: ISO 100, f/2.8, 1/250 sec.

Additional Considerations: As with all portraits, control the depth of field to suit the rendering that you want. Very fast lenses such as the EF 50mm f/1.4 USM and the EF 85mm f/1.2 II USM are ideal when you can't control background distractions.

Child photography tips

✦ **Less direction is best.** Gaining a child's cooperation can be tricky, and if the child feels over manipulated, you can lose the child's good humor. Set up a sense of give-and-take with you giving the most so that the child continues to enjoy the shooting session.

✦ **Have an assistant or baby/child wrangler.** Any photographer who has shot child portrait sessions alone has likely had the sense that sessions often teeter on the edge of chaos. Having an assistant behind the camera to interact with the child and chat with the parents allows you to concentrate on lighting, composition, and changing camera position.

✦ **Plan before the session.** Be sure to talk to the parents about the clothing that the child will wear and how many changes they want during the session. Then you can plan for backgrounds and props that work well with the clothing, if you're shooting in the studio.

Or if you're shooting outdoors, the clothing should be appropriate for the setting. Also, learn as much as you can about the child's interests before the session so that you can more quickly engage the child with subjects, toys, or props that interest him.

Commercial Assignment Photography

This broad category encompasses images used for all types of commercial applications and shot on contract by a photographer including catalog work, fashion, advertising, corporate, industrial, public relations, and promotional assignments. And within this broad category, a range of skills from conceptual, photojournalism, still-life, portraiture, to studio and location are required. Of all the photographic specialty areas, this is the area in which photographers stand to earn the highest fees, but the field is also highly competitive with some of the best shooters in the world specializing in this work.

Getting a good portfolio or book of commercial images requires imagination and creativity, and a distinctive shooting style. Know what kinds of commercial work most appeal to you, and create a book of images that display your shooting style. The days when agencies looked for generalists — photographers who could shoot a range of subjects — are gone. Instead, clients and agencies look for a unifying photographic

7.20 My approach to commercial assignment shots tends to be simple and graphic. The exposure was ISO 100, f/18, 1/125 sec. using a Canon EF 24-105mm, f/4.0L USM lens set to 75mm and four studio strobes.

vision that defines the photographer's style and can be applied with consistency to a range of subjects.

 Design agencies and clients often need larger images, so at 8.2 megapixels, your 30D is competitive for some, but not all, commercial applications. The maximum high-resolution output size of images is approximately 7.5" × 11.5" at 300 ppi. Depending on the size of the publication, this resolution is often adequate for a double-page spread.

If you want to break into commercial assignment shooting, consider shooting for small, locally based companies that need images for brochures, audio-visual programs, and in-house publications, or by shooting executive portraits for public relations agencies. The key to getting repeat business and growing a client list is to demonstrate versatility and creativity that meet or exceed the client or agency's expectations for the assignment.

Inspiration

As Selina Oppenheim states in her book, *Portfolios That Sell*, "The reality of assignment photography is that clients buy *up*. In order to get good assignments you must show great work. The first step to great work is defining your vision."

Taking commercial assignment photographs

7.22 Simple setups such as this are easy and quick to create, and with them you can create clean images of products for promotions on a Web site.

7.21 Experimenting with conceptual setups leads to a variety of shots on the same theme for fresh portfolio images. Taken at ISO 100, f/22, 1/125 sec. using four studio strobes and the Canon EF 100mm f/2.8 Macro USM lens.

Table 7.7
Commercial Assignment Photography

Setup	**In the Field:** In figure 7.22, I tried several setups to illustrate the idea of green apple soda, and settled on this as one of the final images in the series.
	Additional Considerations: Most often in assignment photography, the shooting specification dictates the setup and other details for the shot. Portfolio shooting, however, allows you to incorporate your creative take and personal shooting style for commercial images.
Lighting	**In the Field:** This shot was lit by four Photogenic Studio Max II strobes; two 320s lit the subject and two 160s, one with a silver umbrella, lit the background. A large silver reflector to camera right filled the shadow side of the subject. In this case, I wanted relatively contrasty light to create strong shadow regions to outline the elements in the image.
	Additional Considerations: The lighting should underscore the message the client wants for the image, so a softbox or location shooting may be best depending on the requirements.
Lens	**In the Field:** Canon EF 100mm f/2.8 Macro USM lens.
	Additional Considerations: Your lens choice depends on the subject. For small objects, a normal lens is a good choice, such as the EF-S 60mm f/2.8 Macro USM. If you want to blur the background, choose a telephoto lens, and for large displays, use a wide-angle lens. If you photograph a group of objects or a production process, consider a medium wide-angle lens.
Camera Settings	**In the Field:** RAW capture, Manual mode with a custom white balance. Because the green apple was not exactly the same color as the soda, I was able to bring both of them to the same color using a green gradient in Photoshop CS2.
	Additional Considerations: Settings depend, of course, on the location for the shoot and your objectives for rendering the subject.
Exposure	**In the Field:** ISO 100, f/22, 1/125 sec.
	Additional Considerations: Exposure considerations run the gamut depending on whether the shoot is outdoors, indoors, or in the studio. The best advice is to be prepared with extra lights and strobes if they are part of the lighting, and to use an incident meter for challenging lighting scenarios.
Accessories	For indoor, outdoor, and studio shooting, silver reflectors are invaluable, especially when you have limited options for controlling existing light. Affordable silver reflectors come in a variety of sizes.

Commercial assignment photography tips

✦ **Hone your teamwork skills.**
Most commercial assignments involve working with a team of professionals ranging from the art director to makeup and set stylists. Talking to all team members is critical to ensure that everyone has a clear understanding and is working toward the same goals.

✦ **Maintain the same perspective in a series.** In a series of photos, such as a series of product shots for a catalog, keep the perspective the same throughout. For example, if you are photographing several new food dishes, set up the dishes on a long table and use the same lens and shooting position for each shot. Also be sure to keep lighting consistent through the succession of shots.

✦ **Look at the colors as a group.**
As you set up a photo, consider all the colors in the image. If they do not work well together, change backgrounds or locations to find a better background color scheme for the subject or use a neutral-color background such as a white wall or a poster board.

✦ **Turn off the flash.** If you're photographing small objects, set the camera to Flash Off mode. Maintaining highlight detail at close working ranges using a flash is very difficult. You can supplement with strobes or reflectors, if necessary.

Editorial Photography and Photojournalism

Many people think that editorial shooting and photojournalism is a specialty reserved for working journalists. But the genre of editorial and photojournalism photography has become the style de jour for other specialties including weddings and high-school senior photography. The appeal lies in the documentary aspect of capturing life and events as they happen. There is an essential element of the narrative — visually telling the story as it unfolds in real time with no posing or fabrications in most cases.

Editorial and photojournalistic style includes elements from other types of photography including environmental portraiture, street, action and sports, and documentary, but with an emphasis on a visual narrative that often supports accompanying text.

Unlike with most photojournalism, editorial assignments can be planned, scouted ahead of time, and shot at a somewhat slower pace. Editorial shooting ranges from reporting on people, celebrities, and events, to creating illustrative concept shots for feature articles on general interest topics, book covers, posters, and photo illustrations. In either case, getting shots that define the spirit and character of the person or event goes to the heart of this photographic specialty — all without posing or staging the scene. To get defining shots, you need to understand the event or person, which means that you need to be there, in position, and ready to shoot when a defining moment happens.

7.23 The softly illuminated cross to the left of the pastor, as well as the shadowy audience figures in the foreground provide the context for this image. Taken at ISO 1600, f/4.0, 1/4 sec. with the Canon EF 24-105mm f/4L IS USM lens set to 98mm.

Styles in both specialty areas change over time. And depending on the style in vogue, editorial photographers and photojournalists may be assigned to produce the classic photo story comprised of a series of photos that tells the story of the person or event, or they may be asked to distill the essence of the story in one or two shots. In the field, the EOS 30D is a quick response, capable camera that has a relatively quiet shutter.

If you're new to the field, you may be able to break in as a freelance photographer for local metropolitan newspapers, local magazines, and through resources found in the *Photographer's Market*, a book published annually that lists contacts for magazines, book publishers, and stock agencies.

Note

The 30D is a durable camera, but it does not have weather-sealing of some higher-end cameras. So, use caution when using it repeatedly in inclement weather and with rough handling. However, if precautions are taken to keep it dry and it is treated well, the EOS 30D will serve the editorial photographer and photojournalist well.

Inspiration

Look for opportunities to hone your photojournalism shooting skills at local rallies, political gatherings, conventions, marches, protests, and elections. Often, you can find local news that has national implications and interest a national publication in a photo story on the news item. Because the human impact is important in any editorial or photojournalism piece, consider covering a news event or event of interest from the point of view of a person or family that the event directly affects.

Many photographers have broken into this field by spending hours of their own time developing photo stories on subjects about which they are passionate with the hope that they can later sell the story to a publication.

7.24 In a series of images on a local nursery, this detail shot illustrates some of the basic elements used in the business. Taken at ISO 100, f/4.0, 1/80 sec. using the Canon EF 100mm f/2.8 Macro USM lens.

Taking editorial photographs and photojournalism photographs

7.25 This is one in a series of images documenting the work of a local, fast-growing nursery business. The woman in this image is a production manager with the company.

Table 7.8
Editorial Photography and Photojournalism Photography

Setup	**In the Field:** For most photojournalism assignments, setups are not used unless the objective of the assignment is a formal portrait. For the image in figure 7.25, I followed the subject as she went about her day's work. I watched to try to get a clean background, which was a challenge at this location. After capturing the image, I darkened part of the background to subdue a distracting wire screen.
	Additional Considerations: For editorial shots, you may commonly work with positioning, lighting, and posing, but all toward the goal of accurately representing the subject. For breaking-news shooting, the best strategy is to find an unobstructed view of the unfolding story and stay out of the way of people in the scene.
Lighting	**In the Field:** This image was taken on an overcast day and there was plastic sheeting over the nursery area. The result is soft, pleasing light appropriate for this portrait.
	Additional Considerations: In low-light scenes or indoors, and if you're reasonably close, you can use the built-in or an accessory flash — provided that flash photography is allowed and does not disrupt the proceedings. A reflector is also a handy accessory.
Lens	**In the Field:** Canon EF 100mm f/2.8 Macro USM lens. I used the 100mm lens because I knew that a series of portraits would be required for the project.
	Additional Considerations: A fast telephoto zoom lens, such as the Canon EF 70-200mm f/2.8L IS USM, is ideal for photojournalism and editorial shooting because in many scenes, you cannot get close to the subject. For weather-related photojournalism pictures, a wide-angle lens is ideal to include the context of bad weather surrounding a person or group coping with the weather.
Camera Settings	**In the Field:** Aperture-priority AE. Because I was shooting RAW files, I could set the white balance during RAW image conversion by clicking a white element in the photo.
	Additional Considerations: Always shoot at the highest resolution setting on the camera and maintain high resolution through the editing process so that the image looks good if the editor wants to use it in a large size.
Exposure	**In the Field:** ISO 100, f/6.3, 1/50 sec.
	Additional Considerations: Use wide apertures of f/3.5 or f/2.8 to blur distracting backgrounds. If the background adds context to the scene, stop down to f/8 or f/11 if the light allows.

Editorial photography and photojournalism photography tips

✦ **If you're new to editorial and photojournalism shooting, review current news images to get a feel for photojournalism.** Although everyone has grown up seeing news photos, few study them closely. Take time to carefully study photos in newspapers, news magazines, and consumer magazines to see how the photographers encapsulate the defining moments of a story and its background details through images.

✦ **Shoot for the publication's format.** In many editorial and photojournalism images, the publication runs text and headlines across the image. Leave space at the top, bottom, or sides of the image where the designer can easily insert headlines, subheads, and text. If your work is for a magazine, shooting in a vertical format for cover images and full-page interior images is a good idea.

✦ **Capture the defining moment.** Before you begin, think about what the defining moment might be in the scene that you're shooting. You may miss capturing the defining shot by not knowing in advance what it might be. Of course, as the scene develops, the defining shot may change. Be prepared to keep up with the flow of events and anticipate events so that you can be in a good position to get the best pictures.

✦ **Have plenty of power.** Often, you can't tell how long breaking news or an editorial shoot will last. For this reason, I recommend buying the accessory battery grip so that you have battery power to last the duration.

✦ **Get permission.** Be very cautious when photographing private events, and always ask the event organizers for permission to photograph the event if you aren't carrying press credentials. And even if you are carrying credentials, check in with authorities or event planners.

Environmental Portrait Photography

An environmental portrait, or a portrait taken of a subject in work or leisure-time surroundings, offers several advantages over traditional portraits. With environmental portraits, the work area adds context that helps to reveal more about the subject than is shown in traditional portraits. In addition, the subject is often more comfortable in familiar surroundings, and the work or interest area also gives ample fodder for conversation during

the shooting, both of which help the subject to feel relaxed and comfortable.

Environmental portraits borrow elements from both photojournalism and portraiture. With a successful merger of the two, environmental portraits offer insight into the subject that is often associated with photojournalism and the techniques that are associated with portraits. Because environmental portraiture offers a refreshing and adaptable approach to portraiture, it can become a lucrative specialty area for new and experienced photographers.

Tip *In portraits, be sure that the subject's eyes are in sharp focus. You can ensure this focus by using Auto Focus lock. Position the auto-focus point in the viewfinder on the subject's eyes, and press the Shutter button halfway down. When the camera beeps to confirm focus, continue to hold the Shutter button as you move the camera to recompose the image. Then take the picture.*

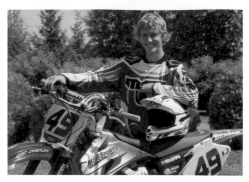

7.26 This environmental portrait is used as promotion for an aspiring professional motocross rider. Taken at ISO 100, f/14, 1/250 sec., with the Canon EF 100mm f/2.8 Macro USM lens.

Inspiration

If you want to chalk up experience shooting environmental portraits, look for opportunities anywhere people are in their work or leisure-time surroundings, whether that's in an office, garage, or studio.

Environmental portraits are not limited to assignment images. The concepts of this technique can be successfully applied to many types of portraiture, senior, and family photography. For example, you might consider making an environmental portrait of a mother or grandmother in the kitchen or gym depending on the person's interests, a high-school senior proudly posing with a first car, or a football player leaning against a goal post.

Taking environmental portrait photographs

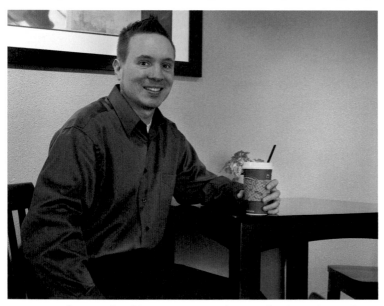

7.27 Part of a new local ice cream manufacturer business is a café that features ice cream, light meals, and coffee drinks. The company's marketing and sales manager is shown here.

Table 7.9
Environmental Portrait Photography

Setup

In the Field: Taken in the company's new café, I chose the location in figure 7.27 for the warmth of the wall color and contrast offered by the dark wood table and chairs. The coffee was added as an element for which the café is known.

Additional Considerations: Get to know the subject to find out what elements play an important role in his work or avocation. Then set up the scene with some of those elements as part of the composition. When framing environmental portraits, use discretion about how much of the scene you include to avoid getting a cluttered look. Ultimately, you want the image to be informative, but also easy for viewers to understand.

Lighting

In the Field: For this image, I took advantage of ceiling-mounted spotlights in the café area. There was a large window behind the camera that provided a small amount of natural light from an overcast day.

Additional Considerations: Light from nearby windows can provide soft and flattering light. You can use an accessory flash and bounce the flash off a wall or ceiling to provide more attractive lighting. Experiment with different levels of flash compensation to get just the right amount of illumination. If you're shooting outdoors, open shade or the light on an overcast day is ideal.

Lens

In the Field: Canon EF 24-105mm f/4L IS USM lens set to 28mm.

Additional Considerations: Shorter focal lengths, 28 to 35mm, are ideal when you want to include environmental elements in portraits. In addition, they provide extensive enough depth of field to make contextual elements visually distinct without competing with the subject. To avoid wide-angle distortion, do not have the subject close to the camera. You can use a normal or short telephoto lens as well. Just step back a little to include environmental elements.

Camera Settings

In the Field: RAW capture, Aperture-priority AE mode.

Additional Considerations: To control the depth of field, choose Aperture-priority AE mode to let the background be either soft (wide aperture) or sharply defined (narrow aperture). If you're working in mixed light, this is a great time to set a custom white balance or shoot RAW images and then correct the color by click-balancing on a white or gray card that you shot under the scene lighting.

Continued

Table 7.9 *(continued)*

Exposure	**In the Field:** ISO 100, f/4.0, 1/10 sec.
	Additional Considerations: Use as low an ISO setting as possible to avoid introducing digital noise in the image, such as 100 or 200. If the light is low, use an accessory flash and bounce the flash off a wall or ceiling. On the EOS 30D, use flash exposure compensation to get a natural-looking level of illumination.
Accessories	A tripod is always a good accessory to ensure sharpness when taking portraits.

Environmental portrait photography tips

✦ **Use a shorter focal length.** Normally, a medium telephoto lens is the choice for portraits, but with environmental portraits, a shorter focal length allows you to include surroundings that provide context. For example, if you're using the Canon EF 24-70mm f/2.8L USM lens, a 24 or 35mm setting is a good choice. If you use a wide-angle lens, be sure that the subject is not close to the camera because facial features can be distorted in very unflattering ways.

✦ **Develop a rapport.** Develop a rapport with your subjects to make them feel more comfortable. The most important ingredient for any portrait is the connection the photographer establishes with the subject. And in an environmental situation, ask the subject to show you what her work involves. As she gets involved in telling you about

her work, she becomes less self-conscious and that's when you're most likely to capture her as she is in her work environment.

✦ **Scout locations that offer flattering light.** Natural light is always a good choice, especially gentle light filtering into the room from a nearby window. You can set up a silver reflector on the opposite side of the subject to reflect light into the shadow areas.

✦ **Identify poses.** Because people quickly tire of posing, discuss poses with your subject before you begin shooting. Have a list of poses and go over them with the subject so that he feels comfortable and can respond to your direction. Or provide minimal posing direction and go for more natural unposed shots. Also provide breaks during which the subject can go about his work or play. The distraction of the activity provides countless opportunities for additional shots.

Event Photography

Perhaps no other area presents as many varied photo opportunities as events such as parades, fairs, festivals, races, and traveling exhibits. Everything from Mardi Gras to a local county fair is a candidate for your photographic prowess and for additional stock or direct sales income.

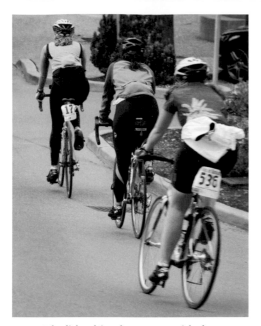

7.28 A holiday bicycle race provided colorful images of the event including this one of riders coming into a rest stop. Taken at ISO 100, f/11, at 1/60 sec. using the Canon EF 70-200mm f/2.8L IS USM lens set to 140mm.

Before you go to the event, think about photographing the event as a story that identifies the theme and provides detailed context to give viewers a true sense of being there. You can include overall shots of the venue to give a sense of the number of visitors as well as close-up shots of visitors in traditional, comical, and poignant situations.

Planning is important. If you're shooting a parade, for example, walk the parade route the day before at the same time of day that the parade will occur. Note areas where you might encounter lighting challenges from the shadows of tall buildings or backlighting.

For festivals, fairs, and other events, check the sponsor's Web site to get a schedule of events a day or two beforehand. Also, get a program or map of the event so that you know where the most interesting booths or exhibits are located, and where and when awards or music events will be held. Many event organizers hire photographers long before the event to take shots that will be used for the next year's event promotions. You can usually do a Web search to find the event planners or sponsors to contact about shooting the activity. In addition, some event shots have resale potential as stock photography images.

If the event is held indoors, check ahead of time to see if there are restrictions on using flash. And, even if the event is outdoors, chances are good that some pictures will be in deep shade and require slow shutter speeds. Plan ahead whether you will use a flash or need to carry a monopod or tripod, especially for late-day and evening shooting.

Inspiration

In a larger sense, popular public events reflect our culture, the fads and fashions of the time. Consider how the series of photos

7.29 Indoor and outdoor events offer opportunities to show both the ambiance of event lighting and the motion of the performance as a creative alternative. Taken at ISO 1250, f/4.0 at 1/15 sec. using the Canon EF 24-105mm f/4L IS USM lens set to 105mm.

you take at an event can become a record of current culture. In the photos, include popular icons that will eventually reflect the era. Fashion, popular foods and activities, cars, and even cellphones are all possibilities. Be sure to include people in typical situations, such as a child holding onto a parent's leg or crying from exhaustion, or adults catching a short nap on the grass.

To capture the ambience of the event, consider close-up and medium-wide portraits of visitors interacting with performers, with vendors, and with each other. If the event is fast-paced and lively, you can use slow shutter speeds to capture motion as a blur.

Taking event photographs

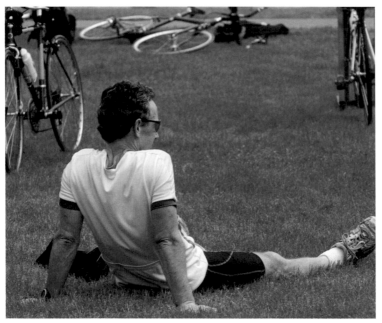

7.30 Sometimes the pinnacle of an event is its completion and taking a breather, as this biker is doing after a seven-hills competition.

Table 7.10 Event Photography	
Setup	**In the Field:** The event shown in figure 7.30 included a proliferation of bicycles, gear, and prizes. The trick was to find a shooting position that offered the context of the competition with this rider who had completed the race without the background becoming too busy.

	Additional Considerations: Look for shooting positions that offer the cleanest background possible, or choose a wide aperture to blur the background. Experiment with both high and low shooting positions to offer unique perspectives on the event. Be sure to take overall crowd shots as well as detail shots of the event.
Lighting	**In the Field:** This was taken on an overcast day, which provided good color saturation and nice skin tones.
	Additional Considerations: Lighting for events can obviously run the gamut. In bright, contrasty light, shoot in open shade areas to lessen deep shadows and too-bright highlights. This can be a good time to use fill-flash, especially for people shots, to fill in dark shadows under the eyes, nose, and chin.
Lens	**In the Field:** Canon EF 70-200mm f/2.8L IS USM lens set to 135mm.
	Additional Considerations: Both wide-angle and telephoto zoom lenses are good choices for event photography. Zoom lenses are indispensable because they allow you to change focal length on the fly.
Camera Settings	**In the Field:** RAW capture, Aperture-priority AE mode.
	Additional Considerations: To control the depth of field switch to Aperture-priority AE mode and set the white balance to the type of light in the scene. If the light is low, switch to Shutter-priority AE mode and set the shutter to 1/30 second or faster.
Exposure	**In the Field:** ISO 100, f/8, 1/200 sec.
	Additional Considerations: In good light, choose ISO 100. In lower light scenes, choose ISO 200, 400, or even 1600 to get faster shutter speeds. At music concerts or events in low light, it's often effective to allow blur of the performers to show in the image as well as at other events. Experiment with different shutter speeds to get a variety of shots that reflect the pace and mood of the event.
Accessories	Using a polarizer on the lens helps deepen the colors and increases the saturation of color throughout the image for outdoor events.

Event photography tips

✦ **Choose multiple location options.** For parades, locate at least two shooting positions — one at street-level and the other from a higher view. Then use the high vantage point to record overall crowd scenes with a wide-angle lens, and use both the wide-angle and a telephoto lens from the street-level shooting position.

✦ **Try creative shooting positions at events.** Don't be afraid to kneel down or even lie down and shoot up. This shooting position makes the subject appear more powerful.

✦ **Ask for permission before photographing children.** Always ask permission from a parent or guardian before photographing a child.

✦ **Plan some shots for the best hours of light.** For most outdoor events, this will be late afternoon through sunset. Also stake out a shooting position that allows you to take the best advantage of the golden light.

✦ **Arrive early at popular events.** Because crowds gather quickly, an early arrival allows you to record pictures of people preparing race cars, musical instruments, booths, or floats. It also allows you to photograph crowds as they begin coming into the event.

Fine-Art Photography

The defining criteria for fine-art photography is the classic, inspiring, or iconic subject, the artistic rendering of a subject, and the extraordinary inner vision that draws curators, collectors, and art aficionados to a photographic series. In many ways, fine-art photographers are the keepers of a vision that reveals life in ways we would otherwise overlook.

7.31 Virtually any subject can become a good subject for fine-art work. For this image, I applied a soft focus effect and gradient during image editing in Adobe Photoshop CS2. Taken at ISO 100, f/8, 1/125 sec., using the Canon EF 100mm f/2.8 Macro USM lens.

Fine-art photography often crosses traditional lines. For example, the spectacular landscapes of MacDuff Everton, the classic still-life images of Irving Penn, and the street photography and portraits of Henri Cartier Bresson cross into the world of fine-art photography.

As a tool for the fine-art photographer, the 30D offers all the creative options required to render subjects with the vision you have in mind. While gallery images are often thought of as being extreme enlargements, the images from the 30D can be upsampled to produce larger prints for gallery exhibitions. Many galleries now accept smaller image sizes, so that prints at the camera's native resolution make it a contender in the fine-art arena.

Inspiration

If you're new to fine-art photography, visit local galleries to see what curators and gallery managers are selecting for exhibition.

© *Cricket Krengel*

7.32 This image of a stormy sea and sea stacks off the coast of Oregon represents the evocative nature of fine-art photography. Taken at ISO 100, f/7.1, 1/2000 sec. using the Canon EF-S 18-55mm f/3.5-5.6 USM lens set to 55mm.

Although many subjects are appropriate for fine-art photography, the most important criterion is your artistic vision. Finding and refining your way of seeing the world so that it inspires others and creates a sense of awe is the foundation of most fine-art photography.

For inspiration, review the classic masters of art. Read the classic and contemporary books to find passages that resonate with you, and then translate the words and concepts into inspiring images. Because other photography specialty areas cross over into fine art, study the latest trends in graphic and industrial design for themes and approaches that inspire you visually.

Taking fine-art photographs

7.33 This image of an old barn with a rusty roof provided a good subject for post-capture manipulation in Photoshop CS2.

Table 7.11
Fine-Art Photography

Setup	**In the Field:** The juxtaposition of the old barn and the light in the background meadow in figure 7.33 leaves room for one of many possible stories. **Additional Considerations:** Fine-art photography leaves much open for viewers to fill in from their imaginations. Artful post-processing is useful, but the importance of getting a good image in the camera is equally important.
Lighting	**In the Field:** The light cutting through the overcast sky initially drew my attention to this scene. The difference between the shaft of light and the darkness of the barn provided nice lighting contrast. **Additional Considerations:** For fine-art images, lighting that is moody and evocative is excellent, and in image editing, the mood can be heightened.
Lens	**In the Field:** Canon EF 24-105mm f/4L IS USM set to 24mm. **Additional Considerations:** The lens that you choose will depend on the scene, of course.
Camera Settings	**In the Field:** RAW capture, Aperture-priority AE mode with white balance set to auto (AWB). The picture style was set to Standard. **Additional Considerations:** Many fine-art images offer a good opportunity to try the different Picture Styles, toning effects in the camera, and to experiment with filters and changes to image saturation in an image-editing program.
Exposure	**In the Field:** ISO 100, f/11, 1/125 sec. **Additional Considerations:** For images with a high dynamic range, many photographers prefer to take two or three images, one exposed for highlights, one for midtone, and one for shadows, and then composite them in Photoshop to get a final image at a higher dynamic range than the camera can deliver.
Accessories	If you choose to shoot multiple images, a tripod is essential.

Fine-art photography tips

✦ **Build a series of images.** As with other areas of photography, curators and gallery managers look for a unified series of images on specific subjects that reveal your artistic vision.

✦ **Explore alternative digital processing techniques.** Unlike other areas of photography where a traditionally processed print is the expectation, in fine-art photography, you can exercise creative freedom in processing and rendering images.

Tip *Some excellent techniques for processing RAW images are included in Adobe Camera Raw Studio Skills and Adobe Camera Raw for Digital Photographers Only, both published by John Wiley and Sons.*

✦ **If you are upsampling images to make very large gallery prints, upsample in a RAW conversion program or upsample incrementally.** Upsampling, or increasing an image beyond its native resolution, allows you to print EOS 30D images at larger sizes. Upsampling can be done in Adobe Camera Raw in the Workflow Options section, or it can be done in Photoshop in the Image/Image Size dialog box using Bicubic interpolation. Most photographers agree that if you upsample in Photoshop, you should do so in successive increments of approximately 10 percent, until you arrive at the size print that you need.

✦ **If you shoot black-and-white, take advantage of Canon's Monochrome Picture Style and filters.** Canon's Monochrome Picture Style offers color filter effects that simulate traditional color filters for black-and-white photography. Or you can also get similar effects in Adobe Camera Raw by using the Calibrate tab sliders to adjust tint and saturation for individual color channels.

Flower and Macro Photography

Rarely can a photographer resist the temptation to photograph flowers, exotic plants, and gardens. The enticements include the riot of colors, the allure of symmetry and textures, and intricate design variations. Flowers and gardens offer an appeal that transcends cultural and language barriers, making them a truly universally captivating subject. Many people think macro photography when they think about shooting flowers. Certainly macro lenses are ideal for flowers as well as for extreme close-up images of a variety of subjects.

The following guidelines will help you capture the best images when photographing flowers and gardens. If the garden is a popular attraction for tourists, it is probably designed with several "best" ways to view it;

7.34 Delicate structures, grace, and stunning beauty are only a few of the enticements of photographing flowers and plants. Taken at ISO 100, f/9, 1/200 sec. using the Canon EF 100mm f/2.8 Macro USM lens.

for example, it may contain arbors, topiaries, fountains, or statues. Get a map at the visitor's center, and look for tips on the best vantage points for the main areas of the garden. Take some overall "establishing" shots of the garden from each main vantage point, and then switch to isolating specific areas of the garden as individual compositions using both macro and non-macro lenses.

Of course, flower and garden images are strongest when they factor in the principles of good composition. The image should have a clear subject, and the composition should lead the viewer's eye to the main subject and then through the rest of the image. Experiment with compositional elements such as color, shape, texture, lines, and selective focus to create the composition.

Employing a little anthropomorphism is helpful as well. In portraiture, the goal is to capture the subject's personality; the same technique can be used in flower photography to capture the personality of individual blossoms.

Inspiration

Take the idea of anthropomorphism a step further by ascribing human characteristics to flowers, and see where it leads creatively. For example, asking questions such as whether flowers have bad-hair days can help you look at flowers differently. How do flowers handle the problem of overcrowding? Consider the implied hierarchy in the scene or arrangement, and try to isolate it as the subject. Can you use color to convey your interpretation of the flower or garden

7.35 A low shooting position and backlighting provided vibrant color and contrast for this image. Taken at ISO 100, f/5.6, 1/1000 sec. using a Canon EF 100mm f/2.8 Macro USM lens.

as being strong, weak, vibrant, or subdued? What photographic techniques can you use to emphasize the grace, beauty, and tranquility of the garden or flower?

Macro lenses reveal the hidden structures and beauty of everything from flowers to insects and small animals. A single drop of water bouncing up from a pool, or the reflections of a garden in a water droplet on a flower petal provide endless creative opportunities for macro images.

Taking flower and macro photographs

7.36 You would typically look for perfect blossoms, but sometimes an imperfect blossom provides added interest, as this one does.

Table 7.12
Flower and Macro Photography

Setup	**In the Field:** I took the picture in figure 7.36 at a nursery. With the Canon EF 100mm f/2.8 Macro USM lens, it was fairly easy to isolate the single flower from among the dozens crowding the area.
	Additional Considerations: Flowers and plants in outdoor light offer ready-made setup and lighting. If you don't have a garden, local nurseries and greenhouses offer plentiful subjects. Indoors, a simple single blossom or bouquet makes a good subject as well. You can compose images ranging from large fields of flowers to smaller groupings and single stems. Outdoors, you can take a low shooting position, and then shoot upward to use the blue sky as a beautiful backdrop.
Lighting	**In the Field:** Diffuse light from both an overcast day and the plastic nursery roof provided even light overall for this image.
	Additional Considerations: Outdoor light ranging from overcast conditions to bright sunshine are suitable for photos. Try using reflectors to direct light toward a small group or blossom. Fill-flash is sometimes helpful to give slightly more color pop.

Continued

Table 7.12 (continued)

Lens	**In the Field:** Canon EF 100mm f/2.8 Macro USM lens.
	Additional Considerations: For large areas of blossoms or plants or gardens, use a 24 to 35mm lens. For small groupings and single stems, consider a normal focal length or short telephoto lens. Or you can use the EF-S 60mm f/2.8 Macro USM or the venerable EF 100mm f/2.8 Macro USM lens. Of course, a long telephoto is useful for isolating small groupings in a large collection of flowers.
Camera Settings	**In the Field:** RAW capture, Aperture-priority AE.
	Additional Considerations: Decide on the best depth of field for the scene you're shooting, and use Aperture-priority AE mode to set the f-stop. To blur the background, start with an f/5.6 aperture. For extensive depth of field, set an f/11 or narrower aperture.
Exposure	**In the Field:** ISO 100, f/5.6, 1/125 sec.
	Additional Considerations: For large fields of flowers or plants, set a narrow aperture such as f/11 or f/16 to ensure maximum sharpness throughout the image. To isolate details of a single stem using selective focus, choose a wide aperture such as f/5.6. And if you want maximum depth of field with a macro image at close focusing range, choose a narrow aperture of f/16 or f/22 and use a tripod.
Accessories	A tripod is always a good precaution when you're taking close-up or macro shots and when using a telephoto lens. You can also buy plant holders that do not damage the plant, but hold it steady against outdoor breezes.

Flower and macro photography tips

✦ **Try a high position.** When photographing large gardens, try shooting from a high position. You can even shoot from a ladder to show the overall scope and color patterns of the garden.

✦ **Ensure precise focus for floral shots.** Anything short of razor-sharp detail detracts from floral images. If necessary, switch to manual focus by moving the switch on the Canon lens to the Manual setting. Then you can tweak the final focus to perfection.

✦ **Enhance color.** In outdoor pictures, use a polarizer to enhance color saturation of the flower colors and the sky.

✦ **Use the sky as a backdrop.** To create striking images, use a low shooting position and tilt the camera up to isolate the flower against a deep blue sky.

✦ **Use lighting to your advantage.**
Many flower petals are transparent, and with backlighting, the delicate veins of the petals are visible. The same is true for many plant leaves. Watch for backlighting to create compelling and very graphic images of flowers and plants.

Food Photography

Photographing food looks easy, but this lucrative niche of the photography business is more demanding than it may appear at first glace. Food photography, along with other photographic specialties, often requires the services of a stylist, as well as multiple versions of the same dish so that new dishes can be swapped in when the current dish has lost its peak of visual/ photographic appeal.

The area of food photography encompasses not only specific dishes, but also conceptual shooting for magazines and books that show food groups, recipe ingredients, nutritional components, and so on. Lighting is set up to give maximum visual appeal to the food. It's not uncommon when shooting a vegetable or group of vegetables, for example, to use lighting patterns similar to those used in portrait photography. This specialty area also borrows from skills, compositional techniques, and natural lighting used in still-life and some product photography.

As in other areas, food photography follows current trends that range from extremely shallow depth of field, backlighting, extreme close-ups, and natural lighting to extensive depth of field with elaborate setups and extensive studio lighting. In some cases, prime specimens are flown in from exotic locations especially for photo shoots.

With wide-angle shots, the 30D produces good edge sharpness with L-series lenses, and for close-up shots with shallow depth of field, the EF100mm f/2.8L USM and EF 180mm f/2.8L Macro USM, as well as the tilt and shift lenses are good candidates for food photography. The telephoto lenses also produce beautiful bokeh, the way the lens renders the out-of-focus area of the image.

7.37 Color and visual appeal are primary factors in photographing food. Taken at ISO 100, f/14, 1/125 sec. using a Canon EF 100mm f/2.8 USM lens.

Inspiration

Most types of food have emotional connotations associated. As you set up food shots, think of the emotion associated with the particular food and set out to capture it in the image. Certain foods are iconic either as foods that everyone enjoys (guilty pleasures), as being healthy (apples, carrots, spinach, etc.), or as being associated with an event (hotdogs at baseball game). These types of images make good stock shots, and for those new to shooting food, they provide practice for assignment shooting.

Taking food photographs

7.38 A simple studio or on-location setup allows you to capture an image that the client can then add text or graphics to in final production. Taken at ISO 100, f/22, 1/1/25 sec. using a Canon EF 24-105mm f/4L IS USM lens.

7.39 Although a food stylist is the best option for setting up shots, you can produce appealing images by keeping the set simple.

Table 7.13 **Food Photography**	
Setup	**In the Field:** For most food photography, plain dishes such as white or black offer excellent contrast with the colors of food, and they don't distract from the food itself as shown in figure 7.39.
	Additional Considerations: A small collection of bowls, saucers, plates, placemats, and utensils is all you need to begin shooting portfolio pieces. Also monitor the current trends in food photography. Currently it is close-up shots with simple setups. The trends, of course, are subject to change, but it's easy enough to keep tabs on trends by checking newsstand magazines periodically.

Lighting

In the Field: This image was shot in the studio using four Photogenic strobes: two 320s and two 160s with a large silver reflector to camera right. Two strobes lit the white seamless background, one strobe was to camera left and another above the dish.

Additional Considerations: Many of the current food shots utilize either natural lighting or studio lighting that is set up to simulate natural window lighting. For shots lit with studio strobes, you can often avoid getting specular highlights on the subject by using a softbox on the main light. This approach also supports the currently popular trend of soft, uniform light throughout the subject for images of entrees, for example, although the style varies to harder lit scenes as well.

Lens

In the Field: Canon EF 100mm f/2.8 Macro USM lens.

Additional Considerations: Your lens choice depends on what you want to achieve in the photo. For a soft background, use a telephoto lens; for close-ups with minimal depth of field, the EF 100mm f/2.8 Macro USM and the EF 180mm f/2.8L Macro USM lenses are good choices.

Camera Settings

In the Field: RAW capture, Manual mode, with a custom white balance.

Additional Considerations: If you're shooting a series of dishes under the same light, you'll save time by setting a Custom white balance before you start shooting. Whether you're shooting food on assignment, for portfolio work, or for stock, set the camera at the highest resolution so that you can offer the client or agency the highest resolution possible for the largest possible reproduction size.

Exposure

In the Field: ISO 100, f/18, 1/125 sec.

Additional Considerations: High image quality is a paramount requirement in food photography. For minimal digital noise, use ISO 100 or 200. In lower-light venues, use a tripod as well. Depending on how much of the subject you want in sharp focus, an aperture of f/5.6 is a good starting point for close-up shots and for food shots that show table settings and people blurred in the background.

Accessories

Regardless of how softly lit and shallow the depth of field is in popular trends for food photography, sharpness is still essential. For that reason, be sure to use a tripod.

Food photography tips

✦ **In a series of shots, establish a uniform shooting position.** If you're shooting a series of dishes, establish an appealing shooting position and maintain it throughout the series by setting the tripod to that position and moving the tripod down the table of prepared dishes or by moving the dishes to the tripod/camera position.

✦ **Maintain the ambience.** The warmth of tungsten (ordinary household) lighting adds an appeal to food because it recalls the warmth and fun of eating at home, while window light adds a sense of realism and freshness. Use natural and artificial light to your advantage to make the food warm and inviting, and to evoke the natural associations that we have with the food.

✦ **Light for the subject.** While a good interplay of highlight to shadow gives the image depth, be sure to use the lighting setup so that it spotlights the main subject of the image and not the background or supporting elements. Many food shots fail to throw light in front of the dish putting the main subject in light to medium shadow. This can happen with high-side lighting. Adding a small reflector to the shadow side so that the main dish receives a small but important kick of light helps keep the food well lit and in the forefront of the image.

✦ **Keep the setup simple, and use a coordinated color palette.** Setups can be as simple as a bowl on a placemat, but generally the contents of the bowl, the color of the bowl, and the color of the placemat should be complimentary.

✦ **Get accurate color.** Setting a custom white balance is the best way to ensure color accuracy for a single dish or a series of food dishes.

Landscape and Nature Photography

With breath-taking vistas of forests, mountains, and expanse of sky, God's handiwork remains a favorite subject of photographers. From dawn to dusk and sometimes beyond, our environment provides an endless source of inspiration for lovely images. And you don't have to go far. You can choose a single location and return day after day to take entirely different pictures. Seasonal changes to flora and fauna, passing wildlife, rain, sunshine, fog, and snow all contribute to nature's ever-changing canvas.

Photographing landscapes and nature requires high levels of both creative and technical skills to create compositions that are dynamic and evocative of the mood of the scene, and that adequately capture the extremes of light and shadow.

Tip *The image histogram is a great tool for evaluating whether the camera has successfully captured detail in both light and dark areas. If the histogram shows pixels crowded against the left, right, or both sides of the histogram, the camera wasn't able to maintain detail in one or both areas. Filters, such as a graduated neutral-density (NDGrad) filter, can help balance the exposure for bright sky areas and darker foreground areas allowing the sensor to hold detail in both areas.*

The challenge of outdoor photography is in capturing the essence of a scene without the aid of chirping birds, the smell of clover, and the warm breeze of a late spring day. Compositional techniques including identifying a center of interest, using leading lines, framing, and placing the line of the horizon off-center go a long way in creating interesting nature pictures that help convey the sense of grandeur and beauty that you sense when the scene catches your eye.

The quality of light plays a starring role in nature photography. The low angles of the sun at sunrise and sunset create shadows that add a sense of depth to landscapes not to mention the beautifully rich hues these times of day add. Fog adds a sense of mystery, overcast light enriches colors, and rain dapples foliage with fascinating patterns of water droplets.

You can set the Picture Style to Landscape to achieve vivid blues and greens with a boost to contrast and sharpness. If you're shooting JPEG images, you can set the Picture Style so that it's applied in the camera, and you can adjust the sharpness, contrast, color saturation, and color tone to your liking. Or if you're shooting RAW, you can apply the

7.40 Whether it's a frog hanging out on a lily pad, or a bird soaring through the air, nature is filled with intriguing photographic opportunities. Taken at ISO 100, f/4, 1/50 sec. using a Canon EF 24-105mm f/4L IS USM lens set to 105mm.

style and adjust contrast and sharpness using Canon's Digital Photo Professional conversion program.

Tip
One of the best tools an outdoor photographer can have is a polarizing filter that not only reduces glare and reflections, but also increases color saturation in the sky.

Inspiration

Choose a place that gives you a unique sense of, say, tranquility. Try different positions, focal lengths, and foreground elements to help capture the sense of tranquility. As you take pictures, look both at the overall scene and the components that make it compelling. Isolate subscenes that make independent compositions or can be used as a center of interest for the overall scene.

As you look around, ask yourself questions such as whether including more or less of the sky will enhance the scene and the composition. Generally, a gray, cloudless sky adds no value to the image; in these conditions, including less of the sky is a better choice. Stormy skies, on the other hand, can add drama as well as beautiful color to outdoor images.

Watch for naturally occurring elements such as an old wooden fence, a winding road, or a decaying archway to create classic compositions.

© *Cricket Krengel*

7.41 The flock of sandpipers taking flight makes this a standout landscape and nature image. Taken at ISO 200, f/8, 1/2500 sec. using the Canon EF-S 18-55mm f/3.5-5.6 USM lens set to 55mm.

Taking landscape and nature photographs

7.42 Expansive mountains, the clouds, and the farming area made this a must-capture scene in Snohomish, WA.

Table 7.14
Landscape and Nature Photography

Setup	**In the Field:** In figure 7.42, the dramatic clouds contrasted beautifully with the mountains and farming area in the foreground. To avoid getting ground-level weeds, I stood on the running board of my truck to get a slightly higher shooting position.
	Additional Considerations: Because such a wide variety of scenes is possible with landscapes and nature, the best advice is to trust your eye to set up and compose images. Try to exclude distracting high-line wires, road signs, and trash within the scene. Shoot from a variety of low, high, and eye-level positions. For sweeping scenes, include a foreground object such as a person, a rock, or a fence to give a sense of scale. As you look through the viewfinder, consider how the elements in the frame will direct the viewer's eye in the final picture.

Continued

Table 7.14 *(continued)*

Lighting	**In the Field:** The overcast lighting reduced the dynamic range of this scene enough that I was able to capture detail in the highlights and open up shadows during RAW conversion.
	Additional Considerations: A variety of lighting conditions is inherent in landscape and nature photography. Often, the best light is during and just after or before sunrise and dawn when the low angle of the sun creates long shadows and enhances the colors of flora and fauna.
Lens	**In the Field:** Canon EF 70-200mm f/2.8L, IS USM lens set to 145mm.
	Additional Considerations: Both wide-angle and telephoto zoom lenses are good choices for landscape and nature photography. For distant scenes, a wide-angle lens renders some elements too small in the frame. Use a telephoto lens to bring them closer.
Camera Settings	**In the Field:** Aperture-priority AE mode with white balance set to Daylight.
	Additional Considerations: Aperture-priority AE mode with white balance set to match the light is a favorite choice. Because some landscape images look better with deeper color, you can set Exposure Compensation to –1/2 or –1/3 stop. Just press the +/- Exposure compensation button on the back of the EOS 30D, and dial in the amount of compensation you want.
Exposure	**In the Field:** ISO 100, f/9, 1/400 sec.
	Additional Considerations: Use the lowest ISO possible to avoid digital noise. In most landscape and nature photos, extensive depth of field is the best choice. Meter for the most important element in the scene, and bracket to ensure that at least one frame does not have blown-out highlights.

Landscape and nature photography tips

✦ **Position yourself to take advantage of the sky as a backdrop.** For pictures of foliage, flowers, and colorful seasonal trees, use a low shooting position and shoot upward if you have a deep blue sky as the backdrop for the subject.

✦ **Get extensive depth of field.** To get extensive depth of field, set the EOS 30D to Aperture-priority AE mode, and choose a narrow aperture such as f/11 or f/16. Then focus the camera one-third of the way into the scene, lock the focus, recompose, and take the picture.

✦ **Don't always default to using a wide-angle lens.** Many people associate landscape photography with wide-angle lenses. However, telephoto lenses are indispensable in all types of outdoor photography, and they are very useful for isolating a center of interest in a wide-ranging vista.

✦ **When you shoot landscapes, include a person or object to help provide scale.** For example, to bring home the massive size of an imposing mountain range, include a hiker in the foreground or midground to give the viewer a scale of reference.

✦ **Look for details that underscore the sense of the place.** A dilapidated fence or a rusted watering trough in a peaceful shot of a prairie helps convey how the land was used.

✦ **Look for interesting light.** For example, when you shoot in a forest or shaded area, look to include streaming shafts of light coming

through the trees or illuminating a single plant.

✦ **Use exposure compensation in scenes with large areas of light colors.** Large areas of light or white such as snow scenes or white sandy beaches can fool the camera meter into underexposing the image. To ensure that the snow or sand appears white in the final image, set exposure compensation on the EOS 30D to +1 or +2.

✦ **Look for different ways to frame the scene.** Try using a tree as a frame along one side of the frame or a break in the foliage that provides a natural window that reveals a longer view of the scene.

Night, Evening, and Low-Light Photography

If you're ready to challenge your photography skills, shooting low-light and nighttime images is a great way to do it. Evening and night images not only expand your understanding of exposure, but they also open a new world of creative challenge, enjoyment, and the potential for lovely results. Some event assignments and stock photography also require you to shoot in low-light scenes and at evening and nighttime, so having a good understanding of how to get good results without excessive digital noise is important.

Sunset and twilight are magical photography times for shooting of subjects such as city skylines, harbors, and downtown buildings. During twilight, the artificial lights in the landscape, such as street and office lights, and the light from the sky reach

7.43 The lure of light against the darkness of evening is always appealing. This lamp post was no exception. Taken at ISO 100, f/4.5, 1/100 sec. using a Canon 70-200mm f/2.8L IS USM lens set to 145mm.

Fireworks Photography

If you want to capture the rocket's red glare, you can use lenses in the range of 28-100mm. Choose an ISO from 200 to 400. Because the camera may have trouble focusing on distant bursts of light, you can pre-focus manually on infinity and get good results. I also recommend using a tripod or setting the camera on a solid surface to ensure sharp images. If you want to keep it simple, you can set the camera to Full Auto and then just point and shoot.

If you want to have more creative control, you should know that capturing fireworks is an inexact science at best. I usually set the camera to ISO 200, use Manual mode, set the aperture to f/11 or f/16, and set the shutter on Bulb, which allows you to keep the shutter open as long as the shutter button is depressed. You can experiment to find the best time, usually between one and two seconds. Check the results on the LCD and adjust the time as necessary. The goal is to get a long enough exposure to record the full burst without washing out the brightest colors.

The different bursts of fireworks composited here were taken at ISO 200, f/11, 1/3 sec. with the Canon EF 70-200mm f/2.8L IS USM lens and a tripod. I merged them using Adobe Photoshop CS2.

Don't worry if you miss some good displays at the beginning of the fireworks show because the finale usually offers the best photo opportunities. During the early part of the display, get your timing perfected and be ready to capture the finale.

approximately the same intensity. This crossover lighting time offers a unique opportunity to capture detail in a landscape or city skyline, as well as the sky.

Low-light and night photos are a great chance to use Manual mode on the EOS 30D. Sample starting metering recommendations are provided in Table 7.15.

Table 7.15
Ideal Night, Evening, and Low-Light Exposures

Subject	ISO	Aperture	Shutter Speed
City skylines (shortly after sunset)	100 [400]	f/4 [f/8]	1/30 second
Full moon	100	f/11	1/125 second

Campfires	100	f/2.8	1/15 to 1/30 second
Fairs, amusement parks [1/30-1/60]	100 [400]	f/2.8	1/8 to 1/15 second
Lightning	100	f/5.6 [f/8]	Bulb; keep shutter open for several lightning flashes
Night sports games	400 to 800	f/2.8	1/250 second
Candlelit scenes	100 [200]	f/2.8 [f/4]	1/4 second
Neon signs	100 [200]	f/5.6	1/15 second [1/30]
Freeway lights	100	f/16	1/40 second

Inspiration

Try shooting city skyline shots in stormy weather at dusk when enough light remains to capture compelling colors in the sky. Busy downtown streets as people walk to restaurants, cafés, and diners; gasoline stations; widely spaced lights on a lonely stretch of an evening highway; the light of a ship coming into a harbor; or an outdoor fountain or waterfall that is lit by nearby streetlights are all potential subjects for dramatic pictures, as are indoor events such as concerts and recitals.

7.44 Waiting for the sky to get just the right amount of deep sapphire blue with a tinge of gold from the sunset meant waiting until almost 10 p.m. to capture this view of the Seattle skyline across Lake Washington. Taken at ISO 100, f/8, 1/6 sec. using a Canon EF 70-200mm f/2.8L IS USM lens set to 173mm and a sturdy tripod.

Taking night, evening, and low-light photographs

7.45 Dusk on a spring evening provided lovely classic low light for this scene of a popular dinner ship in the Seattle area.

Table 7.16
Night, Evening, and Low-Light Photography

Setup	**In the Field:** The primary setup for figure 7.45 was to wait for the right light and position myself on the pier to avoid people who were leaving the dinner ship that evening.
	Additional Considerations: If you are photographing a busy area, find a location that is away from pedestrian traffic and is unaffected by the vibration of passing cars. Ensure that your composition has a clear message and isn't visually confusing by including too much in the frame. Be aware that passing cars and nearby lights can influence the meter reading on the camera. If it interferes, change your shooting position if possible.
Lighting	**In the Field:** This image was taken while there was still clarity in the blue of the evening sky, but also late enough that the pier lights were visible against the darkening sky.
	Additional Considerations: To photograph scenes with floodlit buildings, bridges, or other night scenes, begin shooting just after sunset so that the buildings stand out from the surroundings. Check the image histogram on the LCD by pressing the INFO button to display the histogram.

Lens	**In the Field:** Canon EF 70-200mm f/2.8L IS USM lens set to 78mm.
	Additional Considerations: A wide-angle zoom lens set to 18mm or 24mm allows you to get a broad expanse of night and evening scenes. Telephoto lenses, of course, are great for bringing distant scenes closer, but at this time of day, a tripod is a requirement especially if you use a long lens.
Camera Settings	**In the Field:** Aperture-priority AE with white balance set to auto (AWB).
	Additional Considerations: Assuming that you have the camera on a tripod or on a solid support, Aperture-priority AE mode gives you control over the depth of field. In Basic Zone mode, you can turn off the flash and use Landscape mode.
Exposure	**In the Field:** ISO 100, f/4.5, 1 sec.
	Additional Considerations: Just past sunset, you can usually rely on the meter to give a good exposure, but you may choose to bracket exposures at 1-stop intervals. However, if bright lights surround the scene, the meter can be thrown off. Use a lens hood and check the image histograms often in the LCD. To keep exposure time down, you can increase the ISO up to 400 or even 800.
Accessories	A tripod or setting the camera on a solid surface is essential in low-light scenes.

Night, evening, and low-light photography tips

✦ **Be safe and use common sense.** Night shooting presents its own set of photography challenges, including maintaining your personal safety. Always follow safety precautions when shooting during nighttime. Be sure to wear reflective tape or clothing, carry a flashlight, and carry a charged cellphone with you.

✦ **Use a flashlight to focus.** If the camera has trouble focusing, train your flashlight on the subject long enough to focus manually or automatically, and then turn off the flashlight before you take the picture.

✦ **Use a level when using a tripod.** A small bubble level designed to fit on the flash hot shoe mount is an indispensable piece of equipment for avoiding tilted horizon shots.

✦ **Try the Self-timer mode.** You can, of course, negate the advantage of using a tripod by pressing the shutter release button with your finger. Just pressing the shutter button your finger can cause noticeable loss of sharpness. A better solution is to use the Self-timer mode.

Panoramic Photography

When the full, glorious sweep of a scene takes your breath away and makes you wish that you could capture it end to end, then the scene is a good candidate for panoramic photography. In traditional photography, a panoramic photo is longer and narrower than traditional photos, and it is taken with a panoramic camera. Panoramic cameras vary from those that scan and gradually record the entire scene to others that capture the scene all at once.

With digital photographs and the PhotoStitch program, software that precisely aligns a series of photos side to side or top to bottom that comes with the EOS 30D, you can easily create panoramic photos.

The technique of taking a series of pictures for a panorama is to shoot successive images of a scene from left to right or top to bottom. To make the images consistent, keep the camera exposure and settings the same and keep the camera level across all pictures. Each successive image should include some overlap with the previous image. The overlap helps later when you align the images.

 Note *Programs such as PhotoStitch help you merge two or more pictures into a panorama and print the merged images. If you're so inclined, you can create images with a 360-degree wrap-around view. And you can shoot images for the panorama in vertical or horizontal format. The program also automatically adjusts for differences in brightness and color. Because the final image is a combination of multiple single images, the file size of panoramic images is very large.*

Inspiration

Panoramic photography is most often associated with landscape subjects, but residential and commercial interiors, city skylines, and gardens are good subjects as well. Look for sweeping scenes that have visual beginning and end points and a strong subject or center of interest. Dramatic lighting, clouds, and repeating patterns are good candidates for panoramas.

7.46 A sweeping cloudscape made a good candidate for stitching two images into a panorama. The exposure for the images was ISO 100, f/8, 1/160 sec. using a Canon EF 70-200mm f/2.8L IS USM lens set to 70mm.

Taking panoramic photographs

7.47 This panoramic was stitched together from five images of a farming community in the shadow of the mountains near Carnation, Washington.

Table 7.17
Panoramic Photography

Setup	**In the Field:** As I looked at the scene in figure 7.47, I determined how much of it that I wanted in the final combined image. Then I started shooting from left to right leaving about a 25-percent overlap in each subsequent shot.
	Additional Considerations: Identify the composition that you want in advance of shooting. The composition should include a center of interest and follow the traditional composition guidelines. Moving objects such as birds and planes are not good to include in panoramas. Their movement and position through the series of images can make subsequent image stitching more difficult. Technique is also important: Keep the camera level across the series of images.
Lighting	**In the Field:** The day was cloudy and the cloud formations provided another point of reference for stitching together the images. To lessen the deep shadow areas, I used Photoshop's Curves and Shadow/Highlight command to open up shadow areas during image editing.
	Additional Considerations: Choose a time of day when the lighting remains constant. If you include the sun, try to keep it entirely within one of the images, rather than partly in two or more images to make stitching easier.
Lens	**In the Field:** Canon EF 16-35mm f/2.8L USM lens set to 24mm.
	Additional Considerations: The final panoramic here measures 25 inches wide at 300 dpi. You can make nice panoramas from as few as two images or as many as five, but keeping images to a reasonable number, say three, makes stitching much easier. And images taken with telephoto lenses are often easier to stitch than those taken with wide-angle lenses.

Continued

Table 7.17 *(continued)*

Camera Settings	**In the Field:** RAW capture, Aperture-priority AE mode with the white balance set to Daylight.
	Additional Considerations: Because you want the same exposure for all images in the same panorama, Manual mode may be the best mode; if you use auto exposure, the difference between sections of the panorama may vary making it more difficult to achieve an even exposure across images. Good depth of field is preferable with panoramic images. A panorama need not be horizontal. You can also shoot vertical panoramic images. The more the images overlap, the easier it is for the stitching program to combine them seamlessly.
Exposure	**In the Field:** ISO 100, f/11, 1/125 sec.
	Additional Considerations: To maintain extensive depth of field, set the aperture to f/8 or f/11. This is also a situation where you want to avoid unnecessary digital noise by setting the ISO to 100 or 200.
Accessories	Definitely use a tripod to keep the camera level across the series of shots.

Panoramic photography tips

✦ **Use polarizing filters with caution.** Because the angle of light changes as you take images across the scene, a polarizing filter can cause problems in keeping the image saturation and color consistent across the series.

✦ **Have a composition in mind before you begin.** This helps you determine where you want the center of interest in the final image. And with the final composition in mind, you can determine the starting and ending points.

✦ **Opt for extensive depth of field.** The aperture you use should be as narrow as possible to ensure extensive depth of field.

✦ **Include large objects in a single frame.** Try to have large foreground elements such as trees and buildings in a single frame rather than stitched across multiple frames. If this isn't possible, be very careful to keep the camera level and allow at least 25-percent overlap between frames.

✦ **Take several series of the same scene.** Take a panoramic series more than once as insurance that one series will stitch together seamlessly.

Pet and Animal Photography

Nothing gets an "awww" quicker than a cute pet or animal photo. Next to photographing people, pets and animals are some of the most appealing subjects in photography and can be a lucrative specialty area. And as with people photography, the goal is to convey the personality of the pet or animal. Of course, a major difference is that few if any pets and animals smile, so conveying the animal's mood hinges on eliciting its natural curiosity and interest, and then capturing the mood in the animal's eyes and actions.

7.48 This image was taken in a store specializing in breeding exotic birds. The exposure for this image was ISO 100, f/2.8, 1/25 sec. with the camera handheld.

7.49 If you have a willing subject, there are endless ways to create humorous images. Snickers was raised in front of a camera, and for the promise of a biscuit, she wears almost anything I put on her. Taken at ISO 100, f/22, 1/125 sec. using a Canon EF 50mm f/1.4 USM lens.

 Note *When you photograph pets and animals, keep the welfare of the animal in mind. Never put the animal in danger or expect more of the animal than it is capable of or willing to give.*

Young, untrained pets and animals provide lots of appeal, but they can be harder to work with because they don't respond to verbal commands. In these situations, give the pet a large but confined area and go with the flow, using props, toys, and rewards to entice the behavior you want. Even with older pets that normally respond to verbal commands, don't be surprised if

their response is less predictable when you're photographing them. After all, they can't see your face when it's behind the camera. Instead, establish eye contact with the animal as you set up the camera and talk to the animal throughout the photo session. And, of course, be patient with the animal and offer rewards and verbal encouragement.

If you choose an outdoor location, consider an area that limits the animal's ability to roam. Otherwise, you may find yourself trailing behind your pet trying to get a good shot when your pet would really rather be chasing birds in the yard. And, like people, pets quickly tire of having flash pictures

taken, and some learn to look away from the camera. As an alternative to using a flash, photograph the animal outdoors or by the light of a nearby window. Continuous Drive mode is a good choice for taking successive shots.

Inspiration

Photo opportunities include any new experiences for the animal such as getting acquainted with another pet, the animal sleeping in odd positions or curled up with other pets, a pet watching out the window for kids to come home from school, racing after a ball or Frisbee, or performing in an arena.

Taking pet and animal photographs

7.50 Photographing trained pets in a studio is relatively easy. Here the pet is sitting on a table with white seamless paper as the background.

Table 7.18
Pet and Animal Photography

Setup	**In the Field:** I set up seamless paper on a stand for the background in figure 7.50 and positioned the Schnauzer on the table several feet in front of the background.
	Additional Considerations: Indoor pictures are relatively easy to set up for small pets and animals. If you include a favorite toy, be sure that it doesn't obscure the pet's face. Outdoor setups are easiest and provide a natural background for the animal, but often keeping the animal from wandering off is difficult. Find open areas where grass or natural foliage can be the background. Be sure to focus on the animal's eyes.
Lighting	**In the Field:** Four studio lights were used for this image: Two lights to light the background, a light in front of the Schnauzer, and one to the left shooting into a silver umbrella. A silver reflector to the right of the dog reflected light into the shadow side of the dog.
	Additional Considerations: Indoors, you can use the basic lighting setup described above, or you can use the light from a nearby window. Outdoors, late afternoon and sunset light provide beautiful light for animal pictures.
Lens	**In the Field:** Canon EF 50mm f/1.4 USM. This lens offers excellent contrast and sharpness.
	Additional Considerations: Your lens choice depends in part on whether you're taking a portrait or full-body picture and the size of the pet or animal. For large animals, the Canon EF 24-70mm f/2.8L USM lens is a good choice.
Camera Settings	**In the Field:** RAW capture, Aperture priority AE, with a custom white balance setting.
	Additional Considerations: For outdoor pet portraits, Aperture priority AE mode allows you to control the depth of field, but in lower light and if the animal is fidgety, Shutter priority AE mode may be the best choice to ensure that the shutter speed is fast enough to prevent blur.
Exposure	**In the Field:** ISO 100, f/16, 1/125 sec.
	Additional Considerations: If you use Aperture-priority AE mode, watch the shutter speed to ensure that it isn't slower than 1/30 second to avoid motion blur if the animal moves. In general, try to keep the shutter speed at 1/60 second or faster by choosing a wider aperture. If you fear that the animal will move, brighten the lights or add additional lights so that you can use a faster shutter speed. Or you can increase the ISO to 200, or use a wider aperture, such as f/5.6.
Accessories	For more traditional portraits of pets indoors, use a tripod. Outdoors, a tripod may not be practical, so be sure the shutter speed is fast enough to prevent motion blur. Also, have biscuits and toys available to attract the pet's attention.

Pet and animal photography tips

✦ **In most cases, shoot from the pet's eye level.** Occasionally, a high shooting position is effective to show a young animal's small size, but generally you'll get the most expression when you are on the same eye level with the animal.

✦ **Entice the animal with a treat or toy.** To get an animal to look in a particular direction, try holding a favorite toy or treat in your hand and move it in the direction that you want the pet to look.

✦ **Focus on the eyes.** Always focus on the pet or animal's eye that is nearest to the camera. Depending on how you want to render the background, you'll want to have sharpness throughout the animal for more formal portraits.

✦ **Try other techniques.** Use the techniques described in the earlier sections cover action and sports photography to photograph animals in action.

Portrait Photography

Portraiture is likely the most popular of photographic specialties, and high school seniors can provide a steady source of revenue for professional photographers and aspiring professionals as well. The goal of all portraiture is to reveal an individual's personality and spirit.

The following sections detail some of the key considerations involved in portraiture.

Lens choices

For head and head-and-shoulders portraits, normal to medium telephoto lenses ranging from 35mm to 100mm are excellent choices. With a characteristic shallow depth of field, telephoto lenses help blur the background to make the subject stand out. For full-length and environmental portraits, a moderate wide-angle lens is a good choice, provided that the subject is not close to the lens. A wide-angle lens distorts facial features in ways that the subject will not appreciate.

7.51 Portraits don't require elaborate setups. Simple, straightforward images that capture the inherent happiness of a person form the foundation of good portraiture. Taken at ISO 100, f/14, 1/125 sec. using the Canon EF 24-105mm f/4L IS USM lens set to 58mm.

Flash Photography

The EOS 30D has exceptionally good flash metering for both indoor and outdoor pictures. Even in backlit scenes, the Flash Output Reduction feature ensures that the subject is not overexposed. The distance covered by the flash increases as the ISO increases. In other words, if you set the camera to ISO 200, the flash distance is greater than at ISO 100. Also, to help lessen red-eye, increase the amount of room light as much as possible.

You can also use Flash Exposure Lock in the Creative Zone modes to light an off-center subject. Just turn on the flash and verify that the flash icon is lit in the viewfinder. Press the Shutter button halfway down and hold it. Place the subject in the center of the frame, and press and hold the Exposure Lock button on the back of the camera while you also continue to hold the Shutter button halfway down. Then move the camera to recompose the image and take the picture.

If you use an accessory flash, such as the Canon Speedlite 550EX, buy a synch cord or flash bracket so that you can position the flash unit farther away from the lens. With an accessory flash unit, you can also point the flash head toward a neutral color (or white) ceiling or wall to bounce the flash. The bounced light is diffused producing a much softer and more flattering light. You can use an accessory flash unit to fill shadows, stop action in lower-light scenes, and add a pop of sharpness in panned shots.

Backgrounds and props

A portrait should make the subject the center of attention, and that's why a non-distracting or softly blurred background is important. Even if you have trouble finding a good background, you can de-emphasize the background by using a wide aperture such as f/4.0 or f/2.8. If you plan to use a flash, be sure to move the subject well away from the background to avoid dark shadows. Alternately, use harsh light and let deep shadows outline the subject. With seniors in particular, you can use props and locations that help show the senior's areas of interest. For example, a football field is as good a background for a star football athlete as studio muslin or white seamless. For a musician, the musical instrument can be incorporated into one or more of the images.

Lighting

Lighting choices differ for portraits of men and women. For men and boys, a strong, directional daylight can be used to emphasize strong masculine facial features. For women and girls, soft, diffuse light streaming from a nearby window or the light on an overcast day is flattering. To control light, you can use a variety of accessories including reflectors to bounce light into shadow areas and diffusion panels to reduce the intensity of bright sunlight. These accessories are equally handy when using the built-in or an accessory flash for portraits. For the best exposure, take a meter reading from the highlight area of the subject's face, use Exposure Lock, and then recompose and take the picture.

Flash

The built-in flash produces nice images, especially with a negative flash compensation. However, you often have more flexibility when you use an accessory flash. With accessory flash units, you can soften the light by bouncing it off a nearby wall or ceiling. You can also mount one or more accessory flash units on light stands and point the flash into an umbrella to create studio-like lighting results on location. Inexpensive flash attachments such as diffusers and soft-box-like attachments are also a great option for creating nice portrait lighting.

Tip *Use flash exposure compensation to dial back to the amount of light from the flash that you want.*

Regardless of the light source, be sure that the subject's face is lit so as to bring it to the front of the image. The eyes should have catch-lights, or small, white reflections of the main light in the subject's eyes, and a 2 o'clock catch light position is classic. Light also affects the size of the subject's pupils — the brighter the light, the smaller the pupil size. A smaller pupil size is preferable because it emphasizes the subject's irises (color part of the eye), making the eyes more attractive.

Posing

Entire books are written on posing techniques for portraits. A quick guideline is that the best pose is the one that makes the subject look comfortable, relaxed, and natural. In practice, this means posing the subject in a comfortable position and in a way that emphasizes the attractive features while minimizing less-attractive features. Key lines are the structural lines that form the portrait. Posing the subject so that diagonal and triangular lines are formed by the legs, arms, and shoulders creates more dynamic poses.

Also, placing the subject's body at an angle to the camera is often more flattering than a static pose that has the head and shoulders on the same vertical plane.

Clothing

Today, seniors, and adults as well, expect multiple clothing changes for sessions. If you're shooting on location, consider bringing a relatively affordable popup changing booth, and at the studio, be sure to have a changing and makeup area. Discuss clothing changes with the subject beforehand to coordinate backgrounds with clothing.

7.52 Seniors are savvy about photography trends and often have their own ideas about what they want so it was no surprise that this young man also wanted to use this photo to promote his motocross riding. Taken at ISO 100, f/14, 1/125 sec. using the Canon EF 24-105mm f/4L IS USM lens set to 58mm.

Rapport

Even if you light and pose the subject perfectly, a portrait can easily fail if you haven't established a positive connection with the subject that is mirrored in the subject's eyes. Every minute you spend building a good relationship with the subject pays big dividends in the final images.

Inspiration

Before you begin, talk to the senior or subject about his or her dreams and aspirations or interests. Then see if you can create setups or poses that play off of what you learn. Consider using props; for example, big, floppy hats for women can become inspiration improvisations. Alternately, play off the subject's characteristics. For example, with a very masculine subject, use angular props or a rocky natural setting that reflects masculinity.

When photographing senior portraits, be sure you're up on the latest fashion shooting trends and styles. For inspiration and ideas, browse the latest newsstand magazines and music CD covers.

Taking portrait photographs

7.53 Regardless of the variations that you take during a senior session, be sure to capture a traditional pose because it is often the pose that the parents, who pay for the session, will prefer.

Table 7.19
Portrait Photography

Setup	**In the Field:** For the picture in figure 7.53, Heath was on a posing stool several feet in front of a seamless white background.
	Additional Considerations: Uncluttered and simple backgrounds are effective for making the subject stand out from the background. If you don't have white paper or a large white poster board, use a plain, neutral-color wall and move the subject four to six feet from the background. Moving the subject away from the background and lighting the background separately helps reduce or eliminate background shadows. If you are just beginning, keep poses simple and straightforward, and allow the subject to assume a natural position, and then tweak the pose for the best effect.
Lighting	**In the Field:** This image was taken using four Photogenic Studio Max II strobes: two 320s and two 160s, and a large sliver reflector to camera right. Two strobes lit the seamless background, and two strobes were to camera left. A large silver reflector was placed to camera right.
	Additional Considerations: If you do location shooting, you can use multiple accessory flash units and a wireless transmitter to simulate studio or natural light effects. Otherwise, you can use window light alone or in combination with a silver reflector or two: For example, use one reflector to reflect window light onto shadow areas of the background and one to fill shadows on the subject.
Lens	**In the Field:** Canon EF 24-105mm f/4L IS USM lens set to 105mm.
	Additional Considerations: Most photographers prefer a focal length of 100mm to 105mm for portraits. Canon offers a variety of zoom lenses that offer a short telephoto focal length, such as the EF 24-105mm f/4L IS USM, and the EF 70-200mm f/2.8L IS USM lenses. Another lens to consider for excellent contrast in portraits is the renowned Canon EF 50mm f/1.4 USM lens (equivalent to 80mm on the EOS 30D).
Camera Settings	**In the Field:** Manual mode with a custom white balance.
	Additional Considerations: In the field, you want to control depth of field for portraits, so Aperture-priority AE mode gives the most control.
Exposure	**In the Field:** ISO 100, f/14, 1/125 sec.
	Additional Considerations: Avoid digital noise in shadow areas, particularly on portraits—choose the lowest ISO possible. To get a depth of field that ensures facial features that are reasonably sharp, set the aperture no wider than f/5.6 or f/8, depending on your distance from the subject.
Accessories	A tripod is a good accessory for portrait work, although it limits your ability to move around the subject quickly to get different angles. If the light permits, shooting off the tripod frees you to try more creative angles and shooting positions.

Portrait photography tips

✦ **Prepare a list of poses ahead of time.** People often feel uncomfortable posing for the camera. Having a list of poses minimizes setup changes, and you can move through the pose list with good speed.

✦ **Flatter the subject.** For adults, ask the subject to lift his or her head and move it forward slightly to reduce the appearance of lines and wrinkles. Watch the change to see if the wrinkles are minimized. If not, adjust the pose further.

✦ **Use natural facial expressions.** It's always nice if the subject smiles, but portraits in which the subject is not smiling can be equally effective.

✦ **Pay attention to hands.** If the shot includes the subject's hands, you can minimize the appearance of veins. You can do this by asking the subject to hold the hands with the fingers pointed up for a few minutes before you begin shooting.

✦ **Framing the subject:** In general, keep the subject's head in the upper one-third of the frame unless you are going for a specific look

✦ **Focus.** Always focus on the subject's eye that is nearest to the camera.

✦ **Always be ready to take a shot.** When a good rapport is established between you and the subject, be ready to shoot spontaneously even if the setup isn't perfect. A natural, spontaneous expression from the subject is much more important than futzing to get a perfect setting.

✦ **Take several frames of key poses.** It's entirely possible that something will be amiss with one or more frames. If you take only one picture, you won't have a backup shot of important poses.

✦ **Keep up the chitchat.** Keep up a steady stream of conversation that includes friendly directions for adjusting poses. Friendly chitchat helps put the subject at ease and allows a natural way for you to provide direction during the session.

Still-Life and Product Photography

Poetic arrangements reminiscent of paintings are what jump to mind first when many people think of still-life photography. And, of course, artistic arrangements of pottery, flowers, fruit, and personal mementos are popular subjects. But still-life arrangements also can be found in existing scenes in old homes and buildings, along sidewalks, and in stores. Product photography incorporates many of the same aspects of composition, lighting, and exposure that still-life photography uses.

Although some photographers shy away from still-life and product photography because of its slower pace, both areas offer photographers a chance to expand their creative skills. And they offer ample opportunity to try varied techniques both in the camera and on the computer.

7.54 Almost any venue offers opportunities for still-life images, such as this image spotlighting wedding favors for guests. Taken at ISO 100, f/2.8, 1/500 sec. using a Canon EF 24-70mm f/2.8L USM lens set to 68mm.

Still-life and some product photography subjects invite you to experiment with dramatic lighting and to think of ways to modify existing light. The goal of lighting and light modification is to enhance the overall mood of the setup so that it complements the subject. For example, you might use a diffusion panel or a sheer curtain to modify incoming window light for a delicate floral arrangement or for hand-made soaps, giving either subject a soft, romantic look.

The choice of lenses for still-life photography depends, of course, on the subject. In general, normal, short telephoto zoom, or moderate wide-angle zoom lenses are ideal for most still-life subjects.

Inspiration

Traditional still-life subjects are a great way to start learning the art of still-life photography. Subjects include fruit, flowers, pottery, antiques, clothing, meal entrees, beverages, bottles, soaps, coins, watch and clock parts, and decorative holiday display items.

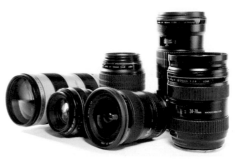

7.55 Product and catalog photography also falls into this category and offers creative opportunities. Taken at ISO 100, f/22, 1/125 sec. using a Canon EF 100mm f/2.8 Macro USM lens.

Almost anything that catches your eye for its beautiful form, texture, shape, and design is a good candidate for a still-life photo. And the same applies to product photography where you want to enhance the form, shape, and design of the product. Because the success of the image often depends on the setup and arrangement, study art and design books; publications can help spark ideas for creating your own setups.

Taking still-life and product photographs

7.56 Still-life images abound in nature and on the street. This image was taken at a suburban restaurant.

Table 7.20
Still-Life and Product Photography

Setup	**In the Field:** Figure 7.56 is a "found" image that required only thinking about how to frame the scene.
	Additional Considerations: You can find many existing still-life images around your home or outside the home. Just watch carefully for small, discrete settings that form a composition on their own. Like still-life, product photography can be shot in the context in which the product will be used, or in a studio setting with a plain background. Very often, designers require a plain background from the photographer so that they can later drop in color or a different background for the shot.
Lighting	**In the Field:** The lighting for this shot was moderate sunshine and some shade provided by the overhang of the restaurant roof.
	Additional Considerations: For small still-life and product shots that you set up on your own, the diffuse light from a nearby window is often the most attractive light. You can modify the existing light using silver reflectors to fill shadow areas, or you can use an inexpensive diffusion panel to reduce the harshness of bright light.

Continued

	Table 7.20 *(continued)*
Lens	**In the Field:** Canon EF 100mm f/2.8 Macro USM lens.
	Additional Considerations: Your lens choice depends on the scene you're shooting and your distance from it. Use a telephoto zoom lens to bring distant scenes closer and a wide-angle lens to capture larger scenes. For minimal product distortion, the Canon EF 50mm f/1.4 USM lens gives great contrast and no lens distortion.
Camera Settings	**In the Field:** RAW capture. Aperture-priority AE mode.
	Additional Considerations: To control the depth of field choose Aperture-priority AE mode and set the white balance to the type of light in the scene. If the light is low, switch to Shutter-priority AE mode.
Exposure	**In the Field:** ISO 100, f/2.8, 1/320 sec.
	Additional Considerations: If you want background objects to appear as a soft blur, choose a wide aperture such as f/5.6 or wider. This brings the focus to the main object in the scene.
Accessories	Silver reflectors and diffusion panels are handy accessories for still-life and product photography.

Still-life and product photography tips

✦ **Choose items with the most aesthetic appeal for still-life arrangements.** If you're photographing fruit or food, spend time looking for the freshest and most attractive pieces of fruit, or the freshest plate of food. With other subjects, be sure that you clean, polish, or otherwise ensure that the subject is as clean and attractive as possible.

✦ **Try out the EOS 30D's various Picture Style options.** For example, if you've set up a subject and you want a soft and subdued look, try the Portrait or Monochrome styles.

✦ **Experiment with focus.** Either with a filter on the camera or later on the computer, try adding a soft-focus effect to your still-life shots.

✦ **Experiment with different backgrounds.** A draped sheer curtain, a black poster board, or a rough adobe wall can make interesting backdrops.

Stock Photography

At some point, almost everyone who has more than a passing interest in photography toys with the idea of making money from their images. And for those who do, their short-list of ideas includes stock photography near the top. Stock photos fill the pages

With more than 1,000 stock photography agencies and organizations to choose from — ranging from the leaders such as Getty and Corbis to grass-roots organizations such as Photographers Direct — it stands to reason that you can tap into additional income that can range from a few hundred or a few thousand dollars a year to a six-figure income.

Using a stock agency as an example, the agency markets the work of many photographers. They negotiate with and finalize licensing rights with clients, collect payment,

7.57 This type of image can be used by editors looking for an image illustrating fast food, by specialty magazines, and so on. Shot in vertical format, which is commonly preferred by publications, it leaves room at the bottom and top for headlines and subheads. Taken at ISO 100, f/18, 1/125 sec. using a Canon EF 100mm f/2.8 USM lens.

of popular newsstand magazines and brochures, and grace posters in public places and billboards along the highways. Stock photography refers to existing images available for licensing by clients including advertising agencies, corporations, magazines, book publishers, and others. Existing images can be offered to clients by individual photographers, cooperatives of multiple photographers, or by stock photo agencies representing multiple photographers.

7.58 Lifestyle images have been the most in-demand images for several years, but images that evoke lifestyles are also popular. This image could be used by clients wanting a sense of peace, a spa-like environment, nature, water, and so on. Taken at ISO 100, f/7.1, 1/30 sec. using the Canon EF 100mm f/2.8 Macro USM lens.

and subsequently pay the photographer a percentage of the licensing price. The percentage split between the photographer and the agency varies, but a common split is 50/50: 50 percent goes to the photographer, and 50 percent stays with the agency. In turn, the agency takes over marketing and licensing tasks giving photographers more time to make pictures. And with the potential to license a single image multiple times, a photo marketed by an agency or cooperative can provide a continuing source of income for months or even years with no additional work on the photographer's part.

Although there are many traditional and many new stock models, stock represents a potentially lucrative way to reuse existing imagery and a creative way to market new imagery. Currently, the hottest trends in stock are for lifestyle images that run the gamut of subject areas from dining to outdoor activities and sports.

Many agencies have a minimum resolution for stock images and ranges from 8″ × 10″ at 300 dpi to 11″ × 14″ at 300 dpi. Some stock agencies allow for upsampling to increase native resolution of images to larger printing sizes. If you're new to stock shooting, check the agency requirements for resolution before requesting a portfolio review.

Inspiration

Over the years, major stock agencies have acquired thousands of images so that now they have more specific subject needs. For photographers shooting on assignment or for pleasure, it pays to consider potential stock use as you work. For example, if you're shooting landscape images, you may veer slightly to shoot roads leading up to the area because design agencies often look for scenic road shots into which they drop the car of their client later.

Conceptual shooting is also a good area to consider. Themes such as "single," "breaking up," and the "tranquility of a spa" are examples of recent stock requests for existing imagery.

Taking stock photographs

7.59 This simple image has a variety of potential uses including by clients wanting to illustrate weight loss, size, and sewing among others.

Table 7.21
Stock Photography

Setup	**In the Field:** For the image in figure 7.59, I used a white seamless background and created a dynamic position for the measuring tape. This is one of several variations in a series of this subject.
	Additional Considerations: White backgrounds are useful because clients often replace the background with a color or other background that fits their needs. Leaving space in the image composition for buyers to insert text and other graphics is also good.
Lighting	**In the Field:** This image was taken using four Photogenic Studio Max II strobes: two 320s, two 160s, and a large sliver reflector to camera right. Two strobes lit the seamless background, and two strobes were to camera left. A large silver reflector was placed to camera right.
	Additional Considerations: Bright, clean images are preferred by buyers, although stylistic variations can set your images apart from the multitudes of stock images.
Lens	**In the Field:** Canon EF 100mm f/2.8 Macro USM lens.
	Additional Considerations: Your lens choice depends on the scene you're shooting and your distance from it. Use a telephoto zoom lens to bring distant scenes closer and a wide-angle lens to capture breath-taking sweeps of landscape.
Camera Settings	**In the Field:** Manual mode with a custom white balance.
	Additional Considerations: Control the depth of field by choosing Aperture-priority AE mode. If the light is low, switch to Shutter-priority AE mode. Be sure to set the white balance to match the type of light in the scene.
Exposure	**In the Field:** ISO 100, f/22, 1/125 sec.
	Additional Considerations: Shoot many variations of stock images including some with extensive depth of field and some with selective focus.

Stock photography tips

✦ **Study existing styles.** Over the years, the quality of stock imagery has risen to some of the best to be found. Minimum expectations are excellent exposure, composition, and subject matter. But more important, agencies look for a personal style that sets imagery apart from the mass of images they have on hand. Study the images offered by top stock agencies, and determine how you can match and better what's currently being offered.

✦ **Captions and keywords.** In most cases, photographers are responsible for providing clear and accurate captions. In fact, some buyers and

photo researchers make go and no-go decisions based on the accuracy of captions.

✦ **Build a sizeable portfolio.** Most stock photo agencies expect potential photographers to have a substantial body of work—images numbering in the hundreds if not thousands. This means that if you only have a dozen or so great images, chances are better than good that a traditional stock agency won't be interested.

✦ **Image content and marketability.** Agencies look for a creative edge, if not creative genius, that makes images stand out. The "stand out" quality is, of course, judged through the dispassionate eye of a photo editor—someone who reviews hundreds of images from polished photographers every day, and someone who can quickly cull pedestrian images from star performers.

Street Photography

Henri Cartier-Bresson spoke eloquently and passionately of using the camera to tell picture stories. Making a picture story, in Cartier-Bresson's view, required that "the brain, the eye, and the heart" of the photographer work together to capture an unfolding process. For some photographers, the heart of photography exists most vibrantly in the picture stories that unfold every day on city streets. And street photography offers the singular ability to capture a broad sweep of our world in action.

Nothing is more important in street shooting than having an acute awareness of what's going on around you at all times. Certainly this awareness helps ensure your personal safety, but more important, it puts you in touch with the heartbeat of the city—that palpable throb of life in progress that makes street photography both compelling and addictive.

Many professional photographers began their careers by shooting on city or small-town streets. The street is an excellent venue to develop skill shooting in all sorts

©*2006 Peter K. Burian,* www.peterkburian.com
7.60 This image of Grand Central Station in New York City is a classic street shot that shows an iconic location with people going about their daily lives. Taken at ISO 800, f/4.0, 1/40 sec.

of lighting conditions and with a variety of subjects and scenes.

For flexibility, a fast telephoto zoom lens is ideal for street photography. It allows you to get in close to the scene while maintaining a distant, background shooting position. And because street shooting varies from bright sunlight to deep shade, a fast f/2.8 lens gives you a better chance of getting sharp handheld pictures in low-light scenes.

Street shooting is also a great way to hone your skill at composition and using selective depth of field. If you're new to street shooting, you'll find that your composition skills improve because you're continually evaluating what scene elements to include and exclude. Likewise, you're also forced to make quick decisions on choosing the aperture and camera-to-subject distance to control depth of field.

Inspiration

On the street, the initial impulse is to photograph everything you see. But as you become more selective in street shooting, try doing a thematic series. Potential subjects for thematic series abound. For example, you could do a study on how people react to the wait for a traffic light to change or do a photo series on a day in the life of a metropolitan bus terminal.

Or choose a spot that is slated for improvement. Assign yourself to document the reconstruction. You can photograph the area as it is now and capture the "life" of the area. Then you can follow up every week or so to see how the construction changes not only the look of the place, but also the sense of place.

Taking street photographs

©2006 Peter K. Burian, www.peterkburian.com
7.61 The lights of Broadway in New York City fill the darkened street with color.

Table 7.22
Street Photography

Setup	**In the Field:** The image in figure 7.61 was taken at night on Broadway. The photographer used a dynamic position to capture the vibrancy of nightlight in one of the world's most famous cities.
	Additional Considerations: Vary shots by taking a high or low shooting position. Watch for iconic shots that describe our life and culture. Street photography is also a great time to capture humorous scenes of people interacting or people juxtaposed with background billboards and signs.
Lighting	**In the Field:** Ambient street light provided the lighting for this image.
	Additional Considerations: Lighting for street photography can run the gamut. Watch for highlight areas on the subject and use negative exposure compensation or bracketing to ensure that highlights are not blown out.
Lens	**In the Field:** Canon EF 16-35mm, f/2.8L USM set to 17mm.
	Additional Considerations: A zoom lens is indispensable for street shots. Typically, a telephoto zoom offers the focal range necessary for you to remain at a distance yet bring the subjects close to fill the frame.
Camera Settings	**In the Field:** Aperture-priority AE mode. The white balance was set to Auto.
	Additional Considerations: To control the depth of field, choose Aperture-priority AE mode and set the white balance to the type of light in the scene. If the light is low, switch to Shutter-priority AE mode.
Exposure	**In the Field:** ISO 100, f/4.0. 1/200 sec.
	Additional Considerations: In low-light scenes, switch to Shutter-priority mode and set the shutter to 1/30 or 1/60 second. At 1/30 second, you may get some blur if the subject moves, which can turn out to make an effective image. If you want sharpness throughout the image to show the surroundings, set a narrow aperture such as f/8 or f/16, or to blur the background, choose a wide aperture such as f/5.6 or wider.

Street shooting tips

✦ **Watch for photo "stories."**
Photo stories involve subjects and sequences that tell the story of a place, building, or group of people. Shoot the photo story sequence over time and edit images carefully to include only the photos that follow your story line.

✦ **Use light to your advantage.**
There's nothing like the warm light of sunset to make city streets and buildings glow. Set a narrow aperture, such as f/11 or f/8, to ensure extensive depth of field.

✦ **Always keep a spare memory card handy.** If a drama unfolds suddenly on the street, you'll be glad you have an empty card that you can slip into the EOS 30D and know that you can continue shooting uninterrupted.

✦ **Pack wisely and travel light.**
Always carry a fully charged cellphone with you and carry only the lenses with which you plan to shoot. The lighter load gives you greater mobility and lessens the chance that equipment might be stolen.

Sunset and Sunrise Photography

The colorful drama that unfolds at the beginning and end of each day has inspired photographers to capture the images of sunrises and sunsets since the dawn of photography. At no other times of day does the sky offer such compelling color. Whether you shoot weddings, portraits, fashion, or commercial assignments, knowing how to shoot in the magical light of sunrise and sunset will net some of the best shots of the assignment or for your portfolio.

7.62 In this image, the boat and the people on the pier are bathed in the golden light of sunset — a light that enhances any subject. Taken at ISO 100, f/8, 1/15 sec. using a Canon EF 70-200mm f/2.8L IS USM lens set to 140mm.

Tip
> To protect your eyesight as well as the image sensor, don't point the EOS 30D directly at the sun. Instead, shoot the sun at a slight angle and be sure to use a lens hood to avoid flare (reduced contrast when light from outside the intended image strikes the lens).

Choosing a lens depends on the subject that you're shooting and how you want to show the sunrise or sunset within the context of the overall photo. If you're shooting

for pleasure, a wide-angle lens provides a large sweep of sky that can lead the eye to the distant horizon, but it also reduces the apparent size of the sun to a small spec on the horizon. By contrast, a telephoto lens gives the sun a more prominent role so that you can isolate an object, such as a sailboat, as it passes in front of the sun.

Because many sunrise and sunset images include the sun, it's important to preserve

the color of the sun in the image. If you meter on the sky, the sun will be white— colorless and without detail—in the final image. For this reason (and because sunrise and sunset pictures look great with rich, deep color), use a -1 to -2-stop exposure compensation and also bracket the exposure to be safe. But for assignment images, obviously metering for the model or subject is the primary objective.

 Cross-Reference *For more information on exposure bracketing, see Chapter 1.*

Inspiration

If you're shooting for pleasure, certainly sunrise and sunset photography is a popular genre. But to be successful, these pictures should have more interest than just the glorious colors of the sky. A foreground object or even a distant object can add context and symbolism that make the picture stand out from run-of-the-mill sunrise and sunset pictures.

7.63 The late light of sunset mixed with street lights provides the light for this image of a beach pavilion. Taken at ISO 100, f/3.5, 1/6 sec. using a Canon EF 70-200mm f/2.8L IS USM lens set to 78mm.

Silhouettes

A solid subject such as a person, tree, or boat that is positioned between the camera and a bright light source such as the setting sun creates a silhouette when you expose the image for the brighter background. Of course, any solid subject that is backlit can produce a silhouette. For example, whole or partial silhouettes are often used in portraits. Because detail in the silhouetted subject will not be visible in the image, choose a subject that has an identifiable shape, and strive to keep the composition clean and simple. In sunset images, silhouettes are especially effective in the light just after the sun sets.

To create a silhouette select Av (Aperture-priority AE mode). This mode allows you to control both the depth of field and the part of the scene that the camera meters. Focus on a bright part of the background (which simultaneously sets the exposure), and press the AE lock button. Then recompose, focus, and take the picture.

Taking sunset and sunrise photographs

7.64 This image captures a popular dinner-cruise ship just before passengers begin boarding for the sunset cruise on Lake Washington.

Table 7.23
Sunset and Sunrise Photography

Setup	**In the Field:** The image in figure 7.64 is a reoccurring scene along Lake Washington in Kirkland, WA. I set up the tripod and waited for the best light to strike the dinner ship.
	Additional Considerations: To set your sunset pictures apart from others, compose the image so that the effect of the light is shown, such as on ripples on a lake. Add interest by including objects in the foreground or midground. For scenic, landscape, and seascape images, keep the horizon in the upper or lower third of the image. Sunrises and sunsets happen over a very few minutes of time. Be sure that you are in position well before the time of sunrise or sunset and ready to shoot.
Lighting	**In the Field:** Full sunset light provided superb color to the clouds, the ship, and the water.
	Additional Considerations: Sunrise and sunset happen within a few minutes of time, and the colors of the sky can change dramatically during those few minutes. The color temperature of sunrise is 3,100 to 4,300 degrees Kelvin, and sunset is 2,500 to 3,100 degrees Kelvin. Knowing these approximate temperature ranges allows you to fine-tune color when you shoot RAW images and process them in Digital Photo Professional.
Lens	**In the Field:** Canon EF 70-200mm f/2.8L IS USM lens set to 73mm.
	Additional Considerations: Your lens choice depends on the scene you're shooting and your distance from it. Use a telephoto zoom lens to bring distant scenes closer and a wide-angle lens to capture breath-taking sweeps of color.
Camera Settings	**In the Field:** RAW capture, Aperture-priority AE mode. The white balance was set to AWB and tweaked during RAW conversion.
	Additional Considerations: Aperture-priority AE mode is a good choice so that you can control the depth of field. If you want to shoot in a Basic Zone mode, Landscape is a good option.
Exposure	**In the Field:** ISO 100, f/9, 1/20 sec. using a tripod.
	Additional Considerations: Light fades quickly during sunrise and sunset. You can set the ISO to 100 to 400 and perhaps even switch from a lower ISO at the beginning of the light change to a higher ISO as the light fades. For expansive scenes, keep good depth of field by using f/8 or f/11. If the shutter speed drops below 1/60 or 1/30 second, set the camera on a solid surface or use a tripod.
Accessories	If you're shooting an assignment just before the golden light has begun, you can add simulate sunset light by using a gold reflector to reflect into the model or subject.

Sunset and sunrise photography tips

✦ **Capture the full range of colors.** The color of the sky before, during, and just after sunset and sunrise changes dramatically. Be sure to use all the time to capture the changes.

✦ **Get in position early.** Be in place and have the camera set up 15 minutes or more before the sunset or sunrise begins. Once sunset or sunrise begins, you have only 10 minutes at most to capture the shots you want.

✦ **Use the sky to your advantage.** Clouds help diffuse sunlight and create colorful and dramatic sunsets. On clear days, the best time to shoot is just before or just after the sun falls below the horizon.

✦ **A tripod or monopod is your friend.** You'll get sharper images by using one.

Travel Photography

The EOS 30D is lightweight, small, and extremely versatile, making it ideal for use when traveling. With a set of compact zoom lenses and plenty of memory cards, you'll have everything you need to take high-quality shots to document your travels and do travel assignments.

Before you begin any trip, carefully clean your lenses, check that the image sensor is free of dust, and ensure that the EOS 30D is in good working condition. Consider buying spare batteries and memory cards. If you're traveling by air, check the carry-on guidelines

on the airline's site and determine if you can carry the camera separately or as part of your carry-on allowance. An advantage of being a digital photographer is there's no worry about film being fogged by the X-ray machines.

Another pre-trip task is to research the destination by studying brochures and books to find not only the typical tourist sites, but also favorite spots of local residents. When you arrive, you can also ask the hotel concierge for directions to popular local spots. The off-the-beaten-path locations will likely be where you get some of your best pictures.

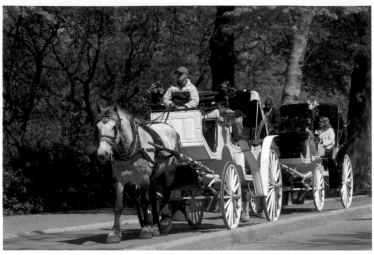

©2006 Peter K. Burian, www.peterkburian.com

7.65 This image from New York City captures one of the charms of the famous location. The exposure for this image was ISO 100, f/5.6, 1/200 sec. using a Canon EF 70-200mm, f/2.8L IS USM lens set to 88mm.

Here are some additional tips for getting great travel pictures:

✦ **Research existing photos of the area.** At your destination, check out the postcard racks to see what the often-photographed sites are. Determine how you can take shots that offer a different or unique look at the site.

✦ **Include people in your pictures.** To gain cooperation of people, always be considerate, establish a friendly rapport, and show respect for individuals and their culture. If you do not speak the language, you can often use hand gestures to indicate that you'd like to take a person's picture, and then wait for their positive or negative response.

✦ **Keep the composition simple with a clear center of interest.** This is where a telephoto lens comes in handy. With it, you can eliminate distracting elements on either side of the subject or eliminate a dull overcast sky. In larger scenes, a wide-angle lens is the ticket.

✦ **Waiting for the best light pays big dividends.** Sometimes this means that you must return to a location several times until the weather or the light is just right. And once the light is right, take many photos from various positions and angles.

✦ **Photographing people and landmarks.** If you want to include family in a shot at a famous landmark, use Landscape or Aperture-priority AE mode with an aperture of f/8 or f/11 to keep the foreground and background sharp.

✦ **Add bold, bright color to your images.** Look for colorfully painted storefronts, boats, gardens, cars, buses, apartment buildings, and so on to add interest to your pictures.

Inspiration

If the area turns out to have a distinctive color in the scenery or in architecture, try using the color as a thematic element that unifies the images you take in that area. For example, the deep burnt-orange colors of the southwest U.S. can make a strong unifying color for vacation images.

Watch for details and juxtapositions of people, bicycles, and objects with backgrounds such as murals and billboards. Also watch for comical or light-hearted encounters that are effective in showing the spirit of a place.

7.66 Colorful scenes such as this are representative of Northern California. Taken at ISO 100, f/11, 1/200 sec. using the Canon EF 70-200mm f/2.8L IS USM lens set to 73mm.

Taking travel photographs

©2006 Peter K. Burian, www.peterkburian.com

7.67 Colorful parades and demonstrations such as this one in Toronto, Canada, offer great photo opportunities during your travels.

Table 7.24
Travel Photography

Setup	**In the Field:** For the picture shown in figure 7.67, the objective was to find a shooting position that allowed the photographer to capture the colorful costumes without distracting background elements.
	Additional Considerations: In many cases, you want to choose locations that are iconic, or classic, and try different positions, angles, or framing to show the location to give a fresh perspective on a well-photographed area. Include people in your images to provide an essence of the location. Narrow the scope of your image so that you present a clear story or message. Always ask permission to photograph local people. Even if you don't speak the language, you can use gestures to indicate your intent and question.
Lighting	**In the Field:** This image was taken on a moderately sunny day.
	Additional Considerations: Inherently, light for travel photos runs the full range. The trick is to know when to shoot and when not to shoot. Ask yourself if the existing light is suited for the subject. If it isn't, wait for the light to change or come back at a different time of day when the light is more appealing. Often, just waiting for a cloud to pass by offers enough diffusion to make a better picture.
Lens	**In the Field:** Canon EF 24-105mm, f/4.0L set to 45mm.
	Additional Considerations: Your lens choice depends on the scene you're shooting and your distance from it. Use a telephoto zoom lens to bring distant scenes closer and a wide-angle lens to capture large scenes such as festivals and fairs or to include environmental context for people shots.
Camera Settings	**In the Field:** Aperture-priority AE mode. The white balance was set to Daylight.
	Additional Considerations: To control the depth of field, choose Aperture-priority AE mode and set the white balance to the type light in the scene.
Exposure	**In the Field:** ISO 100, f/13, 1/400 sec.
	Additional Considerations: Set the ISO as low as possible given the existing light. If you're photographing people of the area, use a wide aperture such as f/5.6 to blur the background without making it unreadable. Watch the shutter speed in the viewfinder to make sure it isn't so slow that subject or hand motion doesn't spoil the picture.

Travel photography tips

✦ **Do your homework.** The more study you do before you travel, the better understanding you'll have of the people and area, and the better your pictures will be.

✦ **Be cautious about deleting images.** As your trip progresses and you fill your memory cards or portable storage unit, you may be tempted to delete pictures to free up storage space. Be very careful in deleting pictures that you haven't seen at full size. You can easily delete images that could be the best of the trip with a little editing.

✦ **Keep an eye on your equipment.** Digital cameras are extremely popular, which makes them a target for thieves. Be sure to keep the camera strap around your neck or shoulder and never set it down and step away. This sounds like common sense, but you can quickly get caught up in activities and forget to keep an eye on the camera.

✦ **Use reflectors.** Small, collapsible reflectors come in white, silver, and gold, and they are convenient for modifying the color of the light. They take little space and are lightweight.

✦ **Don't take too much equipment.** Carry just enough to fill your camera bag and ensure that the camera bag will pass airline requirements for carry-on luggage.

Weather and Seasonal Photography

Just as with sunset and sunrise, weather and the events it brings create compelling photography subjects. Whether you photograph rain, snow, a stormy cloudscape, or fog, you can use the weather to set the mood of the image, to add streaks of falling rain or snow, and to show classic human and animal reactions to the weather.

A variety of techniques are effective in weather photos, but the first consideration is to protect the camera from moisture and dust. Many companies sell affordable weatherproof camera covers, and they are well worth the price. Or you can fashion your own covering from water-repellant fabric or from a large plastic bag. Keep the covering in your camera bag to use in case there's an unexpected shower or snowfall.

Many of the techniques covered in earlier sections in this chapter can be used when you're taking weather photos. The following sections detail some tips for shooting in specific types of weather.

7.68 Early spring fog set the scene for this image. Taken at ISO 100, f/10, 1/40 sec. using a Canon 24-105mm f/4.0L IS USM lens set to 105mm.

Falling rain and snow

You can choose to freeze the motion created by falling rain or snow by using a fast shutter speed. Conversely, you can show the rain or snow as streaks by using a slow shutter speed of 1/30 second or slower. The slower the shutter speed is, the longer the streaks. Try to choose a medium to dark background to help show the rain or snow streaks best.

Fog

Fog adds a sense of mystery and intrigue to a scene, but because the moisture in the air decreases sharpness, it enhances the soft, mysterious atmosphere of the image. Fog varies in color from light gray to almost white. Exposing fog scenes can be tricky. Meter for the subject, and to ensure accurate color, try using a custom white balance.

Custom white balance is a simple process of shooting a white object that fills the viewfinder, selecting the image so that its white balance data is imported, and then setting the camera for custom white balance. For more on setting a custom white balance, see Chapter 2.

Snow

Regardless of where you live, the first snow of the season has the magical quality that brings almost everyone outdoors to enjoy it. Snow, like large expanses of dark water, fools the camera meter. To get beautifully white snow, override the camera's tendency to underexpose the snow by setting a +1 to +2 exposure compensation.

Stormy skies

Huge, heavy, looming clouds with deep, rich colors are a favorite subject of photographers everywhere. When storm clouds begin forming, grab the EOS 30D and head to your favorite shooting location with a wide-angle lens. Find a good foreground object and let the storm clouds lead the eye to the object. As the clouds grow darker, press the AE Exposure compensation button and turn the Main dial to -1/3 or -1/2 compensation to avoid overexposed images.

Inspiration

Although weather can often make a stand-alone subject, photographing how the weather affects people, plants, and animals is lots of fun. In rain scenes, look for people with umbrellas, wet animals, rain-beaded flora and fauna, or a farmer in a field looking up at the ominous clouds.

Also look for contrasts that underscore the weather. For example, you may find a pair of summer flip-flops frozen solidly to a deck or rain collecting on cacti.

7.69 Late afternoon light provided this colorful cloudscape. Taken at ISO 100, f/8, 1/45 sec. using a Canon EF 70-200mm f/2.8L IS USM lens set to 73mm.

Taking weather and seasonal photographs

7.70 Weather can be photographed in its own right, and it can become a dramatic backdrop for images.

Table 7.25
Weather and Seasonal Photography

Setup	**In the Field:** The image in figure 7.70 is one in a series of images that captured this cruise ship as it crossed Lake Washington. The dramatic line of clouds provided a nice backdrop that complimented the overcast conditions and rough lake conditions.
	Additional Considerations: Watch the weather forecast to get a sense of when good weather photos might happen. Then watch the skies for dramatic cloud formations. Show images of how the weather affects people, buildings, and the flora and fauna.
Lighting	**In the Field:** This image was taken in overcast light.
	Additional Considerations: Extremes in light characterize weather and seasonal photography and can provide priceless opportunities as shafts of light break through forested hillsides, fog-covered landscapes, and, of course, illuminate rainbows. Watch carefully for the best opportunities to capture scenes with spectacular light.
Lens	**In the Field:** Canon EF 70-200mm f/2.8L IS USM lens set to 170mm.

	Additional Considerations: Your lens choice depends on the scene you're shooting and your distance from it. Use a telephoto zoom lens to bring distant scenes closer and a wide-angle lens to capture expansive scenes.
Camera Settings	**In the Field:** Aperture-priority AE mode. The white balance was set to auto (AWB).
	Additional Considerations: You want to control the depth of field, so choose Aperture-priority AE mode and set the white balance to the type light in the scene.
Exposure	**In the Field:** ISO 100, f/11, 1/250 sec.
	Additional Considerations: For most weather photos, an extensive depth of field is the ticket. Set the aperture at f/8 or f/11, and use a tripod if the shutter speed is slower than say 1/30 second.
Accessories	Having a tripod handy is a good idea for weather photos. Light can vary tremendously, and in lower light scenes, a tripod is necessary for slower shutter speeds.

Weather photography tips

✦ **Use contrast to your benefit.** Take advantage of the extra-saturated color that overcast and rainy weather provides by including color-saturated flowers and foliage in your weather images.

✦ **Get the best color from your image.** To photograph a rainbow, set the EOS 30D to ISO 100, press the AE Exposure compensation button, and set a -1 to -1.5 compensation to deepen the colors.

✦ **Know your weather.** Veteran storm chasers and weather photographers emphasize the importance of learning as much as possible about weather and observing how the sun strikes different types of clouds.

✦ **Don't put the camera away when the weather clears.** Use the time after a rain shower to capture the sparkle on freshly washed streets and buildings.

Wedding Photography

Today's wedding photographer is more likely to be an ace at applying a photojournalistic shooting style coupled with a little cutting-edge fashion shooting — all mixed with a little traditional portraiture for good measure. And, for some of the top wedding photographers, the goal of every wedding is to produce fine-art imagery that will stand on its own years from now as a classic fine-art photograph.

These are lofty goals for a shooting specialty that can be marked with the height of human stress compressed in a small but charged space, and holds the potential for

7.71 A late afternoon carriage ride made a great photo opportunity to round off this couple's wedding images. Taken at ISO 100, f/2.8, 1/1500 sec. using a Canon EF 24-70mm, f/2.8L USM lens set to 70mm.

7.72 The 30D's focal length multiplication factor brings the couple close. The exposure for this image was ISO 100, f/8, 1/80 sec. using a Canon 24-105mm f/4L IS USM lens set to 105mm.

every heart-stopping disaster that can happen in photography from malfunctioning gear to a missing or inebriated bride or groom.

Despite any wedding or equipment snafus, the wedding photographer has to put on a smiling face and roll with the flow. And the bulk of wedding work happens after the couple has flown away to an exotic location for their honeymoon. It's then that the wedding photographer processes and edits the images, creates the first-cut selections, and compiles the proof books. Many wedding photographers laugh when people assume that they work only on weekends because they know that not only do they put in 6- to 12-hour days on every weekend, but they also spend days afterward sorting and preparing images for the couple to review.

Inspiration

Following the advice of top wedding photographers such as Meg Smith, think of making every wedding image strong — not just as a wedding image in the traditional sense, but as a strong photograph. As with other specialty areas, think through what your voice and look is or would be for wedding photography.

7.73 Detail shots such as this are an important part of the wedding book. Taken at ISO 100, f/2.8, 1/180 sec. using a Canon 24-70mm f/2.8L USM lens set to 72mm.

Think of how you can incorporate themes into the wedding that tie in with either decorations or the couple's interests.

Taking wedding photographs

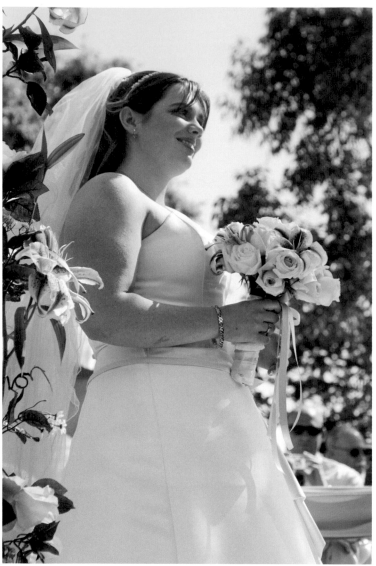

7.74 This image of the bride was taken just before the ceremony began.

<div align="center">

Table 7.26
Wedding Photography

</div>

Setup	**In the Field:** Due to limited shooting positions as the couple waited for the ceremony to begin, I took a low shooting position to stay out of sight of guests as shown by the angle of figure 7.74.
	Additional Considerations: Before the ceremony begins, scout out shooting positions and leave something on a seat to reserve it. Some couples do not want the ceremony photographed and others want it photographed but without the use of flash. Be sure you know the couple's wishes and requirements before the ceremony begins.
Lighting	**In the Field:** Bright mid-afternoon sunlight was the rule of the day for this wedding.
	Additional Considerations: If possible, work with the bride and bridal consultant during the early planning stages to plan where the wedding party will stand, in an outdoor venue, for example, so that the light is optimal for images.
Lens	**In the Field:** Canon EF 24-105mm f/4L IS USM set to 67mm.
	Additional Considerations: Your lens choice depends on the scene you're shooting and your distance from it. Use a telephoto zoom lens to bring distant scenes closer and a wide-angle lens to capture expansive scenes.
Camera Settings	**In the Field:** RAW capture, Aperture-priority AE mode.
	Additional Considerations: You want to control the depth of field, so choose Aperture-priority AE mode and set the white balance to the type light in the scene.
Exposure	**In the Field:** ISO 100, f/5.6, 1/500 sec.
	Additional Considerations: In most wedding venues, sections of the wedding such as the ceremony, the dinner, and the dance occur in lighting that is consistent for the duration of the event. As a result, you can often set the exposure and shoot with it throughout the event, unless you want to change the depth of field for specific images.
Accessories	Having a tripod handy is a good idea for wedding photos, but a tripod limits your ability to move quickly, and it requires more shooting space that may not be readily available. A monopod is another good option.

Wedding photography tips

✦ **Look at the big picture, and understand what you are getting into.** Take wedding photography very seriously. In many ways, this is the most important day of someone's life.

✦ **Always have backup gear.** Most wedding photographers not only carry two bodies as they work, but also in the gear bag are duplicates of critical pieces of equipment so that they can keep shooting regardless of breakdowns. Renting spare camera bodies, lenses, flash units, and tripods is often the most economical strategy.

✦ **Plan for the worst.** Ask exhaustive questions ahead of time such as whether the church or location allows flash or whether the couple wants flash for certain parts of the wedding festivities. If the wedding is outdoors, ask what alternate location the couple will use if the weather turns bad, and plan for lighting in both locations. The list of questions is almost endless, but pre-planning pays big dividends on the day of the ceremony.

✦ **Hone your amateur psychologist skills.** You may need to be a good amateur psychologist as well as a good photographer, especially when dealing with disgruntled or divorced parents or an unhappy bride.

Downloading Images

Downloading digital images has come a long way in the past few years. Rather than crawling behind the computer to hook up cables, you can use the USB cable supplied with the camera, or you can use an accessory card reader or PCMCIA (Personal Computer Memory Card International Association) card. And with direct-printing capability, you may not need to download images, but you can print proof images directly from the memory card. I think that every image is better with at least some editing or adjusting on the computer, so I use printing directly from the memory card only for proof prints.

If you capture RAW images, you have lots of latitude in processing images using either Canon's Digital Photo Professional or Adobe's Camera Raw conversion program to tweak the original exposure, white balance, picture style, and more. When the image-editing cycle is complete, you can back up images to secure media for long-term storage.

Downloading with a USB Cable

Downloading using a USB cable is as simple as connecting the camera and the computer using a USB cable. The computer recognizes the camera as a removable drive. Because the camera must be turned on during download, you should ensure that the battery charge is sufficient to complete the download without interruption.

Note *If you're using a Mac, you see the EOS 30D as a Digital Capture that can be imported.*

Organize and Back Up Images

One of the most important steps in digital photography is establishing a coherent folder system for organizing images on the computer. With digital photography, your collection of images will grow quickly, and a well-planned filing structure helps ensure that you can find specific images months or years from now.

Another good practice is to add keywords to image files. Some programs allow you to display and search for images by keyword—something that can save lots of time as you acquire more and more images.

The most important step is to regularly back up images on a DVD or a separate hard drive. Many photographers make it a habit to burn a backup disc right after downloading pictures to the computer. And, as with images on the computer, having a filing system for your backup discs is important as well.

ImageBrowser is the comparable program for Mac computers.

Canon provides programs for downloading and organizing images. Many other programs are available for these tasks, but for this chapter, I use the Canon and Adobe programs in the examples.

> **Note** *For details on setting the file type for capturing images, see Chapter 2.*

To download images through the USB cable, follow these steps:

1. **Install the Canon EOS Digital Solution disc on your computer.** If you do not install the disc, the computer may not properly recognize the camera when you connect it to the computer.

 Tip *Make sure that the camera battery is not showing a low charge. If it is low, charge it before you continue with these steps.*

2. **Turn on the EOS 30D, turn the Quick Control dial to select the Set-up (yellow) menu, and press the Set button.**

3. **Rotate the Quick control dial to select Print/PC, and press the Set button.**

4. **Turn off the camera.**

5. **Connect the interface cable to the camera's Digital terminal.** The USB icon on the cable should face the front of the camera, and you should connect the other end of the cable to a USB port on the computer.

6. **Turn on the EOS 30D.** Windows displays a Canon EOS 30D dialog box asking you to select a program to launch for this action.

7. **Select EOS Utility, and click OK.** The EOS Utility – EOS 30D dialog box appears.

8. **Under Downloads using computer, click Starts to download images or Lets you select and download images.** The 30D LCD also displays the Direct Transfer screen on the EOS 30D and offers these options:

 • **All Images.** This option transfers all images on the CF card to the computer.

 • **New Images.** This option transfers only images that haven't already been transferred to the computer.

• **DPOF Transfer Images.** This option transfers previously selected Digital Print Order Transfers to the computer.

• **Select & Transfer.** This option displays an image-selection screen so that you can select images one at a time to transfer to the computer.

• **Wallpaper.** This option displays a transfer image selection screen so that you can choose an image to transfer to the computer. When the image is transferred, it appears as wallpaper on the computer's desktop.

8.1 ZoomBrowser EX opens automatically and displays the downloaded images.

9. **In the EOS Utility – EOS 30D dialog box, click the option you want. Or on the camera, rotate the Quick Control dial to select the option you want, and press the Set button.** The camera displays a confirmation screen. Rotate the Quick Control dial to select OK, and press the Set button. While Cancel is displayed, rotate the Quick Control dial to select OK, and press the Set button. During image transfer, the Print/Share lamp blinks. When the image transfer is complete, the direct transfer screen appears on the camera. After the download is complete, ZoomBrowser EX launches automatically on the computer and displays the downloaded images.

10. **Click Edit, and choose Edit Image to edit JPEG images, or click Process RAW Images to convert RAW images.**

8.2 You can choose Edit Image to edit JPEG images or Process RAW Images to convert RAW images.

Downloading with a Card Reader

By far, the easiest way to download images is by using a card reader. A card reader is a small device that plugs into the computer with its own USB cable. When you're ready to download images, you insert the media card into the corresponding card-reader slot.

You can leave the card reader plugged in to the computer indefinitely, making it a handy way to download images. Plus, with a card reader, you don't have to use the camera battery while you download images.

Card readers come in single and multiple card styles. Multiple card style readers accept CompactFlash (CF) and other media card types. Card readers are inexpensive and virtually indestructible and have a small footprint on the desktop. All in all, they are a bargain for the convenience they offer.

After installing the card reader according to manufacturer recommendations, follow these steps to download images:

Note *The steps may vary slightly depending on your card reader and computer's preferences.*

1. **Remove the CF card from the camera, and insert it into the card reader with the holes on one long edge facing into the slot.** Push the card into the reader until it seats. Do not force it.

2. **A window opens showing the CF card folder.** If a window does not appear, on the Windows desktop, double-click the My Computer icon. In the list of Devices with Removable Storage, double-click the icon for the CF card. The card reader appears in the list as a Removable Disk.

3. **Double-click the folder to display the images, select all the images, and drag them to the folder where you want to store them.** You can also drag the entire folder to your computer's hard drive, or drag individual image files to various existing folders.

Tip

You can also upload edited or unedited images or directories from your computer to the CF card in the reader. Simply drag and drop files to the card reader icon. You can do the same with any browser, such as the one in Adobe Photoshop Elements. Then you can take the card to any business that has a self-service printer that accepts CF cards. Modest editing is permitted on the spot, but only JPEG images are accepted.

Note

You can use Canon's ZoomBrowser EX to view JPEG images and Canon's File Viewer Utility to view and edit RAW images.

Downloading with a PCMCIA Card

If you're on the go and you use a laptop computer, an easy solution for downloading images is to use a PCMCIA card. About the size of a credit card, the PCMCIA card fits into

an available PC card slot on the laptop, and the CF card fits into the PCMCIA card. Be sure to look for a PCMCIA card that accommodates CF cards and/or microdrives.

If you are a laptop user, the advantages of a PCMCIA card make them well worth the small investment. Also, some laptop computers have built-in CF card slots making a PCMCIA card unnecessary. In either case, the process of downloading is the same as with the card reader.

Cross-Reference

For more information on choosing a RAW processing program and converting RAW images, see Appendix A.

Shooting Tethered

In addition to viewer programs and editing programs, the Canon Solutions disc includes the EOS Utility program that includes options for camera settings and remote shooting that lets you shoot tethered — controlling virtually all aspects of your camera from the computer. The Camera settings/ Remote shooting option, often used in a studio setting, is a powerful feature to use in the studio when you have the camera and computer in close proximity. If you're shooting with a client or art director, having the images displayed immediately on the computer lets you and your client know immediately if the image matches the specifications or if changes need to be made. You can make quick changes to the scene and retake the picture if necessary.

To control the camera from the computer using Camera settings/Remote Shooting, follow these steps:

1. **Connect the interface cable to the camera's Digital terminal.** The USB icon on the cable should face the front of the camera, and you should connect the other end of the cable to a USB port on the computer.

2. **Turn on the EOS 30D.**

3. **Double-click the EOS Utility icon on the desktop, and then choose Camera settings/Remote shooting.** If the EOS Utility icon isn't on the desktop, choose Start ⇨ All Programs ⇨ Canon Utilities ⇨ EOS Utility ⇨ EOS Utility. The EOS 30D control window appears.

4. **Highlight the parameter you want to change in the control panel, and then click the left or right arrow keys on the keyboard to change the settings.** You can drag the exposure bar to set a plus or minus exposure setting.

5. **Click the Camera button to make the picture (see figure 8.4).** Canon's ZoomBrowser EX starts automatically and displays the image. The image is captured in the My Pictures folder. ZoomBrowser EX opens the image and displays the file name, date, file and image size. You can designate a rating, add comments, and keywords, view the brightness histogram, and view the shooting information.

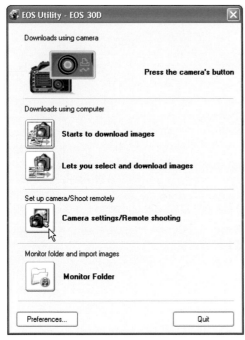

8.3 The EOS Utility dialog box allows you to choose to control the camera remotely by using your computer and keyboard.

Click to take a picture

8.4 With the Camera settings/Remote Shooting control panel, you can control the camera and display images directly on the computer.

Viewing and Organizing Programs

The Canon File Viewer Utility and ZoomBrowser EX/PhotoRecord ImageBrowser are capable programs for viewing and arranging images. And they have the advantage of coming at no additional cost. However, you may want to consider other programs such as Adobe's powerful plug-in for Photoshop CS2, called Adobe Camera Raw. Camera Raw allows you to view and convert RAW images, organize, and label images. Updates for the plug-in to date have been free, and updates can be downloaded from the Adobe Web site.

6. **Click Edit, and then click Edit Image to edit a JPEG capture, or click Process RAW Images to process RAW files.** If you choose Edit Image, ZoomBrowser EX displays the Select Editing tool that offers options for image editing. If you choose Process RAW Images, Canon's RAW Image Task opens, as shown in figure 8.6.

7. **In either editing program, make the adjustments that you want and then save the image.**

Note

For more information on RAW image capture and processing, see Appendix A.

8.5 ZoomBrowser EX launches and displays the remotely captured image along with file and date information and shooting information.

8.6 The RAW Image Task application allows you to adjust and convert RAW images.

Editing Images

Whether you capture images as JPEG or RAW, there are very few images that can't be improved with at least some image editing. During the editing process, it's a good idea to develop and follow a sequence of steps or an editing workflow that makes sense for you from a technical point of view and saves you time overall.

This section provides a sample editing workflow. You could follow this workflow using either Adobe Photoshop Elements or Photoshop CS.

1. **Process, convert, and save a copy of RAW images in TIFF or JPEG format.**

2. **Adjust the tonal range of the image.** You can do this in an image-editing program. To adjust overall tonal levels, use the Levels command in Photoshop CS2. In the Levels dialog box, move the black and white point sliders inward to where the image data is higher than one pixel per tonal level, and then move the midpoint to the left or right to lighten or darken the image.

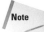
Note — Although it is beyond the scope of this book to provide step-by-step instructions for Photoshop Elements or Photoshop CS, you can access the Help menu of both programs to get detailed instructions.

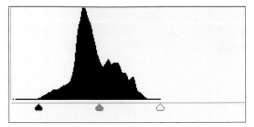

8.7 In this histogram, I moved the black and white point sliders to where the data in the image begins in the Adobe Photoshop CS2 Levels dialog box.

3. **Color-correct the image.** In the Curves or Levels dialog box, click the white and black points in the image using the eyedropper tools, and set the midtone (the middle eyedropper) by clicking an area in the image that should be midgray. If you set the midtone in the RAW conversion program, you don't need to repeat that step here.

4. **Straighten the image.** If the horizon is tilted, or if lens distortion makes objects appear to fall toward the center of the image, you can use the Measure tool or Free Transform command to straighten horizontal and vertical lines in the image.

5. **Crop the image.** You can crop the image to eliminate areas that do not complement the composition or areas that are distracting. Use the Crop tool judiciously because each crop results in a smaller image. And the smaller the image, the smaller the enlargement you can print from it. This fact alone is reason enough to frame images carefully as you shoot.

Tip — If you're using Photoshop CS, set a gentle S-shaped curve using the Curves command. The curve adds punch to the overall image by brightening highlights and midtones and darkening shadows slightly. Use the Curves command to nudge up image contrast. Avoid using it as a hammer to impose dramatic changes.

6. **Correct imperfections.** Spots or blotches on an image may be a result of dust within the scene, or more often, a result of dust on the image sensor. You can make quick work of some spotting tasks by converting the image to LAB mode and using the Dust and Scratches command on the A and B channels. For remaining spots, you can use the Healing Brush or Clone Stamp tool to clean up the image.

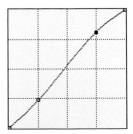

8.8 This shows a slight classic S curve set in the Photoshop CS2 Curves dialog box.

Color Correction Values

Setting the white, midtone, and shadow target values in Photoshop helps ensure consistent color correction. In the Levels dialog box, you can double-click each of the eyedroppers and reset the default values. For example, double-click the black eyedropper. In the Color Picker dialog box, you can type values for Red, Green, and Blue (RGB). Many photographers recommend resetting the RGB values as follows: White (R 240, G 240, B 240), Midtone (R 128, G 128, B 128), and Black (R 20, G 20, B 20).

When you exit the dialog box, you have the option to save the values as the default. By clicking Yes to save the values as the defaults, these values will be used the next time you click the eyedropper tools in these dialog boxes.

7. **Dodge and burn select areas of the image.** Dodge and burn are tools used in a chemical darkroom to lighten or darken areas of an image, respectively. The same types of techniques are available in Adobe Photoshop programs. However, rather than using the Dodge and Burn tools, you can use the Levels command to lighten or darken the entire image, and then use the History brush to paint in the darker or lighter effect.

8. **Convert the image to 8-bits per channel, if necessary.** In Photoshop CS, the Mode command on the Image menu offers the 8/bits/Channel command.

9. **For print or Web use, make a copy of the image.** Once copied, you can size it for printing or Web use as needed.

10. **Sharpen the image.** If you are preparing an image for printing or the Web, use the Unsharp Mask command to create a crisper image.

 Note *I don't recommend using the Brightness and Contrast command because it can over compress highlight and shadow values. That process can result in a loss of image detail.*

Printing Images

Printing images can be done from the computer or directly from the CF card. The EOS 30D offers great prints at any size up to approximately 9 × 13 inches at 300 ppi from uncropped images.

Direct to printer

You can print directly from the CF card to PictBridge-Canon CP Direct and Canon Bubble Jet Direct-compatible printers. This option is handy for quick prints if you're shooting in JPEG format. During the printing, you can control the process from the camera.

To print JPEG images directly from the card to the printer, follow these steps:

1. **Set up a PictBridge-compatible printer with the correct paper and ink, and then turn off the printer.**

2. **Turn on the camera, and press the Menu button.**

3. **Rotate the Quick control dial to select the Set-up menu.**

4. **Rotate the Quick Control dial to select Communication, and press the Set button.**

5. **Turn the camera off, and connect the camera to the printer.** For PictBridge only, PictBridge and CP Direct, and PictBridge and Bubble Jet Direct printers use the interface cable that comes with the camera. For CP Direct only and Bubble Jet Direct only printers, use the cable provided with the printer. Plug the cable into the DIGITAL terminal with the USB icon on the cable facing the front side of the camera.

 Note *Make sure that the camera battery has a good charge before starting.*

6. **Turn on the printer first, and then turn on the camera.**

7. **Press the Playback button on the back of the camera.** The image and the printer connection icon are displayed on the LCD. The Print/Share lamp lights.

8. **Rotate the Quick Control dial to select the image you want to print, and press the Set button.** The print setting screen appears.

9. **Rotate the Quick Control dial to select Paper settings, and press the Set button.**

10. **Rotate the Quick Control dial to select the size of the paper that is loaded into the printer, and press the Set button.**

11. **Rotate the Quick Control dial to select the type of paper loaded in the printer.** The Layout screen appears.

12. **Rotate the Quick Control dial to select the layout you want, and press the Set button.** The Print setting screen appears. You can choose printing effects here. And if you want to adjust the effects, press the JUMP button. Rotate the Quick Control dial to make adjustments, and press the Set button.

13. **Rotate the Quick Control dial to select the file for the date imprint, and press the Set button. Then rotate the Quick Control dial to set the file number imprint, and press the Set button again.**

14. **Rotate the Quick Control dial to select the number of copies field, and press the Set button. Rotate the Quick Control dial to select the number of copies, and press the Set button again.**

15. **Rotate the Quick Control dial to select Print, and press the Set button.**

Digital print order format

Rather than printing as you go, you can choose images and the number of prints from each image to print ahead of time. Then if you go to a photo lab or if you use a Digital print order format (DPOF)-compatible printer, only the images you select are printed in the quantity you specified.

Table 8.1 details the DPOF options that you can set.

Table 8.1		
DPOF Options		
Print Type	Standard	Prints one image.
	Index	Prints multiple thumbnail images.
	Both	Prints both standard and index prints.
Date	On	Selecting "On" imprints the recorded date on the print.
	Off	
File No.	On	Selecting "On" imprints the file number on the print.
	Off	

To set DPOF for JPEG images, follow these steps:

1. **Press the Menu button on the back of the camera.**

2. **Rotate the Quick Control dial to select the Playback tab, and then rotate the Quick Control dial to select Print Order.**

3. **Press the Set button.** The print setting screen appears.

4. **Rotate the Quick Control dial to select the Set-up, and press the Set button.** The print setting screen appears.

5. **Rotate the Quick Control dial to select the Print type, Date, and File No. items, and press the Set button.**

6. **Rotate the Quick Control dial to select the setting, and press the Set button.**

7. **Rotate the Quick Control dial to select Order, and press the Set button.**

8. **Rotate the Quick Control dial to select the images to print.** You can press the AE lock/Reduce button to toggle between a three-image and single-image display.

9. **Press the Set button, turn the Quick Control dial to select the print quantity, and press the Set button.** The print order varies depending on the Print type you selected. For standard-type prints, you can set up to 99 prints for each image.

10. **Repeat the previous steps to select other images.** You can select up to 998 images.

11. **Press the Menu button.** The Print order screen appears.

12. **Press the Menu button again to save the print order to the CF card.** The menu appears.

13. **To print the images, be sure the camera is connected to the printer. Rotate the Quick Control dial to select Playback, and rotate the Quick Control dial to select Print order; then press the Set button.** The Print order screen appears.

14. **Rotate the Quick Control dial to select Print, and press the Set button.** The print setting screen appears. Then you can adjust printing options including paper size.

15. **Rotate the Quick Control dial to select OK, and press the OK button.** To stop printing, press the Set button while Stop is displayed, rotate the Quick Control dial to select OK, and press the Set button.

Working with RAW Images

By now, few digital photographers are new to RAW image capture, but for those who are, the advantages of RAW capture can't be overstated. Many digital photography professionals see RAW capture as the new frontier of photography — a frontier that allows greater creative freedom and expression than was possible in the traditional darkroom.

RAW capture allows you to save the data that comes off the image sensor with virtually no internal camera processing. Because the camera settings have been "noted" but not applied in the camera, you have the opportunity to make changes to key settings such as image brightness, white balance, contrast, and saturation *after* the capture is made. The only camera settings that the camera applies to a RAW image are ISO, shutter speed, and aperture. During RAW image conversion, you can make significant adjustments to exposure, color, and contrast. In addition to the RAW image data, the RAW file also includes information, called metadata, about how the image was shot, the camera and lens used, and other description fields.

RAW capture mode offers advantages that are akin to traditional film photography. For example, in some cases, you can push digital RAW exposures during shooting by 1/2 to a full f-stop, and then pull back the exposure during RAW conversion. The ability to push an exposure can, of course, make a noticeable difference in low-light shooting when you need to hand-hold the camera.

As with all images, the best first step in any workflow is to save the RAW images on either removable media or on another hard drive. This provides backup should anything happen to the files or computer.

Characteristics of RAW Images

An important characteristic of RAW capture is that it offers more latitude and file stability in making edits than is possible with a JPEG file. With JPEG images, large amounts of image data are discarded in the conversion to 8-bit mode, and then the data is further reduced by JPEG compression algorithms. As a result, the image leaves precious little, if any, wiggle room to correct tonal range, white balance, contrast, and saturation during image editing. Ultimately, this means that if the highlights are blown, then they're blown for good. If the shadows are blocked up, then they will likely stay blocked up. It may be possible to make improvement in Photoshop, but the edits make the final image susceptible to posterization and banding.

On the other hand, RAW images with rich data depth allow far more bits to work with during conversion and subsequent image editing. In addition, RAW files are more forgiving if you need to recover highlight detail. Table AA.1 illustrates the general differences in file richness between a RAW image and a JPEG image from a typical digital SLR camera. Note that this table assumes a five-stop dynamic range for an exposure.

The differences shown here translate directly to editing leeway. And having a good amount of editing leeway is important because all image editing after RAW conversion is destructive.

Proper exposure is important with any image, and it is no less so with RAW images. With RAW images, exposure is important in part because it pertains to the distribution of brightness levels in the linear capture. Linear capture can be contrasted with how the human eye adjusts to differences in light levels. When we go from one room to another room that is twice as light, our eyes automatically compress the differences in light so that we don't perceive the difference to be twice as bright, but only brighter. By contrast, the camera makes no such distinctions. Rather, the camera simply counts photons hitting the sensor. It records the tonal levels exactly to the number of photons captured. As Table AA.1 shows, linear capture has significant implications for digital exposure.

Table AA.1
Comparison of Brightness Levels

F-stop	Brightness Levels Available	
	12-bit RAW file	8-bit JPEG file
First f-stop (brightest tones)	2,048	69
Second f-stop (bright tones)	1,024	50
Third f-stop (midtones)	512	37
Fourth f-stop (dark tones)	256	27
Fifth f-stop (darkest tones)	128	20

Underexposure of an image sacrifices valuable bits of data that could have been — and need to be — captured in the image. And underexposure increases the likelihood that the few levels of brightness that are devoted to dark tones will be riddled with noise. With a miscalculation of one f-stop of brightness, half of the possible tonal levels are missing and the few dark levels that are captured must then be redistributed. Visualize this redistribution as stretching a rubber band. As the band is stretched, small holes analogous to breaks between tonal levels appear.

Modest overexposure of a RAW image delivers all the tonal levels that the camera is capable of providing, including the first f-stop of brightness that accounts for half the total tonal levels in the image. And when tone-mapping is applied, significantly more bits can be redistributed down the line to the midtones and darker tones — areas where the human eye is most sensitive to changes. In short, modest overexposure gives you the best image that the EOS 30D can produce.

What Is Bit Depth?

A digital image is made up of pixels. Each pixel is made up of a group of bits. A *bit* is the smallest unit of information that a computer can handle. In digital images, each bit stores information that, when aggregated with other pixels and color information, provides an accurate representation the picture.

Because digital images are based on the Red, Green, Blue (RGB) color model, an 8-bit digital image has eight bits of color information for red, eight bits for green, and eight bits for blue for a total of 24 bits of data per pixel (8 bits × 3 color channels). Because each bit can be one of two values, either 0 or 1, the total number of possible values is 2 to the 8th power, or 256 colors per channel.

In the RGB color model, the range of colors is represented on a continuum from 0 (black) to 255 (white). On the continuum, an area of an image that is white is represented by 255R, 255G, and 255B. An area of the image that is black is represented by 0R, 0G, 0B.

An 8-bit file offers 256 possible colors per channel. A 16-bit file provides 65,000 colors per channel, and a 24-bit file (common on some film scanners) provides 16.7 million colors per channel. There is, of course, an upper limit on bit-depth since the human eye with its non-linear response to light can detect hundreds of thousands of colors while printers can reproduce far fewer distinguishable colors. As a result, high bit-depth images offer more subtle tonal gradations and a higher dynamic range than low bit-depth images. High bit-depth images also provide much more latitude in editing images.

Note that the RBG color model adds varying amounts of red, green, and blue to achieve a very wide gamut of different colors. This type of model is called an additive color model. Note that different RGB devices such as monitors, scanners, and printers have their own color spaces and gamuts.

Choosing a RAW Conversion Program

RAW image data is stored in proprietary format, which means that the RAW images can be viewed and converted using the camera manufacturer's RAW conversion program, such as Canon's Digital Professional Pro conversion program, or a third-party RAW conversion program such as Adobe's Camera Raw plug-in or Phase One's Capture One.

Unlike standard TIFF and JPEG files, RAW files are not portable. They cannot be moved from computer to computer with the assurance that any system can display them.

That means that you must first convert RAW files to a more universal file format or verify that clients have an operating system and conversion program that allows them to display RAW images before you hand off images. And unless the client has a third-party program such as Adobe Camera Raw, they must install and stay up to date with conversion programs from the camera manufacturer. Granted, few photographers hand off RAW images to clients, but as workflow and RAW capture matures, RAW image handoff could become a common part of the handoff process.

Note *Images captured in RAW mode include unique filename extensions such as .CR2 for Canon 30D RAW files.*

AA.1 This figure shows Canon's Digital Photo Professional's main window with the toolbar for quick access to commonly accessed tasks.

Although RAW conversion programs continue to offer more image-editing tools with each new release, you won't find some familiar image-editing tools in RAW conversion programs, including cloning, healing, history brushes, filters, gradient mapping, or the ability to work with layers in the traditional sense. Most conversion programs rightly focus on basic image conversion tasks, including white balance, exposure, shadow control, brightness, contrast, saturation, sharpness, noise reduction, and so on.

Choosing a RAW conversion program is a matter of personal preference in many cases. Canon's Digital Photo Professional (DPP) is included with the 30D, and updates to it are offered free of charge.

Third-party programs, however, often have a lag time between the time that the camera is available for sale and the time that the program supports the new camera. For example, there was approximately a six-week lag time between when the 30D was available and the time when Adobe Camera Raw supported 30D files. Some photographers use the Canon conversion program during the lag time, while others use only the Canon program or wait for a third-party program to support the new camera.

Arguments can be made for using either the manufacturer's or a third-party program. The most often cited argument for using Canon's program is that because Canon knows the image data best, they are most

AA.2 By way of contrast, Adobe presents images in Bridge, and from Bridge or Photoshop you can open RAW images in Camera Raw for conversion.

likely to provide the highest quality RAW conversion. At the same time, many photographers have tested the conversion results from Canon's program and Adobe's Camera Raw plug-in, and they report no difference in conversion quality.

Assuming that there is parity in image conversion quality, the choice of conversion programs boils down to which program offers the ease of use and features that you want and need. Certainly a company like Adobe has years of experience building feature-rich programs for photographers within

an interface that is familiar and relatively easy to use. Canon, on the other hand, has less experience in designing features and user interfaces for software.

Because both programs are free (provided that you have Photoshop CS2 or an earlier version of Photoshop), you should try both programs and any other conversion software that offers free trials. Then decide which one best suits your needs. I often switch between using Canon's DPP program and Adobe Camera Raw. When I want to apply a Picture Style from Canon to a

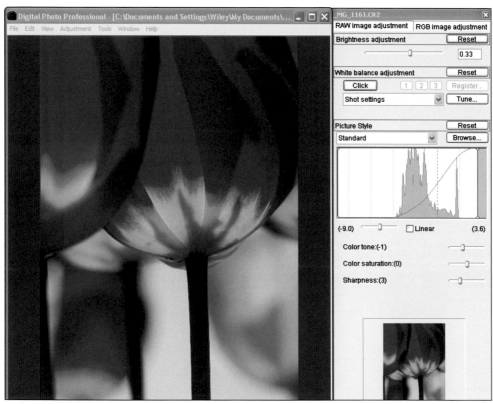

AA.3 This figure shows the RAW image adjustment controls in Canon's Digital Photo Professional. Note that you can apply a Picture Style after capture.

RAW image or when I want to convert a RAW image to monochrome and apply a color filter, I use DPP. For most everyday processing, however, I use Adobe Camera Raw, which offers more flexibility in setting curves and tweaking color.

Another consideration is which program offers the most and best batch features. DPP allows you to apply conversion settings from one photo to others in the folder, as does Camera Raw. Camera Raw also has the advantage of applying actions to batches of images.

Whatever conversion program you choose, be sure to explore the full capabilities of the program. Remember also that one of the advantages of RAW conversion is that as the conversion programs improve, you'll have the opportunity to go back to previous RAW image files and reconvert them using the improved conversion program.

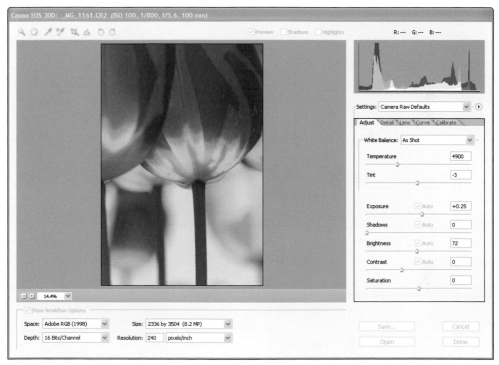

AA.4 This figure shows the Adobe Camera Raw dialog box opened to the Adjust tab where color, exposure, tone, contrast, and saturation adjustments are made.

Sample RAW Image Conversion

Although RAW image conversion adds a step to the processing workflow, this important step is well worth the time spent processing images. To illustrate the process, I give a broad overview using Digital Photo Professional to convert a RAW EOS 30D image.

1. **Start Digital Photo Professional.** The program opens with the images in the currently selected folder displayed. RAW images are marked with a camera icon and the word RAW in the lower left of the thumbnail. On the right of the window, you can select a different directory and folder.

2. **Double-click the image you want to process.** The RAW image adjustment tool palette opens to the right of the image preview. In this mode, you can:

 • Drag the Brightness slider to tweak the exposure to a negative or positive setting by dragging the slider.

 • Use the White balance adjustment controls to adjust color. You can click the Click button, and then click an area that is white in the image to set white balance, choose one of the preset white-balance settings from the Shot Setting drop-down menu, or click the Tune button to adjust the white balance using a color wheel.

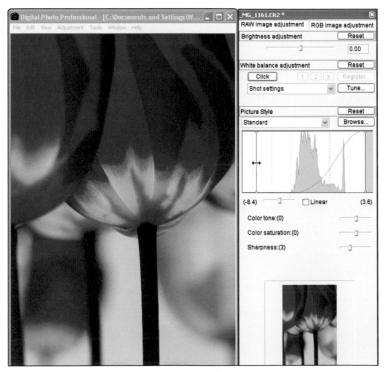

AA.5 This figure shows adjusting the black point in Canon's Digital Photo Professional RAW conversion window.

- Choose a different Picture Style by clicking the drop-down arrow next to Standard and selecting a Picture Style from the list. The Picture Styles are the same as those offered on the menu on the EOS 30D. When you change the Picture Style in DPP, the thumbnail updates to show the change. You can adjust the curve, color tone, and saturation and sharpness. If you don't like the results, you can click Reset to change back to the original Picture Style.

- Adjust the black and white points on the image histogram by dragging the bars at the far left and right of the histogram toward the center. By dragging the slider under the histogram, you can adjust the tonal curve. To set a Linear curve, select the Linear option, although I don't recommend using this adjustment because you cannot make further curve adjustments.

- Adjust the Color tone, Color saturation, and Sharpness by dragging the sliders. Dragging the Color tone slider to the right increases the green tone, and dragging to the left increases the magenta tone. Dragging the Color saturation to the right increases the saturation, and vice versa. Dragging the Sharpness slider to the right increases the sharpness.

3. **Click the RGB image adjustment tab.** Here you can apply a more traditional RGB curve and apply separate curves in each of the three color channels, Red, Green, and Blue. You can also adjust the following:

 - Drag the Brightness slider to the left to darken the image or to the right to brighten the image. The changes you make are shown on the RGB histogram as you make them.

 - Drag the Contrast slider to the left to decrease contrast or to the right to increase contrast.

 - Drag the Color tone, Color saturation, and Sharpness sliders to make the appropriate adjustments.

4. **In the preview window, choose File ⇨ Convert and save...** The Save As dialog box appears. In the Save As dialog box, you can set the bit-depth at which you want to save the image, set the Output resolution, choose to embed the color profile, or resize the image.

 Note *The File menu also enables you to save the current image's conversion settings as a recipe. Then you can apply the recipe to other images in the folder.*

5. **Click Save.** DPP displays the Digital Photo Professional dialog box until the file is converted. DPP saves the image in the location and format that you choose.

Creating an Efficient Workflow

When workflow became a buzzword several years ago, it typically encompassed the process of converting and editing images one at a time or several at a time. Since then, however, the concept of workflow has expanded to include the process from image capture to client handoff, often including pre-press settings, that ensures image quality and consistent settings that meet the client's needs and specifications.

While workflow varies depending on your needs or the needs of the client, here are some general steps that you can consider as you create your workflow strategy.

✦ The first workflow step for many photographers is backing up original images to a separate hard drive or to DVD. Whether you do this step now or later, it's a critical aspect of any workflow.

✦ Batch file renaming allows you to identify groups of images by subject, assignment, location, date, or all these elements. Programs such as DPP and Adobe Bridge offer tools for batch renaming that saves time in the workflow.

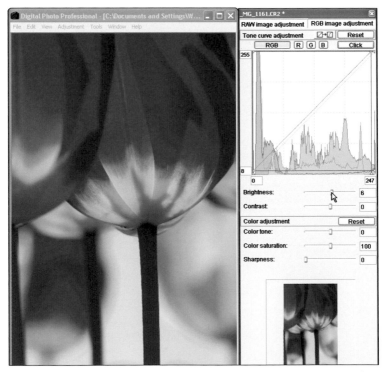

AA.6 This figure shows adjusting the black point in Canon's Digital Photo Professional RAW conversion window.

✦ Create a standard IPTC template that has your name, address, phone number, and other important information about the image that is appended to the image metatdata. Then you can use the Tools ⇨ Append Metadata command in Adobe Bridge to apply the template to all the images in a folder.

✦ Select images and name files consistently. Regardless of whether you're shooting RAW or JPEG images, programs such as Adobe Bridge and Digital Photo Professional provide tools to rate images and then sort them to display top-rated images to process.

✦ If you're processing RAW images, you can open the selected images in groups or all at once for conversion, depending on the RAW conversion program you're using. In some programs, you can select similar images, process one image, and then apply all or part of that image's conversion settings to similar images. Then save the images or open them in Photoshop for additional editing.

✦ If you create JPEG versions of the images for client selection on your Web site, you can use a batch action in Photoshop to make and automatically size images for the Web and save the images in a separate subfolder.

✦ If your workflow includes client selection, you can create subfolders for selected images and move non-selected images to other subfolders. This is a good time to add JPEG versions of the images to a main database of images, if you maintain that type of database. A good practice is to maintain tracking sheets of images that you update during each stage of the process of handing off images to clients, or for your own records for personal images.

✦ Registering images with the Library of Congress protects the copyright to your images and is an important part of the workflow. You can create a 4-×6-inch contact sheet with approximately 12 images per sheet in Adobe Bridge of the images that you want to register. Be sure to leave space on the contact sheet to add your name and contact information.

> **Note** *The copyright gives you the right to control use of your images for your lifetime plus 70 years. The annual fee for bulk image registration is provided on the Web site. For more information, visit www.editorial photo.com/copyright/.*

✦ With the final selections made, you can do the final image processing in Photoshop according to the client's specifications.

✦ When the final images are ready, you can burn a DVD or you can send images via FTP to the client or for your personal archives. Having a fire-safe and flood-safe place to archive hard drives and DVDs is important. Some photographers have a safety deposit box or other off-site location for storage.

The steps you incorporate into your workflow often depend on whether you're shooting for clients or for personal work, but these broad suggestions provide an overview of steps that you can consider for your workflow.

Keep the 30D Up to Date

One of the greatest advantages of owning a digital camera such as the EOS 30D is that Canon often posts updates to the firmware (the internal instructions) for the camera to its Web site. New firmware releases can add improved functionality to existing features and, in some cases, fix reported problems with the camera.

New firmware along with ever-improving software keeps your camera and your ability to process images current as technology improves. To determine if you need to update firmware, you can compare the firmware version number installed on your EOS 30D to the latest release from Canon on their Web site.

Getting the Latest Firmware and Software

To check the current firmware version installed on your camera, follow these steps:

1. **Press the Menu button.**
2. **Press the JUMP button to access the Set-up menu.**
3. **Rotate the Quick Control dial until you see the Firmware Ver., and then write down the number.** If the firmware installed on your camera is older than the firmware offered on the Web site, then your camera needs updating.

To download the latest version of firmware, go to the Canon Web site at `http://canon.co.jp/Imaging/eos30d/eos30d_ firmware-e.html`.

And you can check for other software updates and product notices on the Canon Web site's support area at http://usa.canon.com/consumer/controller?act=DownloadDetailAct&fcategoryid=314&modelid=10464.

 Note *You can check www.rob galbraith.com and search the news section for announcements of the latest firmware updates.*

Before installing firmware updates, be sure that the camera battery has a full charge, or use the Compact Power Adapter CA-PS400 and DC Coupler DR-400 to power the camera. You don't want the camera to lose power during the firmware update because the camera can become inoperable.

Also have a freshly formatted CompactFlash card available on which to copy the firmware update. Or you can connect the camera to your computer with a USB cable, and then copy the firmware file onto the CF card in the camera.

On your computer, go to the Canon download site at www.canon.co.jp/Imaging/eos30d/eos30d_firmware-e.html._Firm-e.html.

To download firmware updates and install them on the EOS 30D, follow these steps:

1. **Insert the CF card in a card reader attached to your computer.**

2. **Scroll down on the Canon Web page to the License Agreement, and click I agree and download.**

3. **Click the link that matches your computer's operating system, either Windows or Mac OS.**

4. **Click Run if a File Security dialog box appears.** If a window appears saying that Publisher cannot be verified, click Run. A window appears notifying you that this is a self-extracting file.

5. **Click OK.** A Self-extracting archive window appears.

6. **Click Browse, navigate to the CF card location, and click OK. The Self-extracting archive window is displayed again.**

7. **Click OK.** A progress window appears. The firmware appears on the CF card as a folder.

8. **Insert the CF card into the camera.** The firmware update program starts and displays an Execute Upgrade screen. Rotate the Quick Control dial to select OK, and press the Set button. A Checking Firmware screen appears. Then a Replace Firmware screen appears listing the existing and new firmware version numbers.

9. **Rotate the Quick Control dial to select OK, and press the Set button.** A Re-writing Firmware screen appears with a progress bar. When the update is complete, a Firmware Replaced Successfully screen appears. As the update progresses, do not press any buttons on the camera, open the CompactFlash card door, or turn off the camera.

10. **Press the Set button to complete the firmware update.**

11. **Remove the battery from the camera and leave it out for at least 2 seconds.**

Internet Resources

A wealth of valuable information is available for photographers. This section is a handy resource to help you discover some of the many ways to learn more about the 30D and about photography.

✦ **Photoworkshop.com.** This Web site (www.photoworkshop.com) is the home of the Canon Digital Learning Center, a rich resource that includes and introduction to and information on the EOS 30D.

✦ **Canon.** When you want to access the technical specifications for the camera or if you want to register your camera online, visit the Canon Web site.

✦ **EOS SLR.** To learn more about the EOS SLR systems, visit the Canon Advantage page at www.consumer. usa.canon.com/ir/controller? act=CanonAdvantageCatIndex Act&fcategoryid=111.

✦ **Firmware.** To download new firmware updates for the Canon EOS 30D, see the previous section. On the Canon site, the Download Library includes an option to download the setup guide and camera manual in English, Spanish, French, or Chinese. You can visit the Download Library at www. usa.canon.com/consumer/ controller?act=Download DetailAct&fcategoryid=325& modelid=8294.

✦ **Accessories.** When you want accessories for the 30D, the Canon Accessory Annex offers everything from AC adapters, battery grips, and battery packs to macro ring lights. You can find the Accessory Annex at www.estore.usa. canon.com/default.asp.

✦ **Lenses.** You can get information on Canon lenses at www.consumer. usa.canon.com/ir/controller? act=ProductCatIndexAct& fcategoryid=111.

Photography Publications and Web Sites

Some of the popular photography magazines also have Web sites that offer photography articles. Here are a few of the venerable photography magazines' Web sites.

✦ **Photo District News.**
www.pdnonline.com/

✦ **Communication Arts.**
www.commarts.com/CA/

✦ **Digital Photo Pro.**
www.digitalphotopro.com/

✦ **Popular Photography & Imaging.**
www.popularphotography.com/

✦ **Shutterbug.**
www.shutterbug.net/

✦ **Digital Image Café.**
www.digitalimagecafe.com/ default.asp

✦ **PC Photo.**
www.pcphotomag.com/

✦ **Digital Photographer.**
www.digiphotomag.com/

✦ **Outdoor Photographer.**
www.outdoorphotographer.com/

Professional Resources

A variety of professional organizations offer support and training for photographers. Here is a selection of some of the most respected organizations by category.

Commercial

Advertising Photographers of America
www.apanational.org

Editorial/Photojournalism

American Society of Media Photographers
www.asmp.org

Editorial Photographers
www.editorialphotographers.com

National Press Photographers Association
www.nppa.org

Fine Art

College Art Association
www.collegeart.org

Photo Imaging Educators Association
www.pieapma.org

Society for Photographic Education
www.spenational.org

General

Professional Photographers of America (PPA)
www.ppa.com

Association of Photographers (UK)
www.the-aop.org

Professional Photographers of Canada Inc.
www.ppoc.ca

PIC (Professional Imagers Club)
www.pic-verband.de

The American Society of Picture Professionals
www.aspp.com

Nature and Wildlife

Lepp Photo
www.leppphoto.com

Nature Photographers Network
www.naturephotographers.net

North American Nature Photography Association
www.nanpa.org

Photoshop

Adobe Design Center
www.adobe.com/designcenter/

Photoshop Support
www.photoshopsupport.com

The National Association of Photoshop Professionals
www.photoshopuser.com

Software Cinema
www.software-cinema.com

Portrait/Wedding

Wedding & Portrait Photographers International

www.wppionline.com

Society of Wedding & Portrait Photographers (UK)

www.swpp.co.uk/

Stock

Adobe Stock Photos

www.adobe.com/products/creative suite/adobestockphotos/index.html

Stock Artists Alliance

www.StockArtistsAlliance.org

Workshops

Anderson Ranch Arts Center

www.andersonranch.org

Ansel Adams Gallery Workshops

www.anseladams.com

Brooks Institute Weekend Workshops

www.workshops.brooks.edu

Eddie Adams Workshop

www.eddieadamsworkshop.com

The Lepp Institute

www.leppinstitute.com

The Workshops

www.theworkshops.com

Mentor Series

www.mentorseries.com

Missouri Photo Workshop

www.mophotoworkshop.org

Mountain Workshops

www.mountainworkshops.org

Palm Beach Photographic Centre Workshops

www.workshop.org

Photography at the Summit

www.richclarkson.com

www.photographyatthesummit.com

Rocky Mountain Photo Adventures

www.rockymountainphotoadventures.com

Santa Fe Workshops

www.santafeworkshops.com

Toscana Photographic Workshop

www.tpw.it/

The Center for Photography at Woodstock

www.cpw.org

Glossary

A-DEP (Automatic Depth of Field AE) The camera mode that automatically calculates sufficient depth of field for near and far subjects within the coverage of the seven AF focusing points, such as when several people are sitting at various distances from the camera.

AE Automatic exposure.

AE lock Automatic exposure lock. A camera control that lets the photographer lock the exposure from a meter reading. After the exposure is locked, the photographer can then recompose the image.

AF lock Autofocus lock. A camera control that locks the focus on a subject and allows the photographer to recompose the image without the focus changing. Usually activated by pressing the Shutter button halfway down.

Ambient light The natural or artificial light within a scene. Also called available light.

Angle of view The amount or area seen by a lens or viewfinder, measured in degrees. Shorter or wide-angle lenses and zoom settings have a greater angle of view. Longer or telephoto lenses and zoom settings have a narrower angle of view.

Aperture The lens opening through which light passes. Aperture size is adjusted by opening or closing the diaphragm. Aperture is expressed in f/numbers such as f/8, f/5.6 and so on.

Aperture priority (Av Aperture-Priority AE) A semiautomatic camera mode in which the photographer sets the aperture (f-stop), and the camera automatically sets the shutter speed for correct exposure.

Artifact An unintentional or unwanted element in an image caused by an imaging device or as a byproduct of software processing such as compression, flaws from compression, color flecks, and digital noise.

Artificial light The light from an electric light or flash unit. The opposite of natural light.

Automatic exposure The camera meters the light in the scene and automatically sets the shutter speed (ISO) and aperture necessary to make a properly exposed picture.

Automatic flash When the camera determines that the existing light is too low to get either a good exposure or a sharp image, it automatically fires the built-in flash unit.

Autofocus The camera automatically focuses on the subject using the selected autofocus point shown in the viewfinder, or tracks a subject in motion and creates a picture with the subject in sharp focus. Pressing the Shutter button halfway down activates autofocus.

Av Abbreviation for Aperture Value that indicates f-stops. Also used to indicate Aperture-Priority mode.

Axial chromatic aberration A lens phenomena that bends different color light rays at different angles, thereby focusing them on different planes. Axial chromatic aberration shows up as color blur or flare.

Backlighting Light that is behind and pointing to the back of the subject.

Barrel distortion A lens aberration resulting in a bowing of straight lines outward from the center.

Bit depth The number of bits (the smallest unit of information used by computers) used to represent each pixel in an image that determines the image's color and tonal range.

Bounce light Light that is directed toward an object such as a wall or ceiling so that it reflects (or bounces) light back onto the subject.

Blocked up Describes areas of an image lacking detail due to excess contrast.

Blooming Bright edges or halos in digital images around light sources, and bright reflections caused by an over saturation of image sensor photosites.

Bracket To make multiple exposures, some above and some below the average exposure calculated by the light meter for the scene. Some digital cameras can also bracket white balance to produce variations from the average white balance calculated by the camera.

Brightness The perception of the light reflected or emitted by a source. The lightness of an object or image. See also *luminance.*

Buffer Temporary storage for data in a camera or computer.

Bulb A shutter speed setting that keeps the shutter open as long as the Shutter button is fully depressed.

Calibration In hardware, a method of changing the behavior of a device to match established standards, such as changing the contrast and brightness on a monitor. In software, calibration corrects the color cast

in shadows and allows adjustment of non-neutral colors that differ between an individual camera and the camera's profile used by Camera Raw.

Camera profile A process of describing and saving the colors that a specific digital camera produces so that colors can be corrected by assigning the camera profile to an image. Camera profiles are especially useful for photographers who often shoot under the same lighting conditions, such as in a studio.

Chroma noise Extraneous, unwanted color artifacts in an image.

Chromatic aberration A lens phenomena that bends different color light rays at different angles, thereby focusing them on different planes. Two types of chromatic aberration exist. Axial chromatic aberration shows up as color blur or flare. Chromatic difference of magnification appears as color fringing along high-contrast edges.

Chromatic difference of magnification Chromatic aberration that appears as color fringing where high-contrast edges show a line of color along their borders. The effect of chromatic aberration increases at longer focal lengths.

CMOS (Complementary Metal-Oxide Semiconductor) The type of imaging sensor used in 30D to record images. CMOS sensors are chips that use power more efficiently than other types of recording mediums.

Color balance The color reproduction fidelity of a digital camera's image sensor. In a digital camera, color balance is achieved by setting the white balance to match the scene's primary light source. You can adjust

color balance in image-editing programs using the color Temperature and Tint controls.

Color cast The presence of one color in other colors of an image. A color cast appears as an incorrect overall color shift often caused by an incorrect white-balance setting.

Color space In the spectrum of colors, a subset of colors included in the chosen space. Different color spaces include more or fewer colors.

Color temperature A numerical description of the color of light measured in degrees Kelvin. Warm, late-day light has a lower color temperature. Cool, early-day light has a higher temperature. Midday light is often considered to be white light (5,000K). Flash units are often calibrated to 5,000K.

Compression A means of reducing file size. *Lossy* compression permanently discards information from the original file. *Lossless* compression does not discard information from the original file and allows you to recreate an exact copy of the original file without any data loss.

Contrast The range of tones from light to dark in an image or scene.

Contrasty A term used to describe a scene or image with great differences in brightness between light and dark areas.

Cool Describes the bluish color associated with higher color temperatures. Also used to describe editing techniques that result in an overall bluish tint.

Crop To trim or discard one or more edges of an image. You can crop when taking a picture by changing position (moving closer or farther away) to exclude parts of a scene, by zooming in with a zoom lens, or via an image-editing program.

Daylight-balance General term used to describe the color of light at approximately 5,500K — such as midday sunlight or an electronic flash.

Depth of field The zone of acceptable sharpness in a photo extending in front of and behind the primary plane of focus.

Digital zoom A method of making a subject appear closer by cropping away the edges of the scene. Digital zoom reduces the overall file size. Some cameras then increase file size by estimating where to add similar pixels to bring file size back up to full resolution.

DPI (Dots Per Inch) A measure of printing resolution.

Dynamic range The difference between the lightest and darkest values in an image. A camera that can hold detail in both highlight and shadow areas over a broad range of values is said to have a high dynamic range.

Exposure The amount of light reaching the light-sensitive medium — the film or an image sensor. It is the result of the intensity of light multiplied by the length of time the light strikes the medium.

Exposure compensation A camera control that allows the photographer to overexpose (plus setting) or underexpose (minus setting) images by a specified amount from the metered exposure.

Extension tube A hollow ring attached between the camera lens mount and the lens that increases the distance between the optical center of the lens and the sensor, and decreases the minimum focusing distance.

Fast Refers to film, digital camera settings, and photographic paper that have high sensitivity to light. Also refers to lenses that offer a very wide aperture, such as f/1.4, and to a short shutter speed.

File format The form (data structure) in which digital images are stored, such as JPEG, TIFF, RAW, and so on.

Filter A piece of glass or plastic that is usually attached to the front of the lens to alter the color, intensity, or quality of the light. Filters also are used to alter the rendition of tones, reduce haze and glare, and create special effects such as soft focus and star effects.

Flare Unwanted light reflecting and scattering inside the lens causing a loss of contrast and sharpness and/or artifacts in the image.

Flat Describes a scene, light, photograph, or negative that displays little difference between dark and light tones. The opposite of contrasty.

F-number A number representing the maximum light-gathering ability of a lens or the aperture setting at which a photo is taken. It is calculated by dividing the focal length of the lens by its diameter. Wide apertures are designated with small numbers, such as f/2.8. Narrow apertures are designated with large numbers, such as f/22. See also *Aperture*.

Focal length The distance from the optical center of the lens to the focal plane when the lens is focused on infinity. The longer the focal length is, the greater the magnification.

Focal point The point on a focused image where rays of light intersect after reflecting from a single point on a subject.

Focus The point at which light rays from the lens converge to form a sharp image. Also the sharpest point in an image achieved by adjusting the distance between the lens and image.

Frame Used to indicate a single exposure or image. Also refers to the edges around the image.

Front light Light that comes from behind or beside the camera to strike the front of the subject.

F-stop See *Aperture*.

Gigabyte The usual measure of the capacity of digital mass storage devices; slightly more than 1 billion bytes.

Grain See *noise*.

Grayscale A scale that shows the progression of tones from black to white using tones of gray. Also refers to rendering a digital image in black, white, and tones of gray.

Gray-balanced The property of a color model or color profile where equal values of red, green, and blue correspond to a neutral gray value.

Gray card A card that reflects a known percentage of the light that falls on it. Typical grayscale cards reflect 18 percent of the light. Gray cards are standard for taking accurate exposure-meter readings and for providing a consistent target for color balancing during the color correction process using an image-editing program.

Highlight A term describing a light or bright area in a scene, or the lightest area in a scene.

Histogram A graph that shows the distribution of tones in an image.

Hue The color of a pixel defined by the measure of degrees on the color wheel, starting at 0 for red depending on the color system and controls.

Hot shoe A camera mount that accommodates a separate external flash unit. Inside the mount are contacts that transmit information between the camera and the flash unit and that trigger the flash when the Shutter button is pressed.

ICC profile A standard format data file defined by the ICC (International Color Consortium) describing the color behavior of a specific device. ICC profiles maintain consistent color throughout a color-managed workflow and across computer platforms.

Infinity The farthest position on the distance scale of a lens (approximately 50 feet and beyond).

ISO (acronym for International Organization for Standardization) A rating that describes the sensitivity to light of film or an image sensor. ISO in digital cameras refers to the amplification of the signal at the photosites. Also commonly referred to as film speed. ISO is expressed in numbers, such as ISO 125. The ISO rating doubles as the sensitivity to light doubles. ISO 200 is twice as sensitive to light as ISO 100.

JPEG (Joint Photographic Experts Group) A lossy file format that compresses data by discarding information from the original file.

Kelvin A scale for measuring temperature based around absolute zero. The scale is used in photography to quantify the color temperature of light.

LCD (Liquid Crystal Display) Commonly used to describe the image screen on digital cameras.

Lightness A measure of the amount of light reflected or emitted. See also *brightness* and *luminance*.

Linear A relationship where doubling the intensity of light produces double the response, as in digital images. The human eye does not respond to light in a linear fashion. See also *nonlinear.*

Lossless A term that refers to file compression that discards no image data. TIFF is a lossless file format.

Lossy A term that refers to compression algorithms that discard image data, often in the process of compressing image data to a smaller size. The higher the compression rate, the more data that's discarded and the lower the image quality. JPEG is a lossy file format.

Luminance The light reflected or produced by an area of the subject in a specific direction and measurable by a reflected light meter.

Manual A camera mode in which you set both the aperture and the shutter speed.

Megabyte Slightly more than 1 million bytes.

Megapixel A measure of the capacity of a digital image sensor. One million pixels.

Memory card In digital photography, removable media that stores digital images, such as the CompactFlash media used to store 30D images.

Metadata Data about data, or more specifically, information about a file. Data embedded in image files by the camera includes aperture, shutter speed, ISO, focal length, date of capture, and other technical information. Photographers can add additional metadata in image-editing programs, including name, address, copyright, and so on.

Middle gray A shade of gray that has 18 percent reflectance.

Midtone An area of medium brightness; a medium gray tone in a photographic print. A midtone is neither a dark shadow nor a bright highlight.

Moiré Bands of diagonal distortions in an image caused by interference between two geometrically regular patterns in a scene or between the pattern in a scene and the image sensor grid.

Mode Dial The large dial on the top right of the camera that allows you to select shooting modes in the Basic and Creative Zones.

Noise Extraneous visible artifacts that degrade digital image quality. In digital images, noise appears as multicolored flecks, also referred to as grain. Grain is most visible in high-speed digital images captured at high ISO settings.

Nonlinear A relationship where a change in stimulus does not always produce a corresponding change in response. For example, if the light in a room is doubled, the room is not perceived as being twice as bright. See also *linear.*

Normal lens or zoom setting A lens or zoom setting whose focal length is approximately the same as the diagonal measurement of the film or image sensor used. In 35mm format, a 50 to 60mm lens is considered to be a normal lens. A normal lens more closely represents the perspective of normal human vision.

Open up To switch to a lower f-stop, which increases the size of the diaphragm opening.

Optical zoom Subject magnification that results from the lens.

Overexposure Exposing film or an image sensor to more light than is required to make an acceptable exposure. The resulting picture is too light.

Panning A technique of moving the camera horizontally to follow a moving subject, which keeps the subject sharp but creates a creative blur of background details.

Photosite The place on the image sensor that captures and stores the brightness value for one pixel in the image.

Pincushion distortion A lens aberration causing straight lines to bow inward toward the center of the image.

Pixel The smallest unit of information in a digital image. Pixels contain tone and color that can be modified. The human eye merges very small pixels so they appear as continuous tones.

Plane of critical focus The most sharply focused part of a scene.

Polarizing filter A filter that reduces glare from reflective surfaces such as glass or water at certain angles.

PPI (Pixels Per Inch) The number of pixels per linear inch on a monitor or image file. Used to describe overall display quality or resolution.

RAM (Random Access Memory) The memory in a computer that temporarily stores information for rapid access.

RAW A proprietary file format that has little or no in-camera processing. Processing RAW files requires special image-conversion software such as Adobe Camera Raw. Because image data has not been processed, you can change key camera settings, including exposure and white balance, in the conversion program after the picture is taken.

Reflected light meter A device—usually a built-in camera meter—that measures light emitted by a photographic subject.

Reflector A surface, such as white cardboard, used to redirect light into shadow areas of a scene or subject.

Resampling A method of averaging surrounding pixels to add to the number of pixels in a digital image. Sometimes used to increase resolution of an image in an image-editing program to make a larger print from the image.

Resolution The number of pixels in a linear inch. Resolution is the amount of information present in an image to represent detail in a digital image.

RGB (Red, Green, Blue) A color model based on additive primary colors of red, green, and blue. This model is used to represent colors based on how much light of each color is required to produce a given color.

Saturation As it pertains to color, a strong, pure hue undiluted by the presence of white, black, or other colors. The higher the color purity is, the more vibrant the color.

Sharp The point in an image at which fine detail and textures are clear and well defined.

Sharpen A method in image editing of enhancing the definition of edges in an image to make it appear sharper. See also *unsharp mask*.

Silhouette A scene where the background is much more brightly lit than the subject.

SLR (Single Lens Reflex) A type of camera that enables the photographer to see the scene through the lens that takes the picture. A reflex mirror reflects the scene through the viewfinder. The mirror retracts when the Shutter button is pressed.

Shutter A mechanism that regulates the amount of time during which light is let into the camera to make an exposure. Shutter time or shutter speed is expressed in seconds and fractions of seconds such as 1/30 second.

Shutter priority (Tv Shutter-Priority AE) A semiautomatic camera mode allowing the photographer to set the shutter speed and the camera to automatically set the aperture (f-number) for correct exposure.

Side lighting Light that strikes the subject from the side.

Slow Refers to film, digital camera settings, and photographic paper that have low sensitivity to light, requiring relatively more light to achieve accurate exposure. Also refers to lenses that have a relatively wide aperture, such as f/3.5 or f/5.6, and to a long shutter speed.

Speed Refers to the relative sensitivity to light of photographic materials such as film, digital camera sensors, and photo paper. Also refers to the ISO setting, and the ability of a lens to let in more light by opening the lens to a wider aperture.

Spot meter A device that measures reflected light or brightness from a small portion of a subject.

sRGB A color space that encompasses a typical computer monitor.

Stop See *Aperture*.

Stop down To switch to a higher f-stop, thereby reducing the size of the diaphragm opening.

Telephoto A lens or zoom setting with a focal length longer than 50 to 60mm in 35mm format.

Telephoto effect The effect a telephoto lens creates that makes objects appear to be closer to the camera and to each other than they really are.

TIFF (Tagged Image File Format) A universal file format that most operating systems and image-editing applications can read.

Commonly used for images, TIFF supports 16.8 million colors and offers lossless compression to preserve all the original file information.

Tonal range The range from the lightest to the darkest tones in an image.

Top lighting Light, such as sunlight at midday, that strikes a subject from above.

TTL (Through The Lens) A system that reads the light passing through a lens that will expose film or strike an image sensor.

Tungsten lighting Common household lighting that uses tungsten filaments. Without filtering or adjusting to the correct white-balance settings, pictures taken under tungsten light display a yellow-orange color cast.

Underexposure Exposing film or an image sensor to less light than required to make an accurate exposure. The picture is too dark.

Unsharp mask In digital image editing, a filter that increases the apparent sharpness of the image. The unsharp mask filter cannot correct an out-of-focus image. See also *sharpen*.

Value The relative lightness or darkness of an area. Dark areas have low values, and light areas have high values.

Viewfinder A viewing system that allows the photographer to see all or part of the scene that will be included in the final picture. Some viewfinders show the scene as the lens sees it. Others show approximately the area that will be captured in the image.

Vignetting Darkening of edges on an image that can be caused by lens distortion, using a filter, or using the wrong lens hood. Also used creatively in image editing to draw the viewer's eye toward the center of the image.

Warm Reddish colors often associated with lower color temperatures. See also *Kelvin*.

White balance The relative intensity of red, green, and blue in a light source. On a digital camera, white balance compensates for light that is different from daylight to create correct color balance.

Wide angle Describes a lens with a focal length shorter than 50 to 60mm in full-frame 35mm format.

Index

Continued

Continued